Art in Society

by Ken Baynes

with contributions by Kate Baynes and Alan Robinson

Preface by Milton Glaser

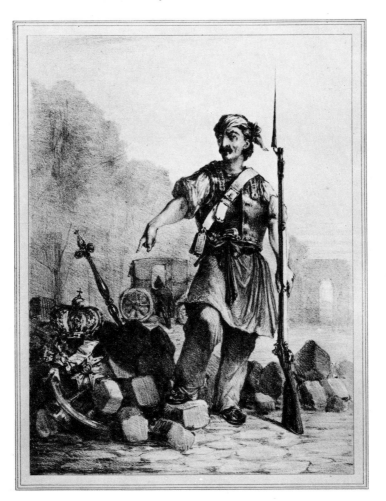

Lund Humphries

First edition 1975
Published by
Lund Humphries Publishers Ltd
12 Bedford Square London WC1

SBN 85331 380 6

Designed by Ken Baynes

Made and printed in Great Britain by
Lund Humphries, Bradford and London

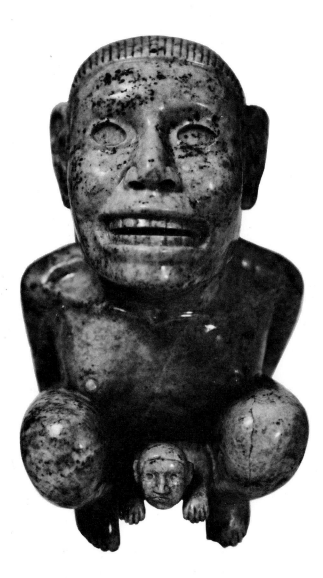

Illustration on title page:
NATIONAL PROPERTY, FOR SALE BECAUSE OF DEPARTURE
A French print, 1848 (British Museum)

1 The Aztec goddess of childbirth Tlazoltéotl (Dumbarton Oaks Collections, Washington DC)

Contents

Preface

Art has no separate reality in primitive cultures; the most apt distinctions might be between useful and ritualistic objects, and even these overlap. Traditionally, art was assigned a high and separate place in terms of study, but in the last decades as a result of factors as various as globalism, ecological concerns, the exhaustion of modernism in art, as well as political tendencies, the split between the useful and the ritualistic has been erased for many people. Explained in another way, the informative and the transcendent have come together in people's minds.

Ken Baynes's approach is therefore very much part of our time, a time in which both tastemakers and the public have come to understand that art may appear without an artistic intention. This may now, at the present moment, seem so true as to appear banal as a statement, but the history of the perception of the art activity until recently was different.

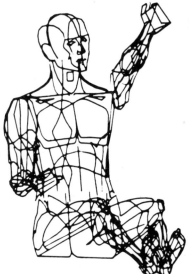

In our technological society, built over centuries on the upward thrust of a merchant class seeking to establish blood lines that it didn't have, the newly rich took many cues from the aristocratic and clerical classes they were replacing. Merchants and the sons of merchants sought in the possession of artistic objects a connection with the societal wellsprings of so much art of the past. But given the ability of a technological society to reproduce things, this acquisitive class, having acquired means, naturally downgraded utilitarian artefacts; the fact of profusion made them less valuable. How could one establish privilege if everyone could possess the same things? Not unnaturally, this attitude was a carry-over from bourgeois attitudes emerging from the business world itself – scarcity produces value.

Art, of course, lies somewhere else again, but in the perpetuation of elitist attitudes, very little study was made of the creative input of the commonplaces of life, as it affected and was affected by such activities as worship, war, sex, and work. As long as the tastemakers were either aristocrats or the rich merchant class (or their appointees) the aesthetics of the daily world were more or less disregarded and certainly not studied as the multifaceted artistic heritage we now, almost without question, accept it to be. The world was still looking for beauty in special places.

The change in attitude I have suggested was a compound of many things. After abstract expressionism it seemed hard at *that* moment to invent a formal system that

2 Computerised man: diagrams showing a man's working positions for use in ergonomic studies and produced by a computer (Computer Graphics, The Boeing Company, Commercial Airplane Division)

had not been officially explored. The great move was in the direction of least expectation–towards the most debased and feared forms in the art vocabulary, those of the commercial artist–an astonishing move to embrace the parasites who allegedly sucked on art! Of course, in the work of Duchamp, the Dadaists, the Bauhaus, and Art Brut there were precursing tendencies. At the same time, the elitist sense of art was under pressure. It emerged after all from a capitalist world of privilege at a time when half the world was beginning to think of collective action, of the commonweal. The romantic agony of the post-Renaissance artist, his individualistic expression, was part of a bourgeois democracy in which, according to prevailing political theory, a consensus of egotistical interests would yet provide for society's good. But after the Second World War such views fell increasingly into disrepute and young people in particular all over the world began to feel that arrant individualism was often destructive of society's welfare. A sensibility began to develop in which great numbers of people became able to perceive the actual superiority of the commonplace when placed against works of an elitist sensibility which did not happen to be sublime masterpieces, e.g. the quilt on page 93 as opposed to most geometric painted abstractions.

Also at this time two contrary attitudes developed with regard to technology: One, that technology had taken man as far as it could and so the best he could do was put limits on growth while looking backward to better times. The nostalgic boom was part of this and, although pernicious as an end in itself, did lead to a re-examination of earlier times and the artefacts of those times. Two, the Fullerian notion that within a humanistic technology lay the only salvation, that a design revolution could preserve and enlarge man. This second view, although opposed to the first attitude, also led people into an examination of style and design as it related to man, not to transcendent and separatist art.

Today, many easily accept the eclectic vision and yet it is quite a recent development, as we see, to recognize that everything that is created reveals its creator's aesthetic–that a study of objects is really a study of man, that one cannot study man only by dates and theories, one must know what he makes. What Ken Baynes's study therefore does is to recognize that every made object reflects and epitomizes the unique moment in which it was made–that there cannot be an absence of style: Even a smooth ceiling is part of an aesthetic impulse. A chair is different in every period and place, yet always has legs, a seat and a back. So not only do the text and illustrations depict the wholeness of man, but the book itself, in its argument and its presentation, becomes part of the societal matrix which continually evolves, in which art assumes its rightful non-separate place. It is lower in that it ascends to man. It is higher in that it can be found in all man's work.

Milton Glaser
New York 1975

3 One of the wheels of the Sun Temple at Konarak in India. Constructed in the seventeenth century, the temple is said to be built on the site of a healing miracle performed by Vishnu-Suraya, the Sun god (Information Service of India)

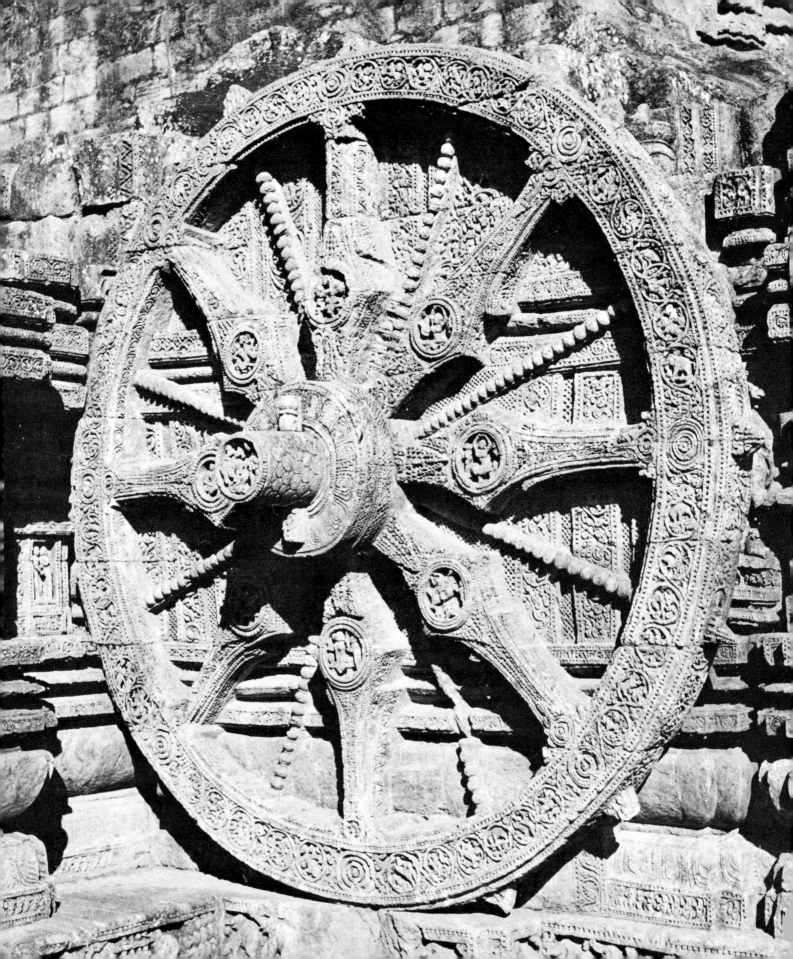

4 NEWTON by William Blake, painted in 1795 at the time of the French Revolution. Blake had an ambivalent attitude to scientific knowledge: he recognised its restricting rationalism as well as its contribution to the enlightenment. Above all, he saw it as an ally of the industrial revolution which he believed was laying waste traditional society (Tate Gallery, London)

Part One
ART AND SOCIETY

*Man by his reasoning power
can only compare & judge of
what he has already perceiv'd.*

from THERE IS NO NATURAL RELIGION by William Blake[1]

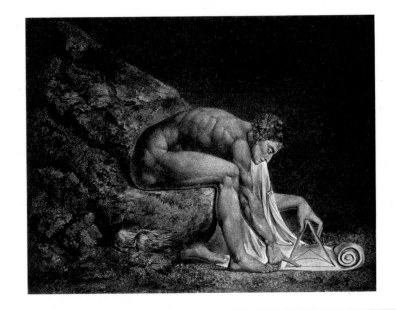

This book contains much historical material, but it is not primarily directed at the past. Its main focus of interest is the present. The kind of analysis which it proposes has been developed in an attempt to provide fresh and better ways of understanding contemporary culture.

The key concept is that culture is more like a tool than it is like a static accumulation of treasures. It is something that men make and use, and which they go on using until it is worn out. It is a changing network to which every member of a community makes a contribution and which, in turn, moulds every member of a community. The sum of a culture is inevitably greater than its individual parts, but it only becomes real – only exists at all – when it comes alive in the actions and imaginations of men.

A culture is a whole thing existing in a particular place and time. It is not an abstraction. It is not legitimate to say of the products of a community: 'this part is culture and that part is not'. Whatever is rejected in that way is organically related to the part selected – in existential terms, the part selected could not be there without it. The culture of slavery was an integral part of the sophisticated culture of the American south, just as the culture of the Lancashire mill worker was an integral part of the culture of the British industrial revolution. In India, it is impossible to separate the achievements of the Brahmins from the wretched conditions of those caste-less people at the very bottom of the social continuum. Such things are historical unities and we may not pick and choose which aspects of them we will acknowledge.

The moment criticism ceases to concentrate exclusively on masterpieces, art takes on an aspect which is morally complex. In looking at the humble and everyday ways in which imagery is applied to life it becomes clear that art is involved in every side of

5, 6 and 7 Cigarette cards produced about the turn of the century (John Johnson Collection, Bodleian Library, Oxford)

8 Detail from an English print satirising the effect of slavery on life in America (The Bettmann Archive Inc, New York)

9 IT WALKS LIKE A MAN, panel from a comic featuring Namor, the super-hero known as the Submariner (Marvel Comics Group, Vista Publications Inc, New York)

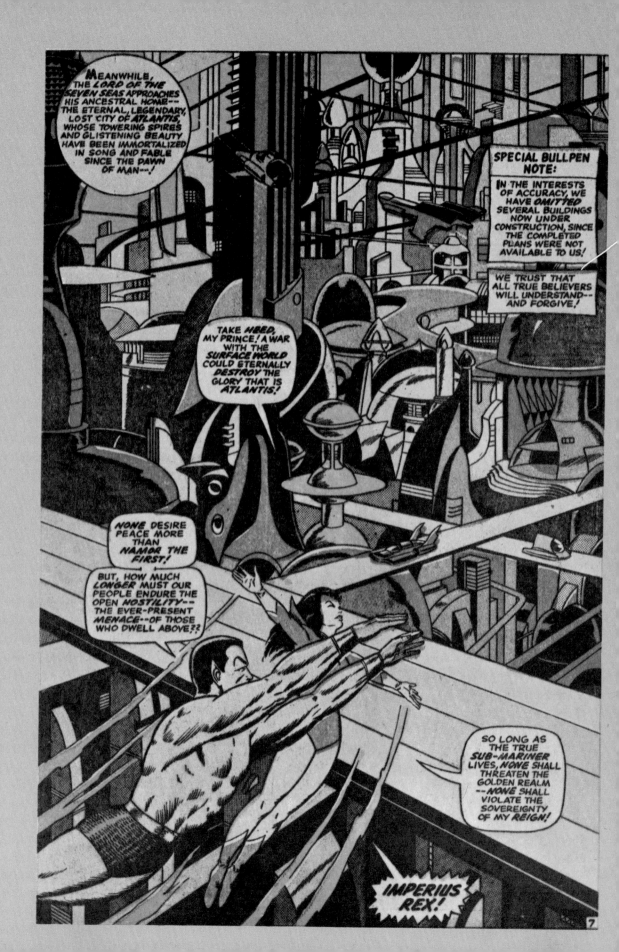

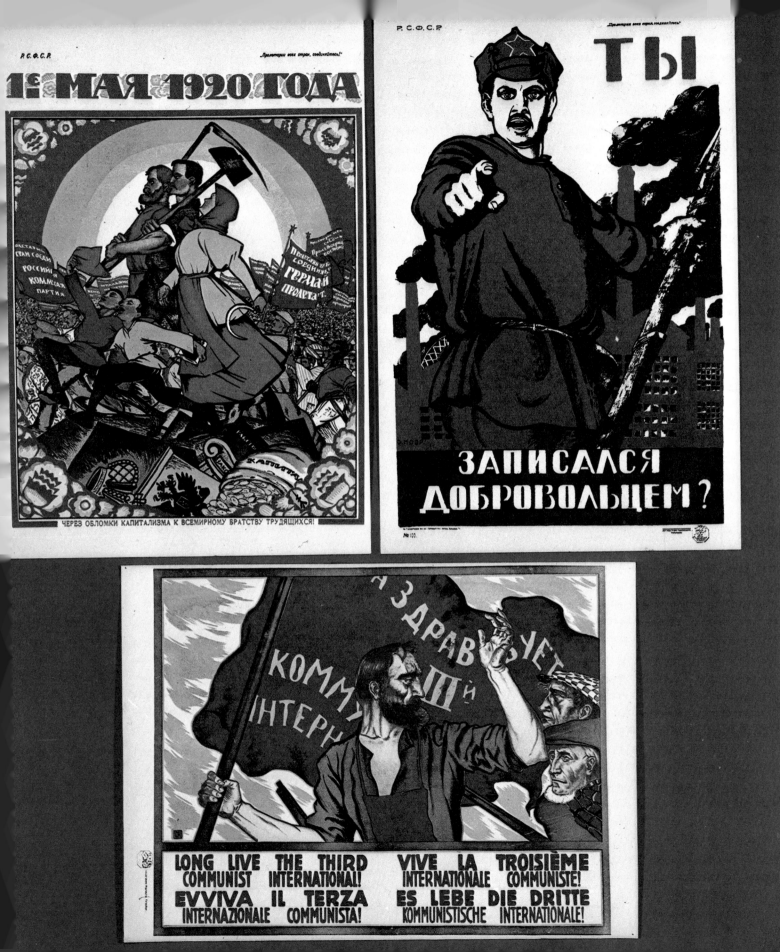

men's activities, positive and negative. It is as truthful as men are truthful; as cynical as men are cynical; as frightened or as brave.

The material gathered in the world's great museums is only the top of a colossal iceberg, the base of which stretches away below the surface of the limited range of attitudes and activities that are thought of as 'cultural'. When the base as well as the top of the structure is included it becomes clear that people's response to life, even their actual experience of it, has always been in all manner of ways determined, described, interpreted, and enlarged by art.

It has not been the traditional concern of critics to look at art in this all-inclusive way. It has fallen to anthropologists and psychologists to develop convincing models of how art and society interact. They have shown how dramatically culture affects the individual, picturing it as a force which reaches down into the most intimate details of experience and understanding. What they have been saying is that one of the most important social functions of culture is to act as a control system. It has been one of the media through which communities have been stabilized.

It is a commonplace of anthropology that the significance of vast areas of human activity is culturally determined. In her book *Patterns of Culture*,[2] the American anthropologist, Ruth Benedict, showed how this concept worked in practice so as actually to affect the lives and thoughts of individuals living in three primitive communities. In each case she showed how the world view of the particular society, as communicated in education, art, and ceremony, affected and formed the experience of the people living in it. Art of every kind was involved in interpreting to the individual the meaning that society placed on his or her actions.

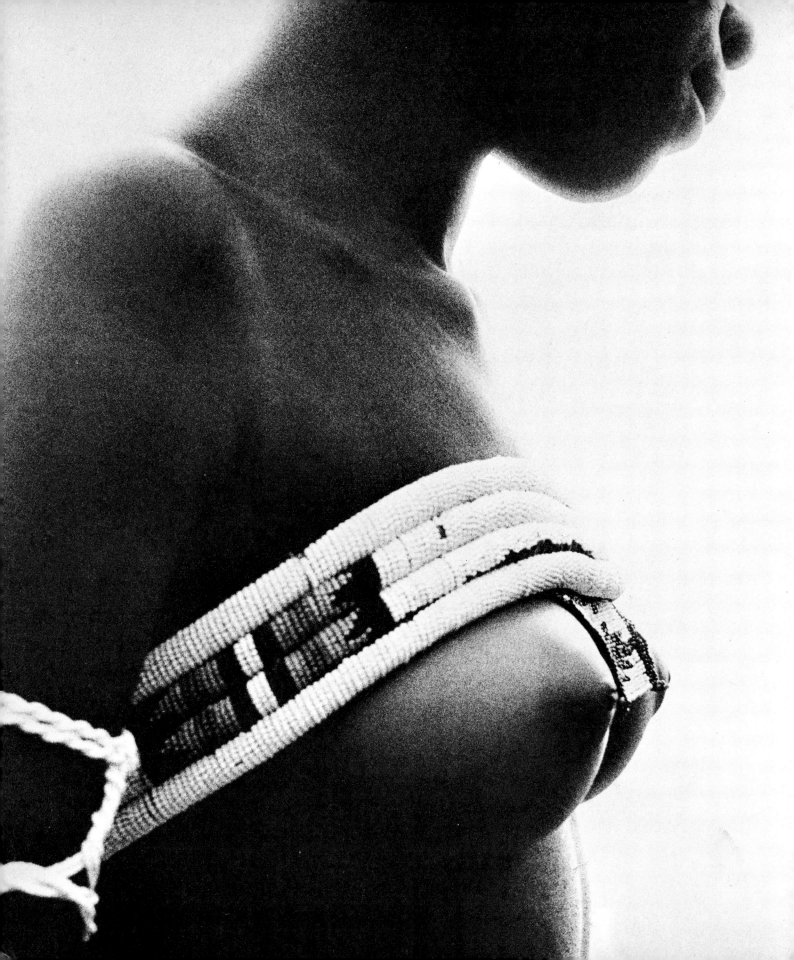

In the following passages she is describing the variations between the puberty rites of different American Indian tribes:

Girls' puberty ceremonies built upon ideas associated with the menses are readily convertible into what is, from the point of the view of the individual concerned, exactly opposite behaviour. There are always two possible aspects to the sacred: it may be a source of peril or a source of blessing. Among the Apaches I have seen the priests themselves pass on their knees before the row of solemn little girls to receive from them the blessing of their touch . . .

[But] the uncleanness of the menstruating women is [also] a widespread idea . . . Among the Carrier Indians of British Columbia, the fear and horror of a girl's puberty was at its height. Her three or four years of seclusion was called 'the burying alive', and she lived for all that time in the wilderness, in a hut of branches far from all beaten trails . . . She was covered with a large head-dress of tanned skin that shrouded her face and breasts and fell to the ground behind. She was herself in danger and she was a source of danger to everybody else . . .

The adolescent behaviour, therefore, even of girls was not dictated by some physiological characteristic of the period itself, but rather by marital or magic requirements socially connected with it. These beliefs made adolescence in one tribe serenely religious and beneficent, and in another so dangerously unclean that the child had to cry out in warning that others might avoid her in the woods.

The contrast is stark. Precisely similar physical events are transformed by culture so that the people subject to them experience radically different feelings and emotions. A person's relationship with his own thoughts and deeds, and his idea of what kind of things he is doing, are dependent to a very large extent on where and when he is alive, and on the art of the social and economic group into which he was born.

The implications are far-reaching and not very well understood. We are more prone to assume that at least the experience of our physical sensations is irreducibly 'real' and not the result of learning. Yet nothing could be farther from the truth, or more confusing for a proper understanding of the relationship between art and society. What we think we see and feel is certainly the result of experience, but the experience is itself formed and focused by family, teachers, wise men, salesmen, artists, and friends.

Because the point is so important, it is worth while to look at another example which is nearer to our own experience. In contemporary industrial society, it is the mass media which carry out many of the functions which were previously assigned to ritual activities of one kind or another. Television and cinema provide models of behaviour; these directly affect our thoughts and feelings. They partly control our appreciation of our own senses. Some of the most intimate influence is brought to bear through women's magazines and other magazines which serve the needs of closely defined economic and social groups.

12 A Zulu girl wearing a fertility band. This photograph by Sam Haskins is taken from his book *African Image*, published in Britain by Bodley Head Ltd

In his extremely intelligent book, *Sexuality and Class Struggle*,[3] the young German Marxist, Reimut Reiche, presented a critique of the social role played by these

magazines in relation to people's perception of their own sexuality. Reiche was concerned to show the media acting as an exploitative aspect of capitalism. This is a theme to which we shall need to return but, for the moment, the significant thing is the clear picture he was able to draw of its functional power in the lives of those who read such material. By examining and classifying the articles and features appearing in *Twen*, *Eltern*, and *Bravo* (among others), he was able to produce not only a typology of material but also a clear explanation of 'the specific objectives of [each] campaign' and the audience at which it was directed.

Here he is discussing the relationship between the content and the audience of *Twen*:

Twen centres upon a world of carefree pre-marital sex, fashion, cars, jobs, fashionable French dishes, a sprinkling of culture, jazz and pop, and numerous other things to which a *Twen*-person can consider himself or herself entitled. No better description has been found of this section of the magazine-reading public than 'Pioneer Consumers' which was produced by a readership survey commissioned by the Springer Group itself. From this it can be seen that the *Twen* reader is intended to express his or her youthful rebellion by extravagant acts of consumption. He or she pioneers a whole new world of social conformity which the readers of *Bravo*, *Eltern*, and *Das Neue Blatt* have not yet cared to explore, from miniskirts to homosexuality.

This particular moral climate is contrasted with that in *Eltern*, a magazine intended for young married people coming from a reasonably prosperous middle-class background:

This magazine is aimed at young married couples in the broad middle area of society who are just embarking on a stable domestic and material existence. The advertisements, which take up a large proportion of the magazine, are predominantly for household and functional clothing (as opposed to fashions), for easily prepared foods, medicines to build up general health, toys, underwear, and small household articles. There are no advertisements for alcoholic drinks or cigarettes. The magazine is read particularly by wives; articles of 'special importance for fathers' are marked with a star on the contents page. Its one leading principle is 'happy marriage at all costs' and great concessions are made to this in the pages of sex information.

An explanation of the physical facts of sexuality . . . would not have been possible in women's magazines ten or even five years ago. The pressure to conform to a restricted, socially inferior role was still too strong, even for young middle-class women with jobs. In this case, then, there has been, to use Marcuse's definition, an increase in 'the range of socially permissible and desirable satisfaction'. Woman remains a sexual 'object' in a situation fraught with constraints of its own – monogamous marriage – but she has gained a certain autonomy.

What Reiche is indicating here is a real change in a woman's perception of her own body and its possible range of responses to lovemaking. Elsewhere he states categorically that there are in use in the media 'a spectrum of symbols and stimuli which work on the pregenital organization of the individual and permanently

13 German women's magazines purchased by the author in 1974. The pages shown confirm the substance of Reiche's analysis made about 1967. It is clear that such material intimately affects 'a woman's perception of her own body and its possible range of responses to lovemaking' (Photograph by Chris Ridley)

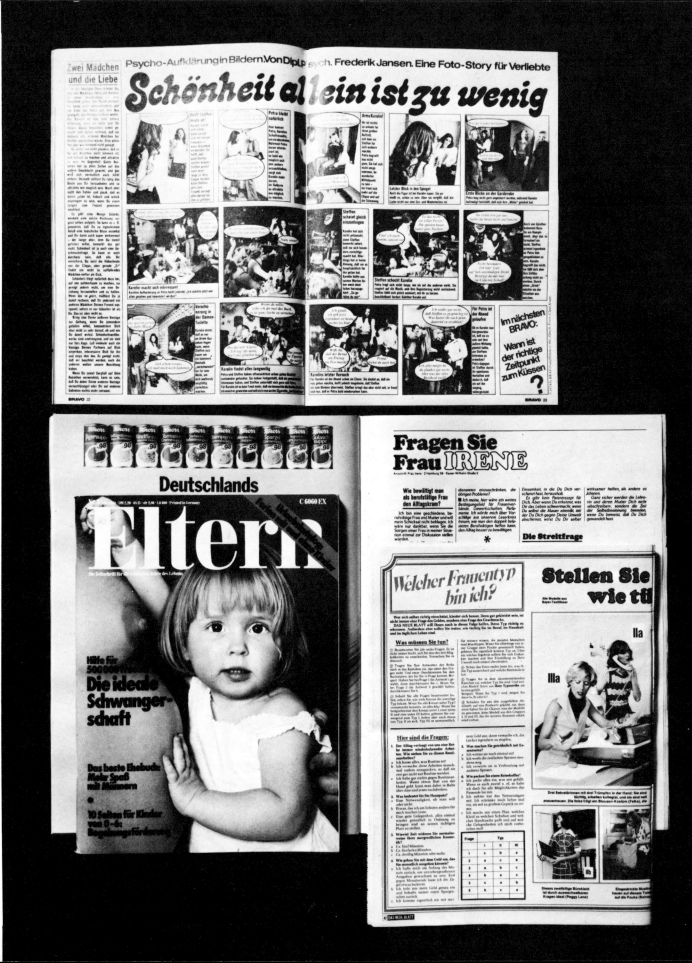

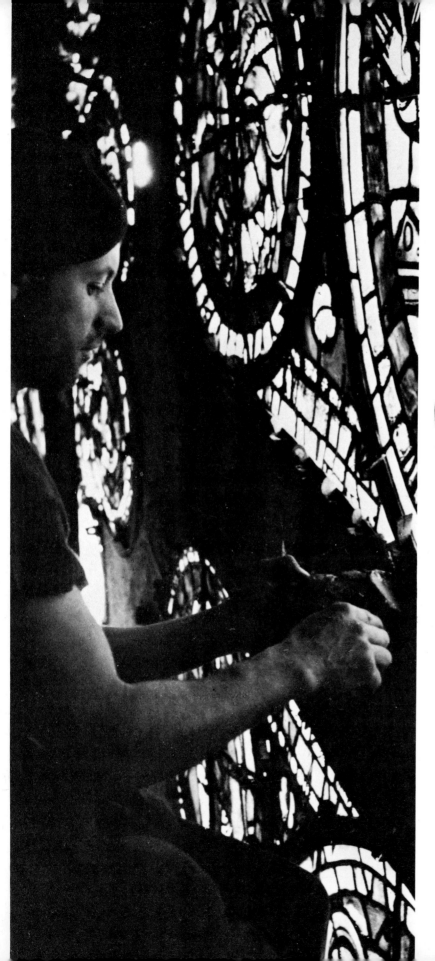

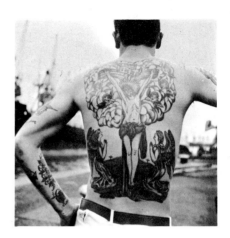

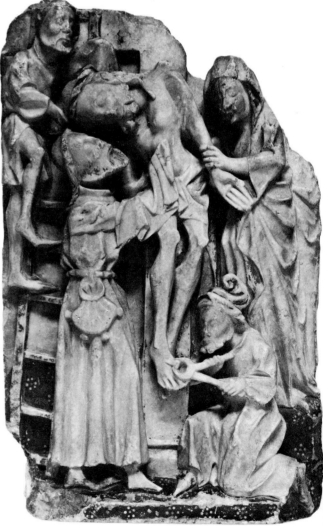

influence the open and private spheres of genital sexuality'. We can only learn and experience what our culture allows us to learn and experience.

It is usual to commence a study of art with a discussion either of artists or the objects they make. In dealing with the relationship between art and society, we have deliberately chosen to begin with what is normally the least regarded aspect of artistic creation: the audience. The selected starting point demonstrates that each individual in a community is ultimately affected by its culture. The next step is to look at the obverse and to recognize how the content and style of art is governed by the power relations, resources, and attitudes of the community in which it exists.

To do this it is necessary to look beyond our own culture's stereotype of the artist. Our picture of a rebellious and often incomprehensible genius is itself culturally determined. It is a legacy of the Renaissance and of the subsequent eras of Romanticism. The artist-hero of Western Europe is historically a freak. Most visual art, at most times and in most places, has been produced on a completely different basis. It is revealing to ask in what way such an image could be relevant to 'folk' art or the great religious masterpieces of the distant past. Works of this kind simply cannot be forced into the mould of the artist-hero. The intentions of those who made them were contrary to those of the Renaissance, and their economic and social status were quite different.

In medieval Europe, for example, changes in styles and forms of art happened only very slowly: the whole pattern of working was more akin to craftsmanship than that which we now associate with painting and sculpture. The relationship of the individual artists to tradition must have been very like that which the English cart-maker, George Sturt,[4] described as still living on in the making of farm wagons in the nineteenth century. Here is a passage from his book, *The Wheelwright's Shop*:[3]

The waggon-builder was obliged to be always faithful, to know always what was imposed on him in wheels, shafts, axles, carriages, everything. The nature of this knowledge should be noted. It was set out in no book. It was not scientific. I never met a man who professed any other than an empirical acquaintance with the waggon-builders' lore. My own case was typical. I knew that the hind-wheels had to be five feet two inches high and the fore-wheels four feet two; that the 'sides' must be cut from the best four-inch heart of oak, and so on. This sort of thing I knew, and in vast detail in course of time; but I seldom knew why. And that is how most men knew. The lore was a tangled network of country prejudices, whose reasons were known in some respects here, in others there, and so on. In farm-yard, in tap-room, at market, the details were discussed over and over again; they were gathered together for remembrance in village workshops; carters, smiths, farmers, wheel-makers, in thousands handed on each his little bit of understanding, passing it on to his son or to the wheelwright of the day, linking up the centuries.

It requires only a little imagination to see that the creation of a great medieval stained-glass window must have been more like the making of a cart of this kind

14 A craftsman repairing a medieval stained glass window at Chartres Cathedral (French Government Tourist Office)

15 THE CRUCIFIED CHRIST. A tattoo by the Bristol tattooist Les Skuse Snr, 1966. This is said to be a traditional design originating in the days of flogging in the navy: the lash would not strike the image of God (Photograph by John Deakin)

16 THE CRUCIFIXION, a small sixteenth-century carving (City Museum, City of St Albans)

than the making of a contemporary painting in an artist's studio. The structural complexity of the task was intense; the time scale was long; and the subject matter was firmly fixed by elaborate ecclesiastical rules of precedent. The various parts of the work were quite highly specialized. No one man painted the whole of the window and though the most skilled would have painted the important heads, there was no magical identification with the Romantic mystery of his personal touch. These windows were made by teams of craftsmen working together in skilled harmony in the context of precisely known didactic requirements. They fitted into a period which hardly had a separate concept of 'art'. At that time, visual communication could not be viewed apart from the requirements of the religious or secular powers, and the craftsman who carried out the work was more like an artisan than today's artist.

It is possible to go further than this and to find examples of societies where the activity of art is totally subsumed with religion or magic, and where social background and artistic function are completely inseparable.

In their contribution to an important study of early societies entitled *Before Philosophy*,[5] H and H A Frankfort said, of the first stages of developed culture, that men did not then distinguish between subjective and objective categories and that 'meaningless, also, is our contrast between reality and appearance'. The existence of such a concept of art 'outside' art, and its institutionalization in the life of the community, profoundly affected the nature of art and what it was that artists thought they were doing. Here are two quotations from the Frankforts which show clearly the significance of what was involved:

In Egypt the creator was said to have emerged from the waters of chaos and to have made a mound of dry land upon which he could stand. This primeval hill, from which the creation took its beginning, was traditionally located in the sun temple at Heliopolis, the sun-god being in Egypt most commonly viewed as the creator . . . [But] each Holy of Holies throughout the land could be identified with the primeval hill . . . Each sanctuary possessed the essential quality of original holiness; for, when a new temple was founded, it was assumed that the potential sacredness of the site became manifest. The equation with the primeval hill received architectural expression also. One mounted a few steps or followed a ramp at every entrance from court or hall to the Holy of Holies, which was thus situated at a level noticeably higher than the entrance.

But this coalescence of temples with the primeval hill does not give us the full measure of the significance which the sacred locality had assumed for the ancient Egyptians. The royal tombs were also made to coincide with it. The dead, and, above all, the King, were reborn in the hereafter. No place was more propitious, no site promised greater chances for a victorious passage through the crises of death, than the primeval hill, the centre of creative forces where the ordered life of the universe had begun. Hence the royal tomb was given the shape of a pyramid which is the Heliopolitan stylization of the primeval hill.

This was not symbolism in our sense of the word, nor in the sense used by Christianity in medieval Europe. It was symbolism enclosed in a concept of space

17 The pyramid of Cheops at Gizeh: it was built during the Fourth Dynasty (Egyptian Ministry of Tourism: photograph by S Afifi)

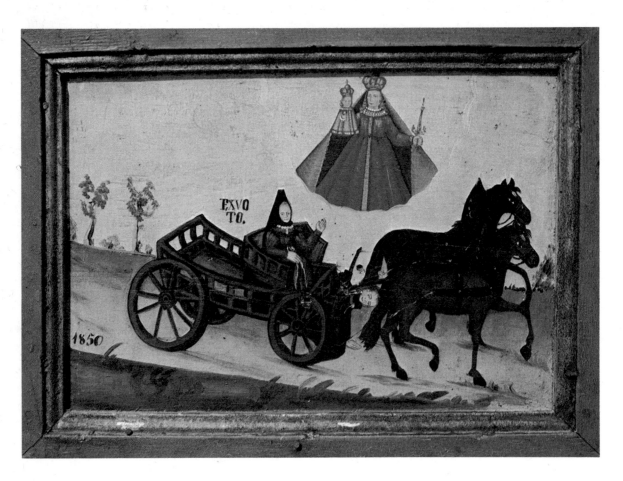

and time which was qualitative and concrete, not quantitative and abstract. In other words, the pyramid was, by its qualities and its concrete reality, the actual primeval hill. The primeval hill could exist in more places than one, and the men who made a pyramid were making a reality, not a sign for it.

The next quotation shows this kind of conceptual framework even more clearly:

Like Isis, the sky-goddess Nūt was considered to be a loving mother-goddess; but the Egyptians of the New Kingdom arranged for their ascent to heaven without [direct] reference to her will or acts. They painted a life-sized figure of the goddess inside their coffins; the dead body was laid in her arms; and the dead man's ascent into heaven was assured. For *resemblance* was a sharing of essentials, and Nūt's image coalesced with its prototype. The dead man in his coffin rested already in heaven.

Nūt's painted arms were also her actual arms. The art was a functional art, creating the presence of divinity and making it real in life. To that degree the artist was a magician working magic. It was not something which he deliberately chose: it was the role of art in that community and no alternative existed to be chosen.

In *The City in History*,[6] Lewis Mumford put forward the idea that the first cities and their associated art were the visible expression of a new balance of power in society which was embodied in the person of the priest-king and his court. The art of the time was completely integrated in that function. We can recognize the urge to a similar degree of integration in the culture of armies, totalitarian states and in every social organization which seeks to maximize its power over its members. But, even beyond such deliberate intentions, it is obvious that the economic structure of a society, which results in a particular distribution of wealth, must always define patronage and set up conceptual, economic and political barriers around the scope and content of the visual forms of communication that are produced.

Magical Art

18 (top left) A contemporary charm hung in motor cars to ward off the evil eye. From Aleppo, Syria (Pitt Rivers Museum, University of Oxford. Collection: P Copeland)

19 (top right) An apron worn by Tibetan exorcists (Pitt Rivers Museum, University of Oxford)

20 (bottom) A nineteenth-century votive offering from Bavaria (Photograph by Claus Hansmann)

Art affects the lives of individuals living in society and society determines the possible content and function of art. At the meeting point of this network is an 'artist' and something which he makes. This is the fulcrum. Why and how does art exert any power at all: why does it exist and what is it?

It is important at the outset to recognize that art has its own terms of reference. It is not a mirror reflecting life. It is radically different in function, form, and content from the world of sensations, though it becomes a part of that world. Art is not mainly a description of reality, but a parallel reality of its own, existing in an organic relationship with experiences and activities of other kinds.

This quality of 'separateness' which art has can be described in philosophical terms, and the conditions affecting its existence can be outlined. But the vitality of art's actuality vanishes when it is translated into theory. It becomes hard to relate the

dryness of the theory to the fascination of art and its universal existence in human society. Even the greatest art criticism suffers from this disability. Any explanation must leave untouched the central core of art because it already exists in a form that cannot be re-created in another medium, and cannot be adequately described.

In one of his BBC *Listening and Writing* programmes,[7] the poet Ted Hughes tried to explain his perception of this separateness, as it occurs in a poem, by linking it with memories of his childhood activity of hunting animals:

In a way, I suppose, I think of poems as a sort of animal. They have their own life, like animals, by which I mean that they seem quite separate from any person, even from their author, and nothing can be added to them or taken away without maiming or perhaps even killing them. And they have a certain wisdom. They know something special . . . something perhaps which we are very curious to learn. Maybe my concern has been to capture not animals particularly and not poems, but simply things which have a vivid life of their own, outside mine.

Art has a vivid life of its own: that is the condition of its existence. But this does not mean that art is unconcerned with, for example, truth or morality, transcendence, or love. It is very much concerned with such things, just as it is with work or sex. Its separateness has nothing to do with its ostensible subject matter, but with the terms on which that subject matter can be organized, interpreted, and understood. At the most fundamental level art accords with Alain Robbe-Grillet's statement that 'the function of art is never to illustrate a truth – or even an interrogation – known in advance, but to bring into the world certain interrogations (and also perhaps in time certain answers) not yet known as such to themselves'.

In short, art is not so much a reorganization of reality, as the creation of a new piece of reality. In his book on the relationship between art and society,[8] the English critic, Herbert Read, wrote that:

art . . . is an autonomous activity, influenced like all our activities by the material conditions of existence, but as a mode of knowledge at once its own reality and its own end. It has necessary relations with politics, with religion, and with all other modes reacting to our human destiny. But as a mode of reaction it is distinct and contributes in its own right to the process of integration which we call civilization or a culture.

In this passage Read defined the terms on which art communicates. Significantly it is possible to penetrate in some detail the elements of the 'mode of knowledge' and to give meanings to technicalities of composition, colour, texture, and craftsmanship. In attempting to do this the aim is to go beyond a superficial interpretation of the 'surface' or 'literary' symbols. It is the message of the unique 'mode of reaction' that needs to be respected and understood *on its own terms*.

At a recent conference on primitive art[9] Gregory Bateson, the Anglo-American

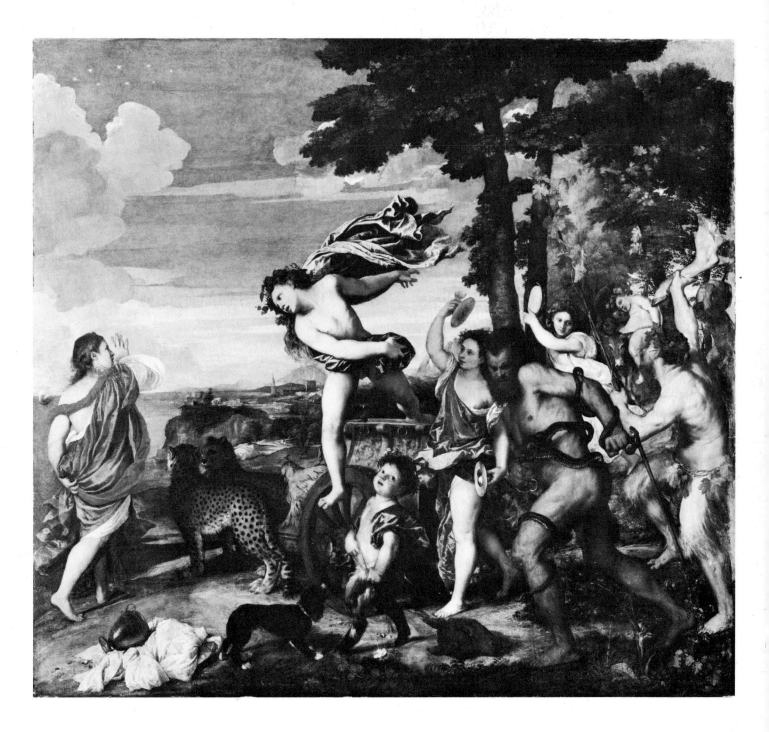

21 BACCHUS AND ARIADNE, a sixteenth-century painting by Titian which tells a 'story' but whose real 'meaning' is only to be found in purely visual terms which have no literary equivalent (The National Gallery, London)

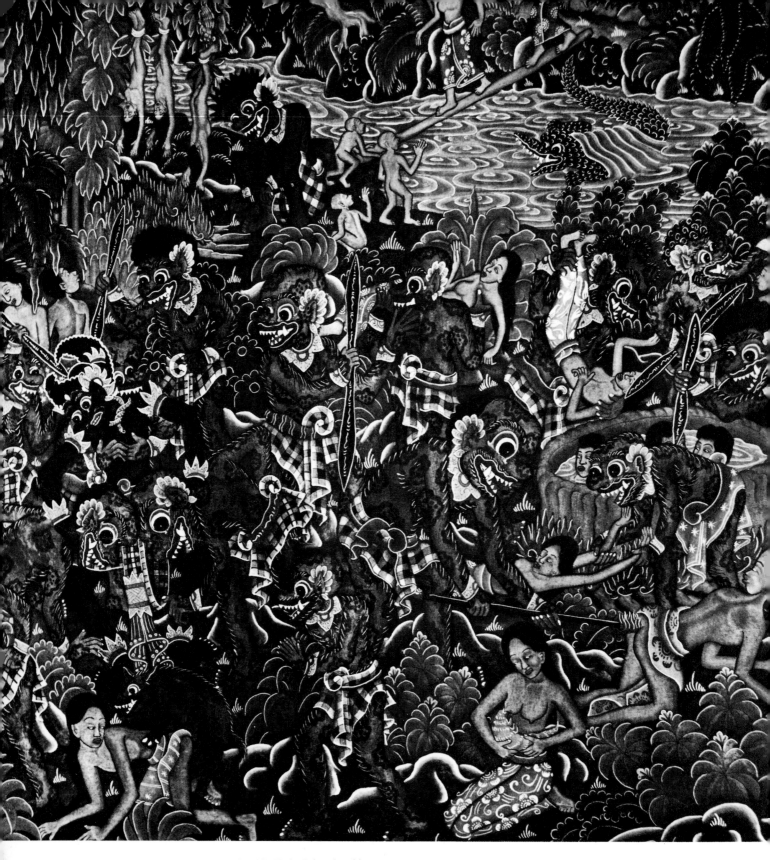

22 A Balinese painting of HEAVEN AND HELL by Wjn Ketig. It is painted in the same way as that discussed by Gregory Bateson on the opposite page (Eric Lister, Portal Gallery, London)

social anthropologist, gave an extended analysis of a painting made in 1937 by a Balinese artist called Ida Bagus Djati Sura who came from the village of Batuan. He rejected the idea of attempting to 'decode', by rendering into words, the 'message' of the artist: 'My goal is not instrumental. . . . To translate the art object into [literary] mythology and then examine the mythology would only be a neat way of dodging or negating the problem of "what is art?" . . . I ask . . . not about the meaning of the encoded message but rather about the meaning of the code chosen.' To reinforce the point he quoted Isadora Duncan who said: 'If I could tell you what it meant, there would be no point in dancing it'. But Bateson then extended her words to indicate an accord with certain non-verbal levels of consciousness. He took this to mean not that visual art is inexplicable, but that there is in it a strong element which is *untranslatable* into non-visual terms.

He rephrased Isadora Duncan so as to say: 'This [art] is a particular sort of partly unconscious message. Let us [artist and audience] engage [together] in this particular sort of partly unconscious communication.' In other words, he insisted that all the artist's unconscious skills of performance and response were not *vehicles* for the message but were themselves the message. He had to find out what the message was.

There is not space here to give the whole of Bateson's interpretation of the Balinese painting but three extracts will serve to make clear the kind of links which he was able to make between technique and meaning. The picture showed a crowded funeral procession progressing through thick jungle towards a phallic cremation tower. The whole surface was closely worked and intricately painted, reminding us more of the obsessive surfaces in the *Book of Kells* than any other Western art. Bateson described how the leaves in the jungle were painted:

When a Batuan artist looks at the work of another, one of the first things he examines is the technique of the leafy background. The leaves are first drawn, in free outline in pencil; then each outline is tightly redefined with pen and black ink. When this has been done for all the leaves, the artist begins to paint with brush and Chinese ink. Each leaf is covered with a pale wash. When these washes are dry, each leaf receives a smaller concentric wash and after this another still smaller, and so on. The final result is a leaf with an almost white rim inside the inked outline, and successive steps of darker and darker colour towards the centre of the leaf.

A 'good' picture has up to five or six such successive washes on every leaf. (This particular painting is not very 'good' in this sense. The leaves are done in only three or four steps.)

What is the significance of this display of skill?

. . . on top of this level of redundancy* is another. The uniformity of the lower-level redundancy must be modulated to give higher orders of redundancy. The leaves in one area must be *different* from the leaves in another area, and these *differences* must be in some way mutually redundant: they must be part of a larger pattern.

Indeed, the function and necessity of the first-level control is precisely to make the second level possible. The perceiver of the work of art must receive information that the artist *can*

*'Redundancy' is a technical term in cybernetics. In the context of visual art it can be taken to mean information and be treated as synonymous with 'order'. It will operate at a variety of levels within any single work. Thus, in the passage quoted, 'this level of redundancy' means, 'the level of ordering created by the way in which the individual leaves are painted', while 'the higher orders of redundancy' are 'the levels of ordering created by contrasts between groups of leaves and other parts of the painting'.

paint a uniform area of leaves because without this information he will not be able to accept as significant the variations in that uniformity.

Only the violinist who can control the quality of his notes can use variations of that quality for musical purposes.

This principle is basic and accounts, I suggest, for the almost universal linkage in aesthetics between skill and pattern.

The discussion of the leaves was linked to a discussion of other differences of repose and energy in the composition of the painting. Bateson saw that these gave strong contrasts between areas of serenity and areas of turbulence. This was a phenomenon which might easily have been identified simply as an aesthetic device for vivifying, with visual drama, the literary or 'story' content of the funeral scene, but he was able to give it a comprehensive ethical and social meaning:

In the final analysis, the picture can be seen as an affirmation that to choose either turbulence or serenity as a human purpose would be a vulgar error. The conceiving and creating of the picture must have provided an experience which exposed this error. The unity and integration of the picture assert that neither of these contrasting poles can be chosen to the exclusion of the other, because the poles are mutually dependent. This profound and general truth is simultaneously asserted for the fields of sex, social organization and death.

The same approach can be effective in dealing with even more humble objects than the Balinese painting. It is particularly interesting to apply it to the kind of popular graphic art which normally falls completely outside the ambit of conventional criticism. What we discover when we do this is that some of the qualities which normally exclude such works from consideration are, in fact, the ones which are most integral with their status as 'modes of knowledge'. Here again it is possible to look at particular visual and technical qualities and to assign to them identifiable meanings.

The illustration opposite shows a French Confirmation card. It is three-dimensional when open, with layers of fretted paper architecture framing a well-printed figure of Christ giving His blessing to the candidate who, dressed as a miniature bride, has the rosy cheeks and angelic face of a nineteenth-century Christmas cherub. The card gives a sense of richness and of finely wrought surfaces although it is, of course, mass-produced by machine and not by hand. It is meant to be reminiscent of complex handwork, and the ethical symbolism implied by this convention must be similar to that of the leaves in the Balinese picture.

The card is not a work that would find a place in any normal discussion of the nature of art at the turn of the century. It is not significant in the history of art as we know it because it is extremely – and intentionally – traditional. It is not even, in the ordinary sense, folk art. All these factors, however, are only the negative aspect of its positive role. The visual quality of being traditional, of being sentimentally Gothic and therefore referring to a style five hundred years old, was undoubtedly a

23 A Confirmation card, printed in Germany for sale in France and produced towards the end of the nineteenth century (Ken and Kate Baynes: photograph by Chris Ridley)

28

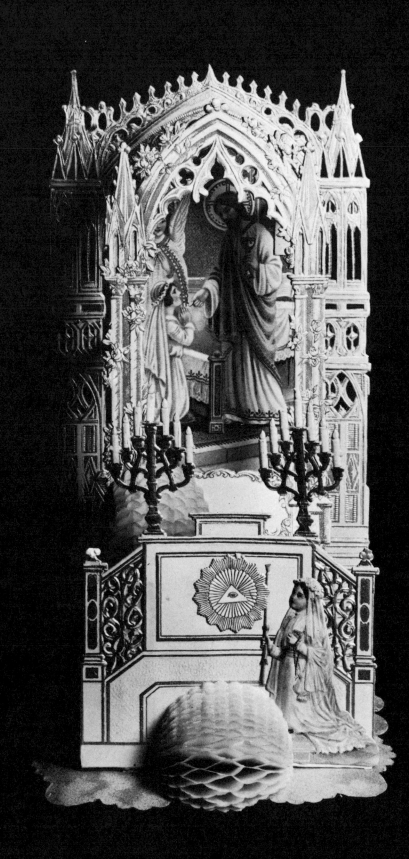

part of its meaning to those who bought it and sent it as a token of remembrance for one of Christian life's central events. Its style spoke of security and continuity: its sentimentality brought the remoteness and dignity of the religious ceremony onto an accessible and domestic plane.

In its small, but not unimportant, way the card helped to articulate a particular network of human emotions and relationships. It was a symbol. Its symbolism was integral with its visual qualities and with its style which echoed the past. The significance of an event was made tangible in an object so that it could be felt and seen, admired and remembered. But it only did this socially important job because, like Ted Hughes' poems, and like the Balinese painting, it had a vivid life of its own: in the terms of its own reality, it 'knew something special'.

It is now possible to draw together the three themes which have been introduced so far: the audience being affected by art; the audience affecting art; and the nature of the product – art – itself.

For visual art to be said to exist a 'work' must be produced. But, even although the work is the focus and can be studied and described as an artefact, its real significance is to be found in its making and in its use. In many important ways it is simply of a piece with all the other material things – cities, utensils, gardens – that men have made in an attempt to control the world, to understand it, and to extend their power over it. They are all things exterior to man, but created by him, which symbolize, define, and broaden the meaning and scope of his life, internal and external.

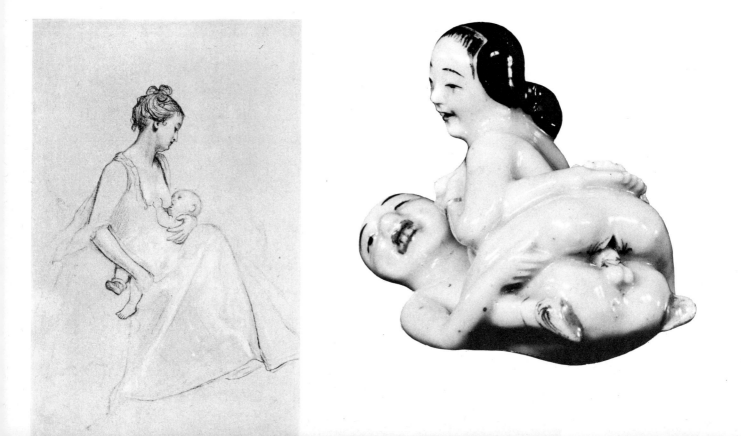

Man is a social animal. It is impossible to think of 'a man' in isolation. The whole definition of what it is to be human depends on creations which are to do with relationships. In order to grow, in order to achieve anything which has meaning in the world, it is necessary for an individual to energize his links with other individuals. This means that communication is likely to be the most important human activity. It is communication that spins the network which makes possible mankind and which, in a very direct sense, controls evolutionary development.*

The analyst R D Laing began a chapter entitled 'Complementary Identity' with a quotation from a Rabbi called Kabia who, when a captive of the Romans, wrote to his favourite pupil: 'My son, more than a calf wishes to suck, does the cow yearn to suckle.' For Laing, it is in the breakdown of these loving relationships that is to be discovered the source of madness. Such breakdowns exhibit the negative complementarity of isolation, non-communication or exploitation. They cause pain. Non-communication or exploitation destroys the essentially positive mutuality of human aspirations. In his book *Self and Others*,[10] Laing wrote:

A woman cannot be a mother without a child. She needs a child to give her the identity of a mother. A man needs a wife for him to be a husband. A lover without a beloved is only a would-be lover. Tragedy or comedy, according to the point of view. All 'identities' require an other: some other in and through a relationship with whom self-identity is actualized . . .

. . . One person may complement another in many different senses. This function is biologically determined at one level, and a matter of highly individualized choice at the other extreme. Complementarity is more or less formalized, culturally conditioned. It is often discussed under the heading of role.

*For a clear exposition of this idea, I am indebted to CHANGING ART CHANGING MAN by David Mandel. Horizon Press, 1967. Mandel himself ascribes a specifically evolutionary role to Fine Art and has recently been strongly supported in this view by the distinguished biologist Jonas Salk in his book THE SURVIVAL OF THE WISEST.

24 (far left) MOTHER AND CHILD, a pencil drawing by the English nineteenth-century painter Ford Madox Brown (City Museum and Art Gallery, Birmingham)

25 (left) LOVERS, a porcelain figurine dating from the Ch'ing Dynasty in eighteenth-century China (Gulbenkian Museum of Oriental Art, University of Durham)

26 (right) SATURN EATING HIS CHILDREN, a detail of the painting by Goya (Prado, Madrid)

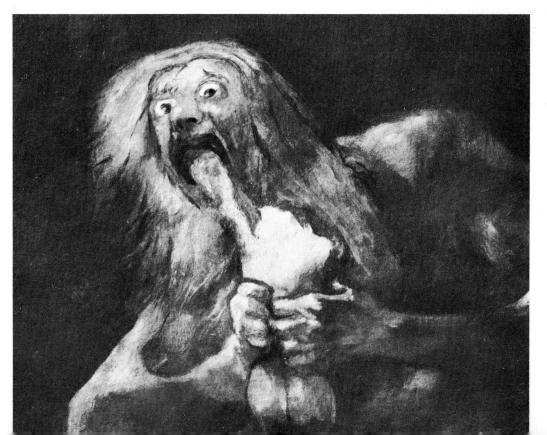

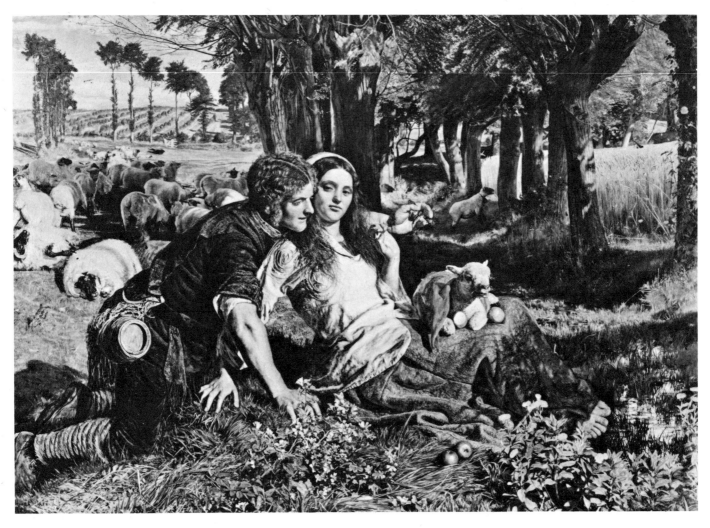

27 (above) THE HIRELING SHEPHERD by William Holman Hunt, 1851
(City of Manchester Art Galleries)

28 (left) An English cartoon, circa 1870, showing a wealthy farmer
supervising a skeleton labourer tending a plough (James Klugmann
Collection)

29 (right) THE GAME LAWS; OR, THE SACRIFICE OF THE PEASANT TO THE HARE.
An English cartoon attacking harsh laws against poaching: it appeared in
Punch in 1845 (Syndics of the Cambridge University Library)

30 (far right) LOVE CONQUERED FEAR, an illustration from an edition of
Frances Trollope's novel Life and Adventures of Michael Armstrong the
Factory Boy dating from 1840. The book attacked the use of child labour in
factories and showed how relationships between employer and employed
were poisoned by exploitation
(British Museum)

Like culture, role is much more than an abstraction. It is the expression of 'complementariness' in a social situation. E P Thompson, the English historian, explained this clearly in the Preface to his book *The Making of The English Working Class*.[11] His analysis echoed, from a sociological and historical point of view, Laing's more psychologically-based interpretation. Here he is discussing what he means by the term 'class':

. . . I do not see class as a 'structure', nor even as a 'category', but as something which in fact happens (and can be shown to have happened) in human relationships.

More than this, the notion of class entails the notion of historical relationship. Like any other relationship, it is a fluency which evades analysis if we attempt to stop it dead at any given moment and anatomize its structure. The finest-meshed sociological net cannot give us a pure specimen of class any more than it can give us one of deference or of love. The relationship must always be embodied in real people and in a real context. Moreover, we cannot have two distinct classes, each with an independent being, and then bring them INTO relationship with each other. We cannot have love without lovers, nor deference without squires and labourers . . .

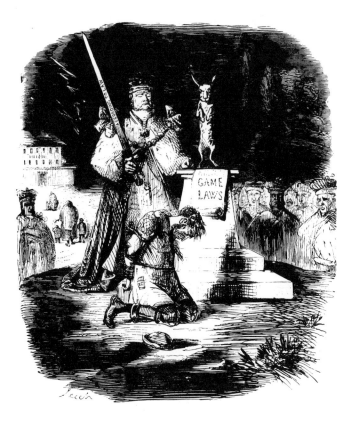

THE GAME LAWS;

OR, THE SACRIFICE OF THE PEASANT TO THE HARE.

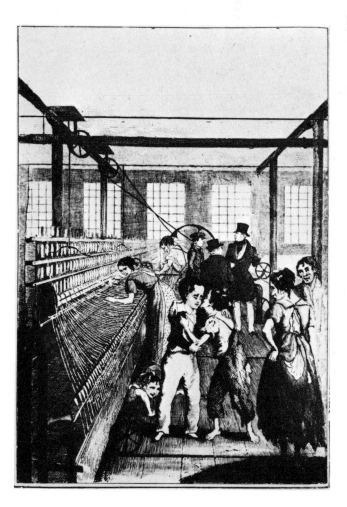

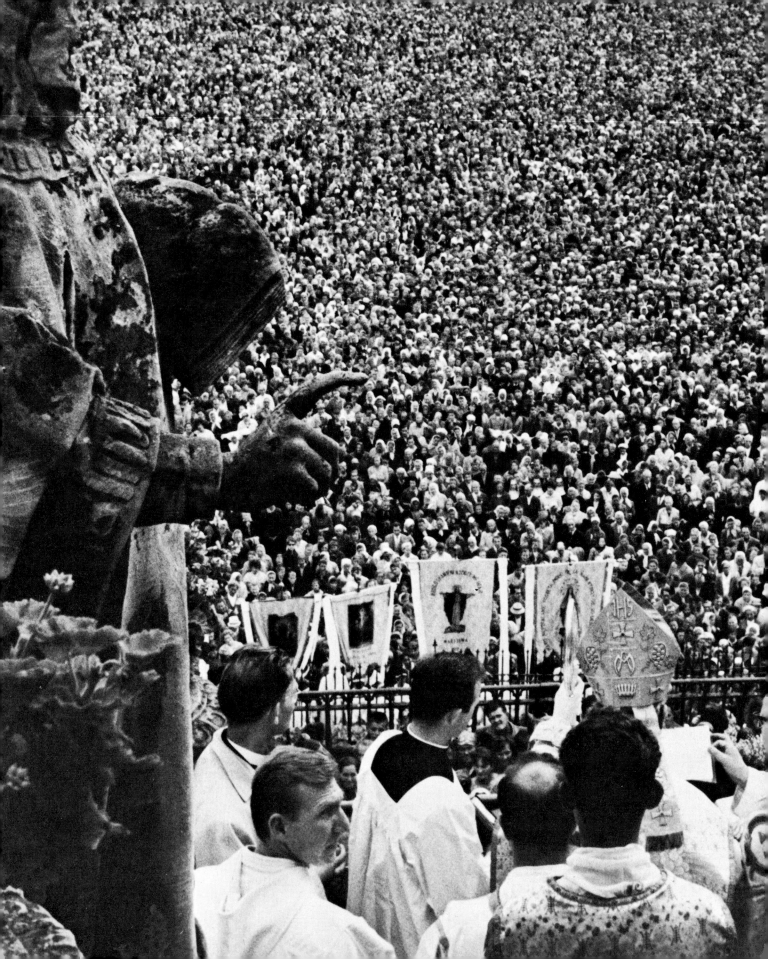

31 A photograph of an open-air service in Poland by Elliott Erwitt. It symbolizes vividly the role of art as an integral part of an important social ceremony (The John Hillelson Agency Ltd)

What we can begin to see here is that in discussing art *and* society we are not really faced with a duality. The 'and' is misleading. There exists no point where art can be removed from a total involvement in society. Art, in fact, is a part of society: it not only articulates and helps to make possible the communications on which human relationships are based, but it is also a part of the nature of those relationships.

During the past two hundred years, the interpretation of all kinds of social phenomena has suffered from the use of physical metaphors derived from Newtonian science. The idea of discrete 'cause' and 'effect' mechanisms in society is a source of confusion. It is thinking in these terms that leads us to formulate such questions as: 'Do men make culture, or does culture make men: do we mould our environment, or does it mould us?' We might now begin to grope our way towards a more ecological way of thinking. We need to be able to acknowledge that man/culture must inevitably form a single 'system' because nothing exists without an environment.

Metaphors taken from biology or evolution would almost certainly be more helpful. Here is Gregory Bateson on a key evolutionary interrelationship – that between horse and grass:

. . . the evolution of the horse from *Eohippus* was not a one-sided adjustment to life on grassy plains. Surely the grassy plains themselves were evolved *pari passu* with the evolution of the teeth and hooves of the horses and other ungulates. Turf was the evolving response of the vegetation to the evolution of the horse. It is the *context* which evolves.

In other words, there was never a moment when the cause and effect of grass and horse evolution could be taken apart. Within an historical context they evolved together as parts of an interdependent system from the unique position reached by their respective progenitors. In the same way, there never was a moment when the cause and effect of man and culture or man and habitat could be taken apart. Men made art made men made art made men made art.

Wassily Kandinsky, the modern painter, expressed something of this interdependence when he said: 'Every work of art is the child of its own time: often it is the mother of our emotions.' But this does not go far enough in suggesting the wholeness that

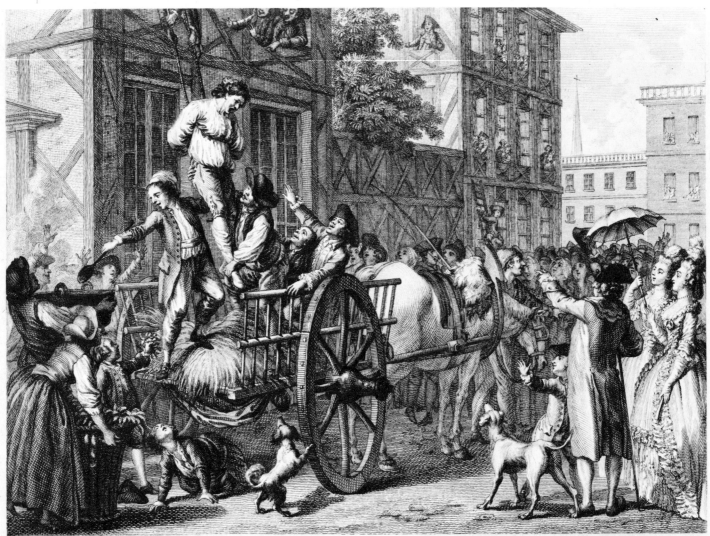

Dessiné et Gravé par F. Godefroy
de l'academie Imp.le et R.le de Vienne &c

JOHN MALCOM.

Le 25 Janvier 1774 la populace irritée pénétra sans armes dans sa maison. Il blessa plusieurs personnes à coups d'épée: mais les Bostoniens, modérés jusques dans leur vengeance, le saisirent, le descendirent par la fenêtre dans une charrette; ensuite il fut depouillé, goudronné, emplumé, mené sur la place publique, battu de verges, et obligé de remercier de ce qu'on ne le punissait point de mort; puis on le ramena chez lui sans autre mal.

ORIGINE DE LA REVOLUTION AMÉRICAINE.

Les Provinces de la Nouvelle Angleterre jouissaient du droit de s'imposer elles-mêmes dans leurs assemblées: les officiers du gouvernement et les juges étaient nommés par le roi, mais au gages du peuple. L'Angleterre éprouvant des besoins de finances, et voulant les faire partager aux Américains, fit paraître un bill le 4 avril 1764,

Après de longs débats, l'Angleterre y établit des douanes le 29 juin 1767 pour faire exécuter des prohibitions de commerce sous l'inspection de commissaires nommés et gagés par le roi. Par tout on s'opposait à l'exercice de leurs fonctions, et le 18 mai 1770 la populace de Boston arrêta un commis pour avoir saisi

32 News of the American revolution reached France by means of this broadside published in 1774. It shows the citizens of Boston hanging the tax collector John Malcolm. No attempt has been made to depict Americans as they really were: clothes and setting are those of fashionable Paris. The event has been absorbed into the cultural background of those reading about it (The Bettmann Archive Inc, New York)

we are trying to interpret. In order to make the reality of the situation more explicit, it is helpful to look at two contrasting examples. The first has to do with the way in which art can reinforce hierarchical divisions in society while, at the same time, creating a highly desirable situation within the most privileged group.

During the period between the Renaissance and the institution of compulsory education for all late in the nineteenth century, there was in existence an identifiable 'high' culture. Over a period of time, familiarity with it came to be seen more and more as the mark of an educated man. Inevitably it became involved in the preservation of social class. This was no negative thing; but it was profoundly conservative in its assumptions and in its social reality. George Steiner, author of *In Bluebeard's Castle*, has put this very clearly in a brilliant article 'Classic Culture and Post-Culture' which appeared in *The Times Literary Supplement*[12] in October 1970. In the following quotation he is discussing the background against which authors wrote in what he described as the 'classical age of the book' between 1730 and 1885:

. . . The consensus of echo on which the authority and effectiveness of books depended went deeper than schooling. A corpus of agreed reference is in fact a set of philosophic, social values. The economy of statement that makes possible a literary style, and the recognizable challenges to that style by the individual writer, has underlying it a large sum of undeclared but previously agreed-to social and psychological presumptions. This is especially so of the high literacy between the times of Montesquieu and of Mallarmé. The kind of lettered public they had in view is directly expressive of an agreed social fabric. Both the linguistic means and range of matter of books – in short the semantic whole of authorship and reading – embodied and helped perpetuate the hierarchic power relations of western society.

It is the interaction which Steiner designated 'the semantic whole of authorship and reading' that is the centre of our interest. This is the key element and it is clear that a similar relationship will be found in every situation involving artistic creation. It is certainly not something which is confined to the workings of 'high' culture. We can recognize it just as vividly in the creation of jazz in New Orleans, or in the development of the 'underground' *samizdat* press in Soviet Russia.

The second example comes from the Durham coalfield in the north of England. In this area there is a long and still living tradition of folk-song that exists alongside a strongly developed vein of cynical humour. Both are expressed in one of the most beautiful of all the gradually fading English dialects. The miners' songs and jokes are self-defensive: they weave a pattern that keeps the mine at bay. In his book *Pit Talk in County Durham*,[13] Dave Douglass, himself a miner, has described the various functions served by song and language in this culture and has explained just how closely they are integrated into the reality of mining life.

Unlike sailors, colliers do not sing on the job – their songs are not work songs. There is a reason for this: 'there is no spare breath in a mine for songs. . . . Miners' songs are sung in pubs, at booze-ups, at political galas and demonstrations, but being written by miners they necessarily fetch the pit into the verse.' To outsiders it

is the songs about disasters which are best known. But, as pointed out by Dave Douglass, these are the ones least often sung by the miners themselves:

The only kind of pit song which you rarely if ever hear miners sing (though they are popular in the folk clubs) are disaster ballads. The lads would feel far too silly sitting in front of each other hearing songs of how brave they are, especially when they've come out to enjoy themselves with a drink and a song. 'We want nowt o' that this side a the pit.' Having put up with the place for eight hours and very soon to face the next, they do not want to be reminded of its dangers. The only time anyone gets away with it is near the end of the evening when quite a few drinks have been put away and the night has taken on a more mellow nature. Then you may get a disaster song, but it will usually be sung by a woman. Woe betide any in the room then that didn't give order or talked while a song of this nature was being sung . . .

Away from the setting of social or political gatherings – back in the pit – the language and the jokes are functional:

The mine necessitates a different attitude of mind, a different temperament to that on the surface; necessarily it gives rise to a culture and language which are peculiar to that environment. A man who could not 'switch off' his surface self and change his nature when he went underground would not last long in the mine . . .

. . . A man must become hardened to this hellish cavern; he is in a permanent state of aggression and the temper stimulates hard work; cruel things happen to men underground,

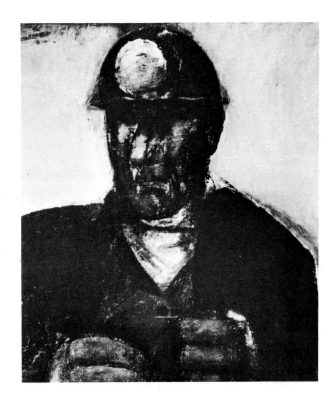

33 (left) HEAD OF A MINER by Josef Herman who, for a time after the Second World War, lived and worked in the Welsh coalfield (Joseph Wolpe, Cape Town, South Africa)

34 (right) Coalmining subjects recorded on postcards now in the collection of the National Museum of Wales. The card at bottom left shows the funeral of some of the miners killed in the terrible Senghenydd tragedy (Photograph by Chris Ridley)

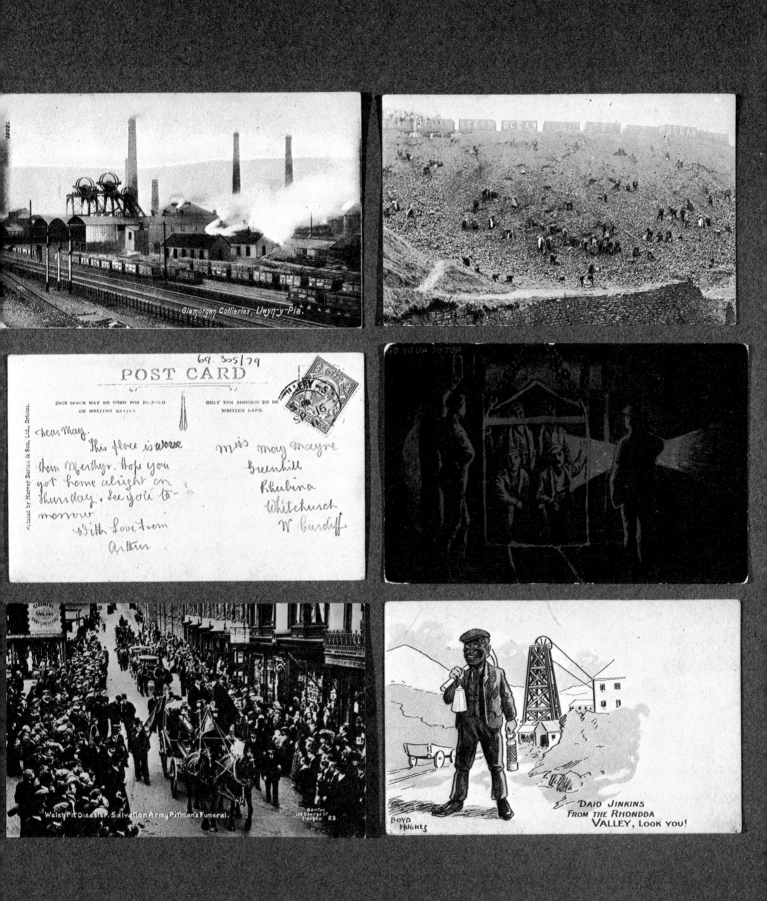

Glamorgan Collieries, Llwyn-y-Pia.

POST CARD

69. 305/79

THIS SPACE MAY BE USED FOR PRINTED
OR WRITTEN MATTER

ONLY THE ADDRESS TO BE
WRITTEN HERE.

Dear May,
 This place is worse
than Merthyr. Hope you
got home alright on
Thursday. See you to-
morrow.
 With Love from
 Arthur

Miss May Mayne
Greenhill
Rhubina
Whitchurch
Nr Cardiff

GOING UP ON TOP

Welsh Pit Disaster. Salvation Army Pitman's Funeral.

DAIO JINKINS
FROM THE RHONDDA
VALLEY, LOOK YOU!

LLOYD HUGHES

YOUTH.

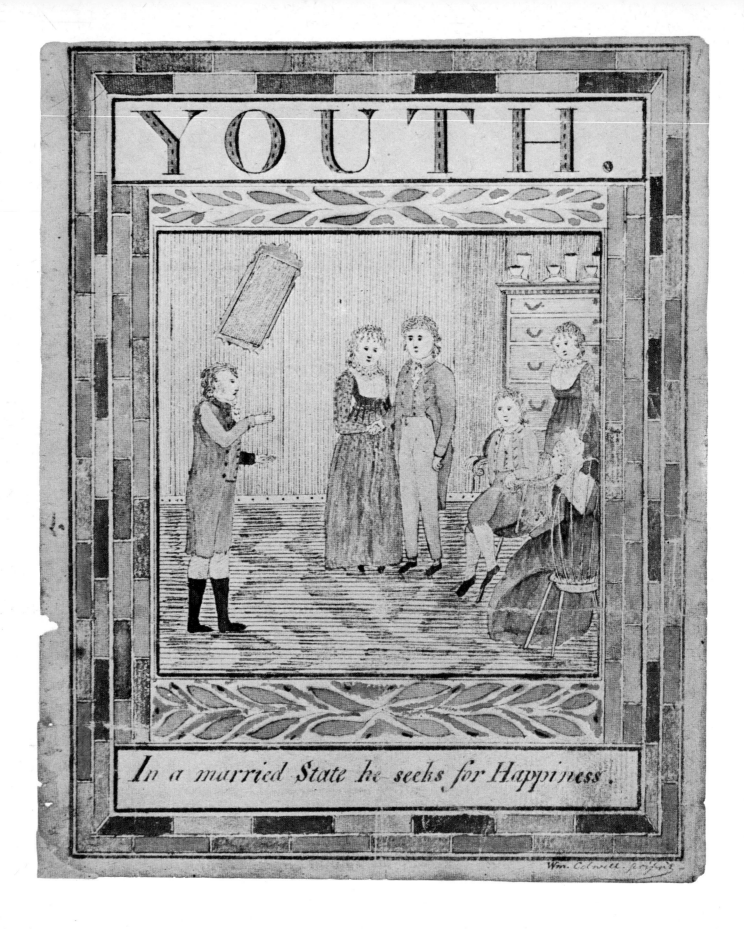

In a married State he seeks for Happiness.

and as in a war, men must steel their minds against the thought of them. All day long the miners are being prodded and struck by supports and rock; the blood is at boiling point; if it wasn't for the jokes which come non-stop we would all be fighting in a few minutes . . .

The miner's 'language', however strange it appears to the outsider, is an inevitable part of him. The language of the miner, regardless of what dialects it embraces, is an intricate and inseparable part of his whole culture. It is directly related to his community, his work, and the way he handles it, his trade union struggle and movements, his songs and stories. It is one political whole, each facet dovetails into the other.

Here again is a description of a 'semantic whole': this time of speaking or singing and listening or answering.

Among the most potent of all folk songs are those which express the terms of man's journey through life. Like Shakespeare's seven ages of man, or the life sequence in the traditional prints illustrated opposite, they exhibit for view the well-rehearsed stereotypes which, on the largest scale of all, are the semantic whole of art and society.

In 1973 the following was being sung and mimed in the playground of a South London school:

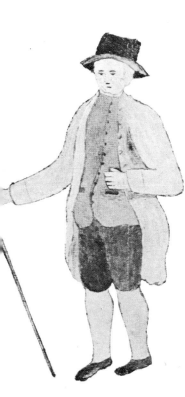

35–36 The front cover and a detail from a hand-drawn and coloured American child's book dating from 1752. It consists of a series of eleven pictures depicting the progress of man from babyhood to old age. It is by an otherwise unknown artist called Wm Colwell. The detail shown above is from 'Old Age': the caption reads 'grown old he retires from business' (Free Library of Philadelphia, Collection of Early American Children's Books)

When Suzy was a baby
A baby Suzy was
She went ooh ah, ooh-ah-ooh
(thumbs in mouth)

When Suzy was a schoolgirl
A schoolgirl Suzy was
She went Miss, Miss, Miss-Miss-Miss
(hand in air)

When Suzy was a teenager
A teenager Suzy was
She went mmm, mmm, mmm-mmm-mmm
(lifts up skirt)

When Suzy was a stripper
A stripper Suzy was
She went ooh ah, take off your bra,
ooh-ah-take-off-your-bra

When Suzy was a teacher
A teacher Suzy was
She went huh, huh, huh-huh-huh
(crosses arms and looks severe)

When Suzy was a mother
A mother Suzy was
She went whack, whack, whack-whack-whack
(silent smacking)

When Suzy was a grannie
A grannie Suzy was
She went knit, knit, knit-knit-knit
(action of knitting)

When Suzy was a-dieing
A-dieing Suzy was
She went groaan, groaan, groaan-groaan
-groaan
(actions of staggering back and groaning)

When Suzy was an angel
An angel Suzy was
She went flap, flap, flip-flap-flip.

The roles that Suzy plays are immediately recognizable: they are on the one hand

limited and caricatured and on the other brightly comprehensible. This combination is no accident. To make simplifications of such a kind has always been one of the roles of popular art. It can be argued that simplification is central to the existence of a stable and comprehensible society even though it is, at the same time, full of savage potential in its impact on the individual.

We are used to the idea that art enriches people's lives, and widens their horizons. We are familiar with a concept of culture which shows it as aiding growth and maturity. Today we see art as playing a central role in an education directed towards allowing 'people to develop their own personalities'. But, in fact, every aspect of culture is more ambiguous and double-edged. By celebrating certain modes of behaviour, it inevitably outlaws others.

Steven Marcus prefaced his book *The Other Victorians*,[14] a study of nineteenth-century sexuality, with a quotation from Freud in which he placed the European culture of the day and sexual gratification in direct conflict. Freud takes us deeply into the cultural paradox:

However strange it may sound, I think the possibility must be considered that something in the nature of the sexual instinct itself is unfavourable to the achievement of absolute gratification . . . The erotic instincts are hard to mould; training of them achieves now too much, now too little. What culture tries to make out of them seems attainable only at the cost of a sensible loss of pleasure; the persistence of the impulses that are not enrolled in adult sexual activity makes itself felt in the absence of satisfaction.

The attack on culture is taken ever farther by R D Laing. In *The Politics of Experience and The Bird of Paradise*,[15] he sees capitalism as controlling, perverting and destroying the lives of individuals through a barrage of social, economic, educational and artistic pressures:

As adults, we have forgotten most of our childhood, not only its contents but its flavour; as men of the world, we hardly know of the existence of the inner world; we barely remember our dreams, and make little sense of them when we do; as for our bodies, we retain just sufficient proprioceptive sensations to coordinate our movements and to ensure the minimal requirements for biosocial survival – to register fatigue, signals for food, sex, defecation, sleep; beyond that little or nothing.

Our capacity to think, except in the service of what we are dangerously deluded in supposing is our self-interest, and in conformity with common sense, is pitifully limited: our capacity even to see, hear, touch, taste, and smell is so shrouded in veils of mystification that an intensive discipline of unlearning is necessary for *anyone* before one can begin to experience the world afresh, with innocence, truth and love.

The key phrase here is 'unlearning'. The proposition is that to survive, the individual must escape from his conditioning. Laing presents a picture in which men are not supported by the workings of culture, but threatened and mutilated by it.

37 SEX WAR SEX CARS SEX, a 'poster-poem' by Christopher Logue and Derek Boshier, attacking the alienating effect of capitalist technology on human sexuality (Ken and Kate Baynes: photograph by Chris Ridley)

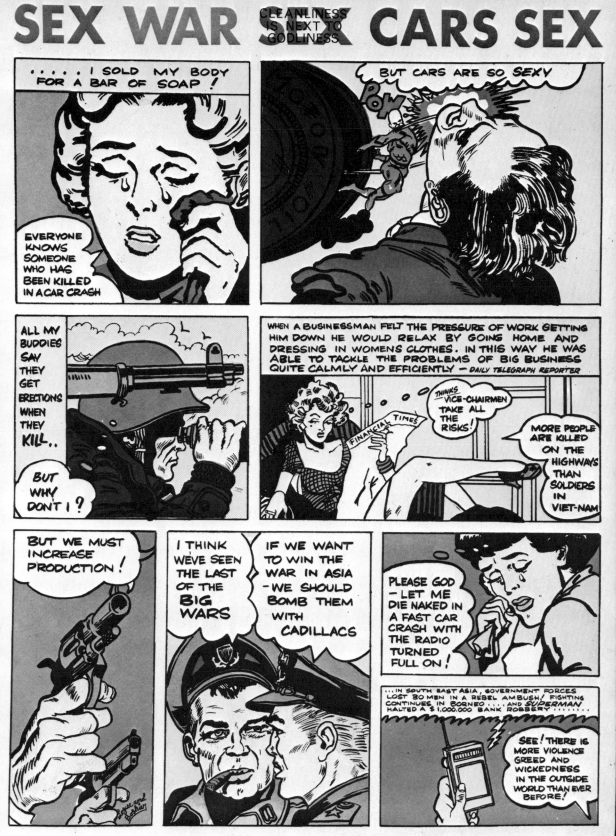

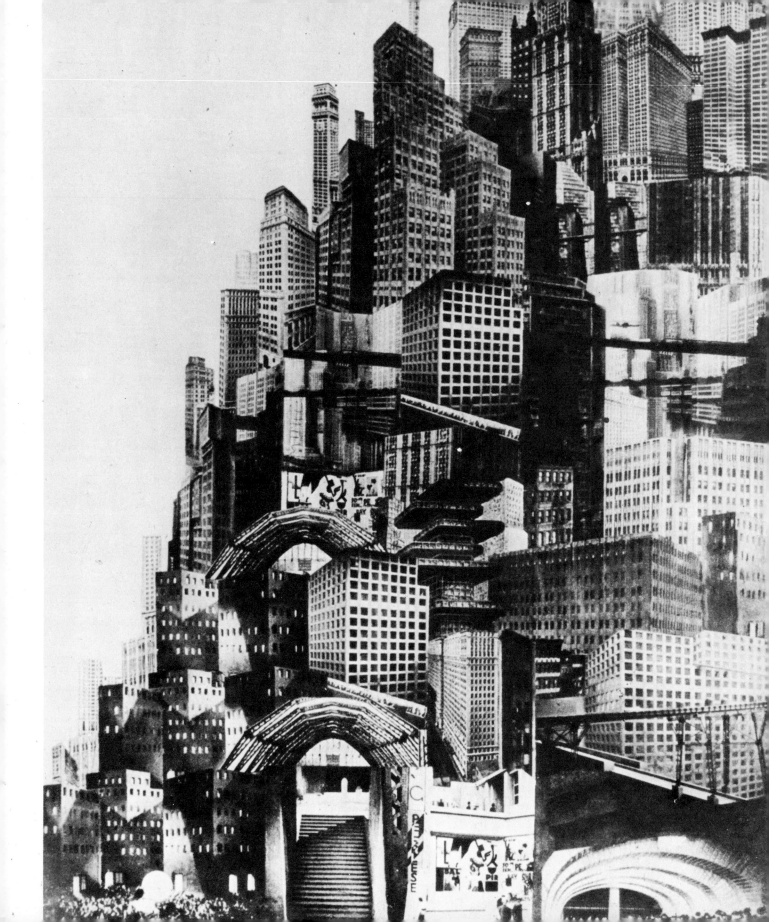

These characteristically modern critiques of the relationship between culture and the individual are a valuable insight, particularly where sexuality and class are concerned. Yet, if they are taken as a blanket rejection of culture as such rather than of aspects of a particular culture, their effect is dangerously romantic and philosophically untenable. In their desire to affirm the humanity of those labelled 'ill' or 'underprivileged' by society, such therapists sometimes seem to imply that if society did not exist, men and women would revert to a state of 'natural' innocence. Their special attack on industrial culture comes from the extreme distance which it appears to have created between a complicated existence and primordial feelings.

The point at issue is: what is natural to man? But this is a question which so far has no answer, and which cannot even be thought about without recognizing the structural importance of culture for the development of the individual.

Ironically, Laing's own theories are a remarkable product of contemporary liberal culture. Freud's thought was directed to the crux of nineteenth-century European sexuality and his insight into the past and future of men's minds was controlled by that situation. This is not to say that his approach was invalid: only that he was a human being and, therefore, inevitably dependent on a finite world of available attitudes and experiences, partly provided by culture.

In a way which is positive as well as negative, culture is a definition of possibilities. For example, the different interpretations of sexuality, tribal and contemporary, that we discussed earlier are, at the same time, a simplification. Each is the result of a process of selection from the baffling complexity of life. They represent the creation of 'human' meaning out of 'natural' chaos. The parallel with language is very strong. Here, again from *Patterns of Culture*, is Ruth Benedict's description of the process involved:

It is in cultural life as it is in speech, a selection is the prime necessity. The numbers of sounds that can be produced by our vocal cords and our oral and nasal cavities are practically unlimited. The three or four dozen [sounds] of the English language are a selection which coincides not even with those of such closely related dialects as German and French . . . each language must make its selection and abide by it on pain of not being intelligible at all . . .

. . . Every human society everywhere has made such selection in its cultural institutions. Each from the point of view of another ignores fundamentals and exploits irrelevancies. One culture hardly recognizes monetary values; another has made them fundamental in every field of behaviour. In one society technology is unbelievably slighted even in those aspects of life which seem necessary to ensure survival; in another, equally simple, technological achievements are complex and fitted with admirable nicety to the situation. One builds an enormous cultural superstructure upon adolescence, one upon death, one upon after-life.

What we see here is that the limitations imposed on individual thought and action by culture are the negative side of its positive function. The inevitable price of

38 A still from *Metropolis*, the German film directed by Fritz Lang which, between the First and Second World Wars, reflected on the urban and industrial future that might be created by technology (National Film Archive, London)

culture's definition of meaning seems to be its selectivity. It looks as though there can be no communication, no ritualization, no sharing of values, and therefore no humanization of the natural world, without the complementary exaction of a cost, which is expressed in selectivity.

It is at this point that we find that the broadest possible problems of human life have entered into the discussion of art, culture and society. We are forced to look away from the development of schools of artists or the succession of historical styles. Instead, we have to be involved with analysing the role of art in aiding the process of growing up; with assessing its capacity to expand or contract the possibilities of behaviour open to an individual; with assessing the degree to which a particular culture succeeds in giving meaning and stature to life or, conversely, in diminishing it.

There already exists a clearly defined, well-worked, and precisely detailed cultural history of art, design and craftsmanship for the period from the industrial revolution to the present. It consists of great movements and famous men whose activities have become the subject of scholarship. To a quite astonishing degree the themes and landmarks of this scholarship are familiar: they form the common background of understanding of anyone who has devoted any time at all to the history of the subjects involved. They are institutionalized in education, learned societies, exhibition programmes and publications. A similar situation, though naturally with a different emphasis, and with different heroes, exists in eastern Europe. Marxist critics present an equally well-defined picture of the last two hundred years.

It is a powerfully simple way of seeing the immediate past. It focuses on those who were avowedly engaged in creative work, and on the ideas which most intimately influenced the form and content of their creations. But unfortunately it seriously distorts history.

If one looks at the material culture of the nineteenth and twentieth centuries solely in terms of what was made by such well-known people, the resulting picture is unsatisfying. There is about it a sensation of anti-climax. It lacks light and shade. It is incomplete. There is a suspicion that it is a tiny detail, cut from a much larger and more complex work. Most of all, there is the strong feeling that the resulting picture does not describe adequately the forces at work in contemporary culture.

Traditional criticism is forced to see the nineteenth century in terms of the development of Romantic painting and Pre-Raphaelitism instead of the music-hall song, the seaside postcard, or men's use of technology for fun as well as work, though it is these cultural forces that are still vivid in our own lives. It may be generally recognized that the engineers were the designers of genius in the nineteenth century, but it is not so frequently seen that it was in the pages of the *Illustrated London News* or the French satirical journals, in cheap excursion trains, and in the establishment of compulsory universal education that the new outlines of a mass culture were to be found.

39 An illustration from the cover of a French satirical magazine *L'Assiette au Beurre*. The issue deals with the hypocrisy of doctors (The Mansell Collection)

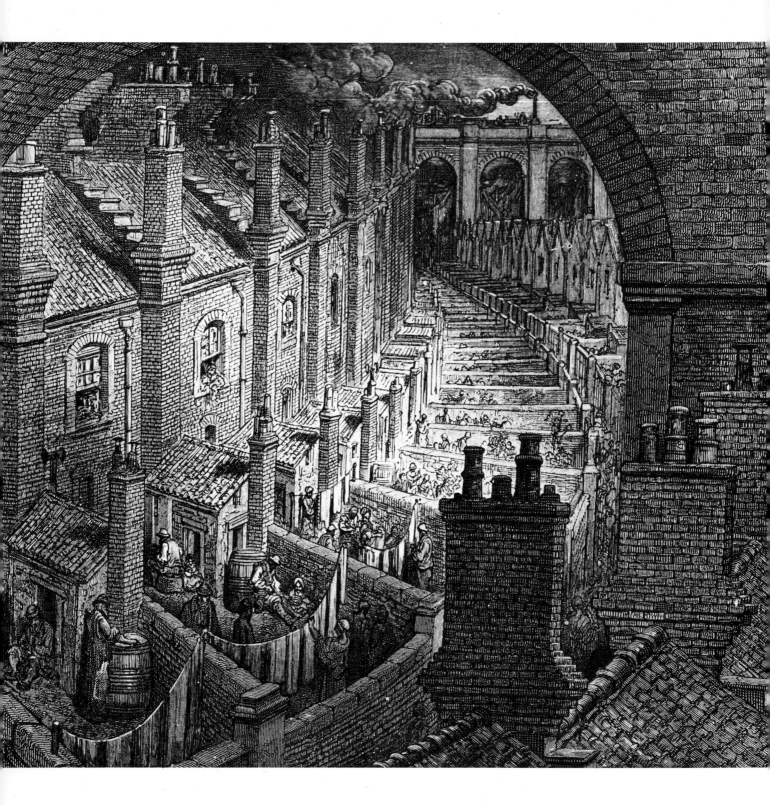

40 One of the famous series of illustrations of London made by Gustav
Doré in the first phase of nineteenth-century expansion and industrialisation
(Ken and Kate Baynes)

48

Yet the emergence of this mass culture, dependent on technology, is one of the two most influential events in the history of the immediate past. The other is the wave of egalitarianism which has swept the world. Since the French and industrial revolutions the centre of gravity in society has changed decisively, and the centuries-old formula of a hierarchical society has been shattered for good, replaced by egalitarian ideals expressed in a variety of ways. The machine's involvement in culture, and the world of big cities that Victorian technology made possible, are completely new elements in men's lives.

The visual arts have been profoundly affected by these changes. Engineers and designers have taken over, from the artist/architect of Renaissance days, the task of providing the world with its everyday surroundings. Their assumptions and methods are totally different from those which produced traditional building and craftsmanship. A concern with housing as a social responsibility is not an absolute novelty: but what is new is the entwinement of aesthetic vision with public cost, social policy and bureaucratic management. It is a mixture which calls for a style of analysis previously unknown in architectural debate. In the same way, traditional approaches to art break down completely when faced with the problem of trying to

41 A centrespread from the *Daily Mirror* at the time of the Russian Revolution. The *Mirror* was the first British newspaper to use photography on a large scale (Syndication International Ltd/John Frost Collection: photograph by Chris Ridley)

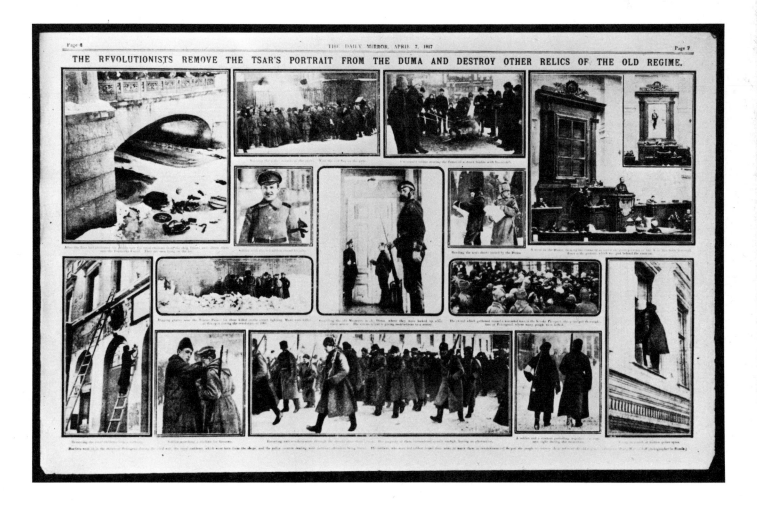

find a yardstick to measure cinema, or television, or the design of a newspaper like the London *Daily Mirror*. In these media, conglomerate commercial forces are at work on items produced by groups of people for mass consumption. In art, such means of production and dissemination never existed before.

Here, from the Introduction to *The Long Revolution*,[16] is Raymond Williams's interpretation of the situation:

We speak of a cultural revolution, and we must certainly see the aspiration to extend the active process of learning, with the skills of literacy and other advanced communication, to all people rather than to limited groups, as comparable in importance to the growth of democracy and the rise of scientific industry . . .

42 Front and back pages of the *Daily Mirror*. Events at Little Rock are pushed out of the main headlines! (Syndication International Ltd/ John Frost Collection: photograph by Chris Ridley)

Yet at this point it is particularly evident that we cannot understand the process of change in which we are involved if we limit ourselves to thinking of the democratic, industrial, and cultural revolutions as separate processes. Our whole way of life, from the shape of our communities to the organization and content of education, and from the structure of the family to the status of art and entertainment, is being profoundly affected by the progress

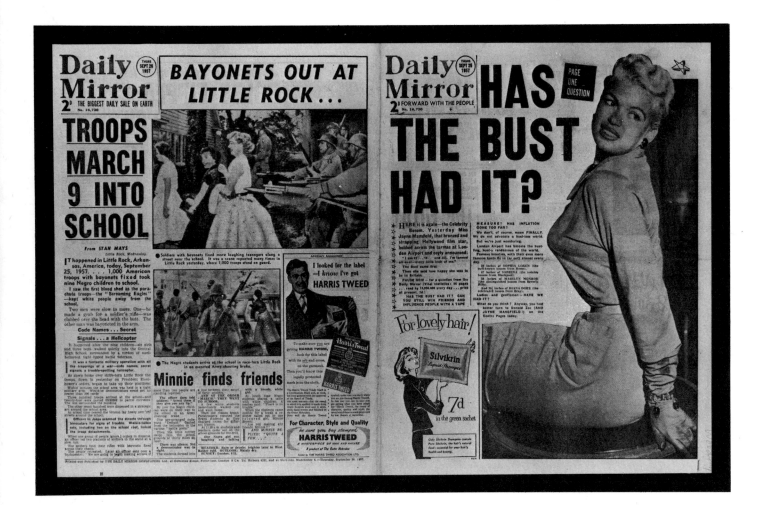

and interaction of democracy and industry, and by the extension of communications. This deeper cultural revolution is a large part of our most significant living experience, and is being interpreted and indeed fought out, in very complex ways, in the world of art and ideas. It is when we try to correlate change of this kind with the changes covered by the disciplines of politics, economics, and communications that we discover some of the most difficult but also some of the most human questions.

If we take the French Revolution as marking the start of mass nationalism in Europe and the beginnings of a coherent popular movement, we can see that it also stands in a significant relationship to technological and industrial developments. From that time, production, society, and media seem to unfold logically into the present through a sequence of innovations in economics and material culture; innovations in education, politics, and social organization; and innovations in the communication and sources of ideas.

The key sequence of inter-relationships, which emerges gradually, is this: new production techniques serve very large numbers of people who rely on them for those aspects of culture which were previously produced by traditional methods, or

43 Schoolboys at a Welsh country school in the first years of the present century. Photograph by Pierce Roberts (Welsh Folk Museum/Enid Pierce Roberts)

44 Groucho Marx as a spoof academic in *Duck Soup* (Universal International Pictures Ltd/National Film Archive, London)

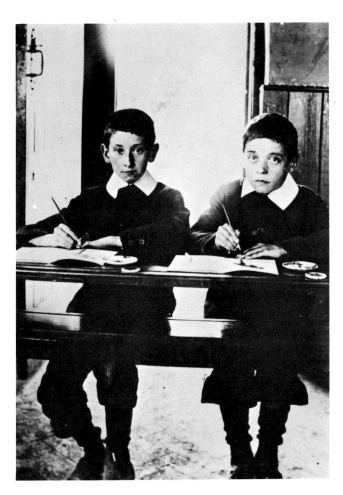

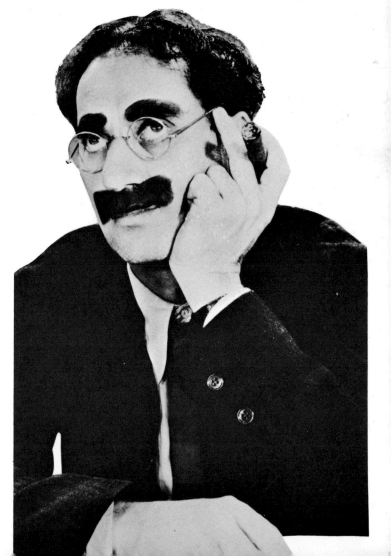

which were simply not available before. But the material demands of the new production techniques, and the different social background of the new audience, transform the culture which then comes into existence. And this culture, in its turn, radically affects future events in the technological and social spheres. In the broadest sense it would be possible to interpret European and American nineteenth-century culture as a continuing effort, by people of every kind, to understand the process of industrialization through which they were living, and to find within it a meaning for their existence. It was they who first experienced vividly the sequence of continuity within dramatic change which now dominates mass culture and thus our lives.

These developments suggest a host of very specific questions which we should be asking about the role of art since the industrial revolution: How has technology changed art through printing, photography, cinema, and television? What relevance have traditional forms of criticism to the social function of art? How does art support or defy public morality? How are forms of art used by society to foster ends it considers good? Can art be genuinely subversive – has it any direct political role? What relation to the effectiveness of communication have aesthetic principles like harmony and proportion? What kinds of standards are significant in assessing art's social function – is it appropriate to consider standards at all?

The fundamental problem in answering these questions is the lack of an appropriate model for contemporary culture. We are no longer examining a static situation. We are no longer faced with clearly defined divisions between 'high' and 'low' culture. The old formulas have ceased to have utility. We need a style of criticism that includes the phenomenological possibility of recasting terms to fit changing situations. We need a fluency that can accommodate dramatic alterations in the means of production, in the type of audience, and in the status of particular types of artist.

Put at its most brutal, the choice seems devastatingly plain. It is either to work to develop a fluid, broadening definition of art related to the mass media of today as well as to the aristocratic media of the past, or to accept the continued use of a narrow concept that will become steadily more remote from the key cultural questions of a technological world.

The proposition put forward here is that only a model which gives full weight to the creative role of the context as well as that of the artist is capable of responding to our need to understand the content and meaning of our own culture. Only an ecological or sociological viewpoint can provide the perspective required to interpret events in a mass society.

The remainder of this book is an attempt to put this proposition to the test by looking more closely at specific roles which art has played or is playing. The

questions asked are not: 'Is it art: is it good art or bad art?' but 'What does it do: how does it do it: what does it mean?'

In each of the four sections which follow, art is examined in relation to a fundamental human activity – worship first, then sex, work, and war. Each activity is used to examine a particular aspect of art's social role. The sequence moves steadily towards themes which depend specifically on technological developments and on the changes wrought in culture by the emergence of mass society. Finally, the focus is on the uneasiness and conflict inherent in a world which is painfully attempting to become more egalitarian whilst submitting itself more and more to the inegalitarian pressures of technological bureaucracy. The mirror used to examine this idea is our striving for peace and the changed image of war.

The themes treated in the sections are as follows:

WORSHIP Here art is shown as a great stabilizing force in society. It performs the function of relating the individual to the cosmological beliefs of his community. It interprets the meaning of the relationship between past, present, and future and, in this sense, intimately affects experience. The image of himself which each man carries and responds to is partly the outcome of the nature of religion and the picture of life which it presents. Art is the primary tool by which this picture is communicated.

SEX In this section art again appears as a mainly stabilizing force. Art plays a very large part in defining the meaning of gender and in regulating the relationship between male and female. Here art affects the most intimate and private aspects of life. It provides the basis of a chain of attitudes linking lovemaking and marriage customs with economics, social status, and religion. Its function is very clearly that of social control.

WORK Here the emphasis is radically different. By taking the upheaval of values caused by the industrial revolution, art is shown operating as an active part in a Marxist dialectic for change. First there is a breakdown in traditional values around the work situation; then there is the articulation of the resulting situation; then a mobilizing of anger and the development of alternative visions of social order. Finally, after a period of struggle in which art performs a violently polemical function, there follows social reform or revolution.

WAR War represents the mobilization of a society's resources to an abnormal degree. It is, therefore, a situation in which art, as a medium of social communication, has to play a highly symbolic and restrictive role. That is one aspect explored in this section. Another is the transformation of the image of war by the development of mass media. This is used, in the guise of a discussion of our efforts to attain peace, as a vehicle for a general critique of the implications of the mass media for contemporary and future society.

From the four sections a pattern emerges which suggests certain key changes in the

semantic whole of art and society. In them we can see something of the direction taken by cultural evolution. First, culture appears as relatively undifferentiated and very stabilizing: in a tribal situation art, religion, and social organization tend to coalesce. Then we see the development of a variety of 'high' cultures. These are socially divisive and concerned to reinforce the power relations in society but, at the same time, achieve great aesthetic subtlety and perfection. Finally, egalitarian ideas and industrialization go hand-in-hand to create our own paradoxical culture. Here we find that the individual is both valued as never before and ruthlessly exploited, that a plurality of social groups and beliefs go with and are parly supported by an otherwise standardizing mass media, and that capitalism has succeeded in producing popular art which is richly relevant to the lives and experiences of those who are most exploited by industrialization.

What stands out most clearly is a complete revolution in the social function of art. The change is from embalming the traditions of a static society to interpreting the high hopes and violent confusions of a rapidly evolving world.

45 (below) photograph from the cover of *Oz*, satirizing 'revolutionary chic'

46 (right) A still from the American musical film, *South Pacific* (National Film Archive, London)

54

47 CREATION OF THE UNIVERSE. This Tantric painting is from an eighteenth-century Indian manuscript called the *Suddhachittavani* or *Course of Correct Understanding*. In Tantra it is said that the creation of the universe involves three co-existing forces: creation; maintenance; and dissolution. Here spheres are breaking up to form new spheres: they stand for the forces of creation in the 'world egg' (from *Tantra Art* by Ajit Mookerjee)

Part Two
WORSHIP

When heaven had not yet come into existence,
When men had not yet come into existence,
When gods had not yet been born,
When death had not yet come into existence.

from an ancient Egyptian pyramid text[1]

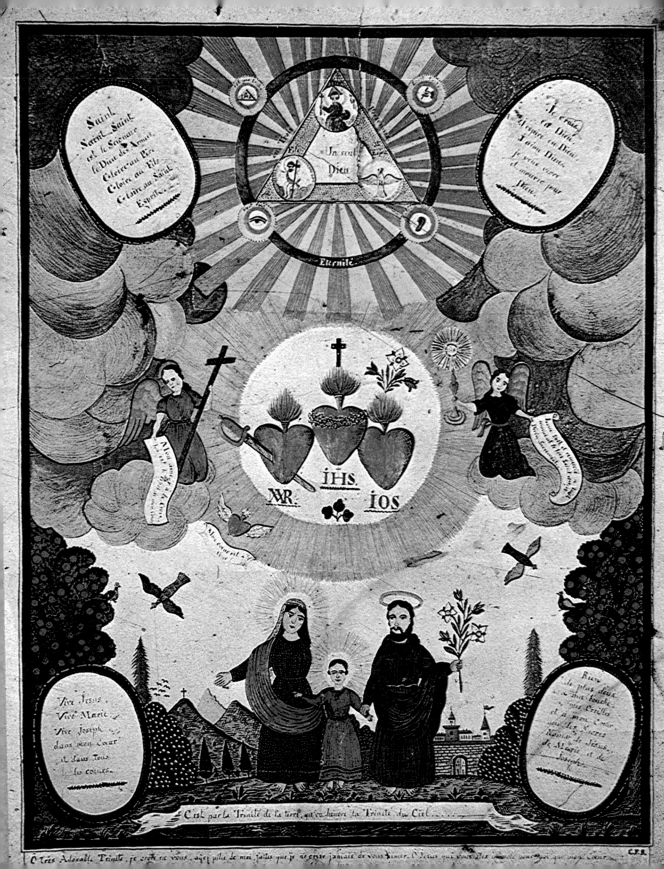

Religion provides one of the most challenging areas for art criticism. Not only did art and religion exist together in some form right from the very beginnings of organized communities, but they were also inextricably mixed so that it is sometimes impossible to tell them apart. At the start, they operated in a world which did not display the highly differentiated categories of our own society. Art, religion, politics, and agriculture were all submerged – and latent – in a basically magical interpretation of the universe. The social function of art and the social function of religion were bound together in the charismatic power of image-making, dance, and ritual.

At times one is tempted to think that art made religion possible. At times, that it was the opposite way round. It would be more accurate to say that they began together before any question of this kind had meaning.

The Egyptian pyramid text quoted on page 57 points back even further, to a moment of non-existence when there was no heaven, no men, no time, no gods, and no death. This is a state of nothingness which has a place in most religions. It is tempting to believe that it represents the inhumanity of a semi-conscious world unordered by the structures of art or religion.

In the context of such a concept, the coming into existence of the structures would be a key event. For the evolution of mankind, it must have been of greater importance than any specific content then carried by the structures themselves. If we accept the primacy of communication and the cultural significance of simplification and ordering, it is easy to recognize the central social meaning of what happened. Beliefs and actions that have sometimes been thought of as primitive and limiting must, in fact, have been creative and liberating. They formed, for the first time, a world of shared meaning within which men could know and experience one another.

This is akin to the argument put forward by the leading French anthropologist Claude Levi-Strauss. He valued the social significance of cultural structures because they support action and communication. To him, this was more important than the ideas they happened to contain. What he identified here was the central dynamic of the relationship between the individual and his culture. It is the structural aspect of phenomena like art and religion which, at base, make possible the inter-relationships of the human world and which articulate the pattern of social creativity which Ruth Benedict, in *Patterns of Culture*,[2] characterized in the following way:

48 THROUGH THE TRINITY ON EARTH WE HONOUR THE TRINITY IN HEAVEN by C F Brun, 1868. C F Brun, 'Le Déserteur', was a fugitive from French justice who lived for twenty-one years in the remoteness of the Valais in Switzerland. Here he was protected by the local population and earned his living by painting religious pictures to order (from *Le Déserteur* by Jean Giono, published by Editions de Fontainemore, Lausanne)

Society in its full sense . . . is never an entity separable from the individuals who compose it. No individual can arrive at the threshold of his potentialities without a culture in which he participates. Conversely, no civilization has in it any element which in the last analysis is not the contribution of an individual.

The useful thing about the structuralist interpretation is that it provides a way of resolving the debate about the twin origins of art and religion.

As an example of what is involved, let us compare the way in which two important

49 A prehistoric rock painting from
Tahl in the Libyan desert
(Hamlyn Group Picture Library)

critics give quite different evaluations of this question of origins. The critics are the
Austrian Marxist Ernst Fischer and the English aesthetician Herbert Read. Notice
how their philosophical priorities drastically affect their interpretations. Both argue
from their view of the present, and the needs of the present.

In *The Necessity of Art*,[3] Ernst Fischer presented the history of art in terms of a
journey from the time of primitive collectives, through the development of trade,
industry, capitalism, and the bourgeoisie, to a point where the definition of art lay in
its awareness or unawareness of the class struggle. For him, religious art was simply
an aspect of power: of man's attempt to control the material world through a belief
in occult forces and, more subtly, to assure himself of the reality of the great
collective of humanity.

In *Art and Society*,[4] Herbert Read concentrated on the primacy of the individual
and on the role of art in championing feeling as against reason. His interpretation
was naturally related to his pioneering work in education. It represented a clear
statement that art was an end after which society should strive. He argued from a
conviction that the pursuit of art was the high point of civilization, and that the
artist offered to the community individual insights that it desperately needed. His
whole emphasis was on the artist rather than on ideology. He said:

The practice and appreciation of art is individual; art begins as a solitary activity, and only
in so far as society recognizes and absorbs such units of experience does art become woven
into the social fabric. The strands in the 'pattern of culture' represent the supernormal
activity of a few individuals, however communal the pattern itself may be; and the value of
the pattern will depend on the delicacy with which the relationship between the artist and
society is adjusted.

Both Read and Fischer considered the significance of those early cave paintings that
show vivid representations of animals. Here is what Fischer had to say:

Clearly the decisive function of art was to exert power – power over nature, an enemy, a
sexual partner, power over reality, power to strengthen the human collective. Art in the dawn
of humanity had little to do with 'beauty' and nothing at all with aesthetic desire; it was a
magic tool or weapon of the human collective in its struggle for survival.

It would be very wrong to smile at the superstitions of early man or at his attempts to tame
nature by imitation, identification, the power of images and language, witchcraft, collective
rhythmic movement, and so on. Of course, because he had only just begun to observe the
laws of nature, to discover causality, to construct a conscious world of social signs, words,
concepts, and conventions, he arrived at innumerable false conclusions and, led astray by
analogy, formed many fundamentally mistaken ideas (most of which are still preserved in
one form or another in our language and philosophy). And yet, in creating art, he found for
himself a real way of increasing his power and enriching his life. The frenzied tribal dances
before a hunt really did increase the tribe's sense of power; war paint and war cries really did
make the warrior more resolute and were apt to terrify the enemy. Cave paintings of animals
really helped to build up the hunter's sense of security and superiority over his prey.

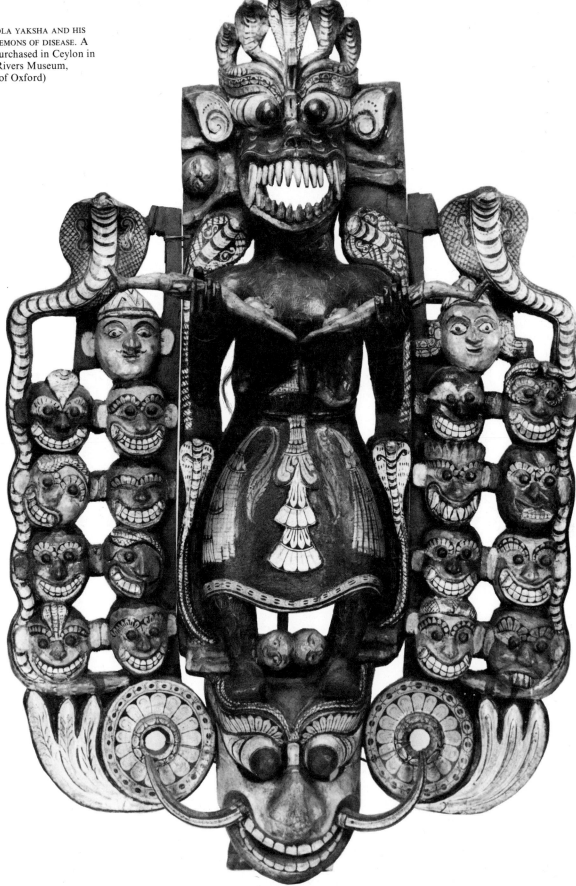

50 MAHÂKOLA YAKSHA AND HIS EIGHTEEN DEMONS OF DISEASE. A sculpture purchased in Ceylon in 1899 (Pitt Rivers Museum, University of Oxford)

51 (left) A sculpture of the Virgin and Child from Sangenjo in Spain (The Spanish National Tourist Office: photograph by Josip Giganovic)

52 (below) FOR GOD AND HOME AND NATIVE LAND. The image of the Virgin and Child used as an element in war propaganda. It appears on a First World War postcard sent from the USA (Mansell Collection)

FOR GOD AND HOME AND NATIVE LAND

Religious ceremonies with their strict conventions really helped to instil social experience in every member of a tribe and to make every individual part of the collective body.

In this passage, Fischer totally identified the work of art that is the cave painting with its social and communicative functions. For him the sensibility and ability of the artist was clearly of less importance than his social role as a magician. This attitude unfolded logically into Fischer's contemporary interpretation which saw the artist as, above all, a political instrument.

Herbert Read's point of view was almost the opposite. Here is part of his discussion of the cave paintings:

The paintings are, in fact, highly selective stylizations of the object – so vital that we cannot doubt that the man who painted them took a disinterested pleasure in the manner in which he did his job. An attempt has been made to explain this perfection as due entirely to the cave man's *desire* to make his representations magically effective – 'par le désire d'obtenir l'efficacité', as M. Schuwer expresses it. But when this critic used the word 'desire' I think he has given his case away. Primitive man has a *desire* to paint efficaciously. He has the desire

53 (left) A 'god image' collected in the South Sea Islands by Captain Lord Byron in 1825. It may have been made as an object of trade for Europeans who, at the very beginnings of an interest in exotic religion, were starting to collect such 'curiosities' (Pitt Rivers Museum, University of Oxford)

54 (right) Indian playing cards decorated with paintings of the exploits of Krishna (Horniman Museum and Library, London)

55 An illustration from the *Illustrated London News*, 1866, showing the Sunday School Jubilee Commemoration in the Piece Hall, Halifax (Mansell Collection)

to make one painting more effective than another. That is to say, he distinguishes between one painting and another, but surely not by the magical results obtained from it. It is quite fantastic to imagine that the stylistic mannerisms of the Altimara paintings were arrived at by a process of trial and error . . .

Admitting the aesthetic nature of palaeolithic art, its interpretation . . . remains a vexed question. At the one extreme there are anthropologists who are unwilling to concede to man of the Old Stone Age any such degree of mental development as a system of magic would imply, and who therefore regard these cave-paintings as entirely aimless, the product of the enforced leisure of hunters. They explain the vividness and aesthetic value of all the drawings as due to the intense images which must have haunted the minds of primitive men, dependent for their lives on their animal prey. At the other extreme are anthropologists who read a magical significance into every stroke they can discover in the gloomy bowels of a cave. The position I take up is an intermediate one: the magical significance of some of the drawings is

beyond question; but there is no reason to assume that every drawing had this kind of significance. Primitive man was already human, and must surely have enjoyed the creative activity he was endowed with, and pursued it for its own sake. In other words, the art existed independently of the magic; had its separate origin and only in the course of time came to be associated with magical practices . . .

In its turn, Read's attitude unfolded logically into his contemporary interpretation which placed art and the artist at the centre of society, but on their own terms.

The point at issue between Fischer and Read is really which comes first: art or society; religion or society. Fischer identified magic as primitive science and worship as primitive communism. Read identified the aesthetic sense as the creative element in society and argued that, therefore, society depended for its continued development on the untrammelled freedom of the artist: he clearly thought the art of early peoples more important than their religion.

56 This photograph, taken in 1884, shows the 'Joint Choirs of St John's, Burgess Hill and The Chapel Royal' (Mansell Collection)

In structuralist terms, however, these arguments represent the division of the indivisible. We have already seen that art cannot be thought of as separate from society because the 'mode of knowledge' which it represents is actually a part of society. Clearly the same applies to religion. The real achievement was quite simply the creation of a number of structures that, in aggregate, formed the larger articulation which is human society.

What the interaction of art and religion essentially did was to bring into consciousness and, therefore, into society, the concepts referred to in the Egyptian hymn. But these concepts also formed society; they *were* society. They were the framework which allowed communication to take place. The gods in heaven, the concept of 'men' as a collective category, and the significance of death as a cosmologically important event, are ideas which, in varying degree, are stamped on every society. Worship is the formalization of man's relationship with these fundamental human concepts.

Looked at in this way, the key social aspect of art's link with religion can be seen to be its ability to make real the congruence of past, present, and future. Here the category of past stands for custom, the category of present stands for ritual and ceremonial in life, and the category of future stands for immortality either for the individual or for humanity as a whole.

The real significance and humanizing power of this way of structuring time can best be seen through the eyes of an individual life. The most vivid perspective is that of a person within a particular cultural situation. He looks back to stories of the Creation, to myths which explain the nature of the relationship between men and God, and to the wisdom and practices of his ancestors. In everyday life the reality and vividness of this background is made manifest in ritual and ceremonial, and spiritual forces are called upon for good or ill. He looks forward to his appointed fate: to becoming a spirit perhaps, or to being reunited with family and ancestors in the presence of God.

The process is circular, or spiral, because he, himself, one day becomes an ancestor or a part of the past.

57 A woman's prayer stick. It is Norwegian and dates from 1655 (Pitt Rivers Museum, University of Oxford)

In social terms the pattern is most often one of reassuring stability, linked to the continuation of accepted customs, institutions, and behaviour. In such a situation art is not concerned with novelty but with reaffirming and refining truths which are

BIRTHS

Mary Ann Wilford. Feby. 6th . 1847
Joseph Wilford. July. 14th . 1849
Henry Wilford Septr. 15th . 1855
Elisa Wilford April. 7th 1857
Joseph Wilford July . 1 . 1859
Arther Wilford. April. 21 . 1861
Willm Samuel Wilford Jany 15 . 1863
Emily Isabella Wilford July 21 1864
Ellen Louisa Wilford Jany 9 1866
Henry Wilford Born Oct 23 1886

MARRIAGES

Thomas Wilford. Father
Margeret Wilford. Mother
Elizabeth Wilford - Jones
Henry Wilford
Arthur Wilford.
Mary Ann Wilford - Richards
William. Samuel Wilford
Joseph Wilford
Ellen Louisa Wilford - Thomas

Mary Ann Wilford's Bible presented by
in the year of our Lord 1863

His father & mother Thomas & mother Mary
Wilford

58 Pages from a Welsh family Bible recording 'Births' and 'Marriages'.
Family Bibles in the nineteenth century nearly always contained these pages
together with another for 'Deaths'. This Bible was presented to its first
owner in 1863 (Mrs Joy Goodfellow)

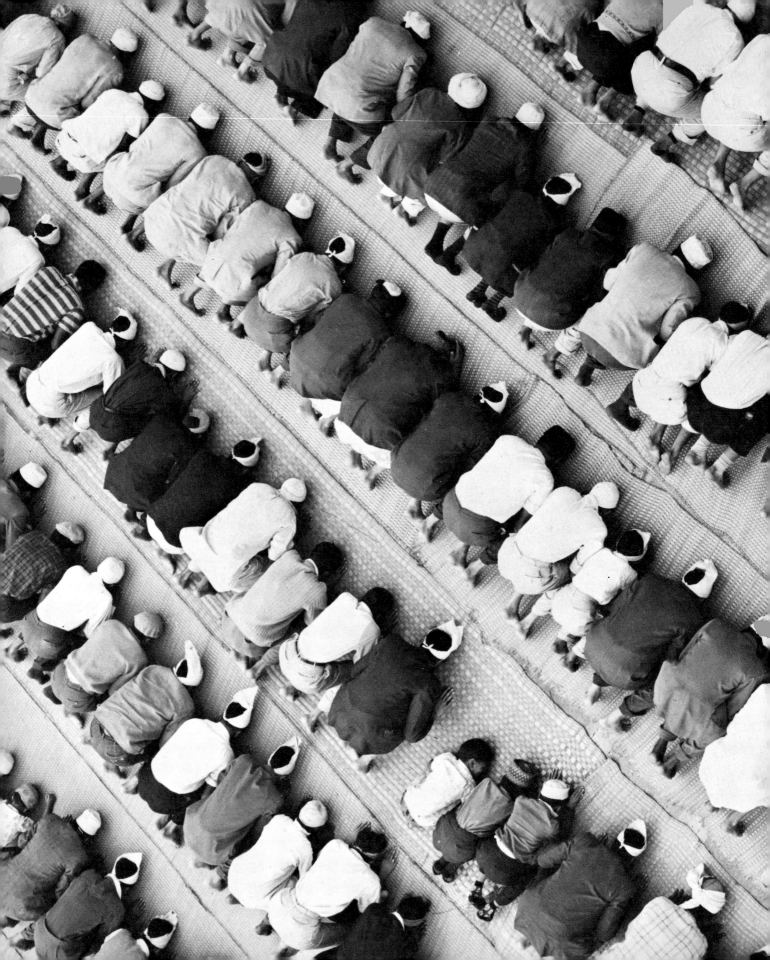

60 THE FAMILY. In this drawing by the author's daughter, Polly, members of her family ride in a train: dead as well as living people are included (Ken and Kate Baynes)

already accepted in essence. Only when the philosophical framework is destroyed by change or when proselytizing zeal takes up art as a weapon, does this alter.

What we see as most typical are works created within a system of belief for people who shared that system, thought it entirely true, and who, unlike ourselves, had little enough knowledge of the relationship between their culture and others that were different.

59 A photograph by Günter R Reitz showing Moslems at prayer in a mosque in Nairobi (Barnaby's Picture Library)

Past, present, and future were, as in medieval times, points between which an individual had to travel but which existed within a timeless scheme. Art described the terms of the person's journey and made it real.

61 (left) A young woman clings to the Holy Cross, surrounded by the stormy seas of life. The scene is taken from the scrapbook of a Scottish child. It was made late in the nineteenth century (Museum of Childhood, Edinburgh)

62 (right) A prayer carved on a small tablet of wood. It comes from Tibet and is brightly coloured (Anthropological Museum, University of Aberdeen)

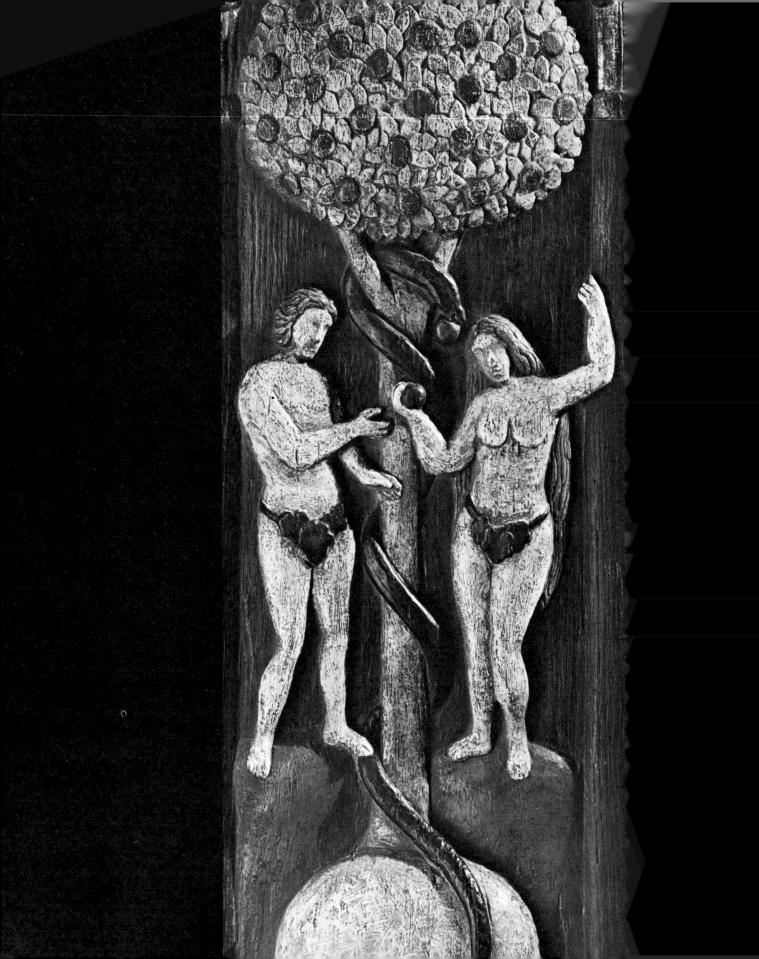

WORSHIP: Past

And God said, Let us make man in our image, after our likeness: and let them have dominion over the fish of the sea, and over the fowl of the air, and over the cattle, and over all the earth, and over every creeping thing that creepeth upon the earth.
So God created man in his own image, in the image of God created he him; male and female created he them.

from Chapter I of the First Book of Moses, called GENESIS[5]

In most periods stories about gods have permeated every aspect of life, serving as the major subject matter of applied decoration. While handcraft methods lasted, religious themes provided the primary source for imagery on every kind of domestic utensil.

This has, on one hand, made holy images commonplace and widely available and, on the other, made it difficult to distinguish between the sacred and the profane in the visual arts. In terms of the theme of past, present, and future such representations make constant reference to the religious philosophy of a particular culture, reiterating time and again the basis of the relationship between God and man. They bring the past constantly into the present.

The transmission of the concept of past, present, and future extends far outside formal worship and its associated activities. It is an important ingredient in education in all societies and, in most, forms a part of home and play activity.

Words have a special place in the transmission of religious philosophy from past to present. They may actually be the 'word of God' and thus deserving of the most magnificent embellishment and the most splendid presentation. The illuminated manuscripts of medieval Europe are among the best known, but every major religion has its superb holy books, and the Middle East has an architecture of sacred words where mosques are covered with decorations based on the texts of the Koran.

Men are fascinated by their own beginnings. It is a form of curiosity which may be applied to the family and its ancestry, to the local community, to nation or tribe, or to the whole of mankind and the world. Creation stories are satisfying in so far as they wrest a pattern of recognizable motivations and coherent narratives from the most remote point of time. They may be excessively abstract, as in the Tantric *Creation*

63 (left) Part of a carved and painted wooden cross from Czechoslovakia (National Museum, Prague: photograph by Alexandr Paul)

64 (above) A Hungarian cake-mould, either seventeenth or eighteenth century, showing Christ in a carriage drawn by a lamb (Museum of Arts and Crafts, Budapest)

illustrated on page 57 or, as in the case of Christianity, richly personalized. They frequently involve prototypical humans in direct confrontations and dialogues with God.

The obsession with beginnings goes very deep. It is often extended to explain the supernatural origins of technology and agriculture, art, and music. Credo Mutwa, a Zulu witch doctor, gives in his book *My People*[6] a description of how a goddess created a musical instrument for use by the Wakambi:

Afterwards the gourds were boiled in animal fat to make them more resilient and waterproof. With her own delicate hands [the goddess] Marimba assembled the instrument, arranging the gourds and planks in gradually diminishing sizes, while vast crowds of Wakambi men and women watched in awe and astonishment.

Thus the xylophone – the marimba – was born. Soon this melodious companion of the feast and the dance was sending its notes through the festive air, each note as gentle as a maiden's promise . . . Indeed it is an instrument worthy of bearing the name of the goddess of music.

In the simplest sense all this is easy to understand. The

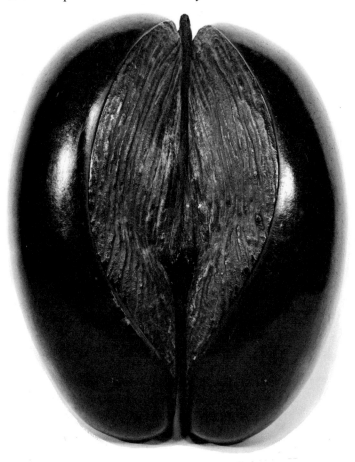

65 (above) The Shepherds in the Christmas myth are frequently highly personalized even though they are humble participants in the story. This shepherd is a contemporary bread doll from Ecuador (from *Cookies and Breads: The Bakers Art*, Museum of Contemporary Crafts, New York: photograph by Ferdinand Boesch)

66 (right) A Coco-de-Mer. This is a type of palm fruit which is often washed ashore in India where it is worshipped as an emblem of the cosmic generating organ of a goddess (Gulbenkian Museum of Oriental Art, University of Durham)

67 (right) Christmas emblems. A selection of nineteenth-century Christmas cards (Mansell Collection: photograph by Chris Ridley)

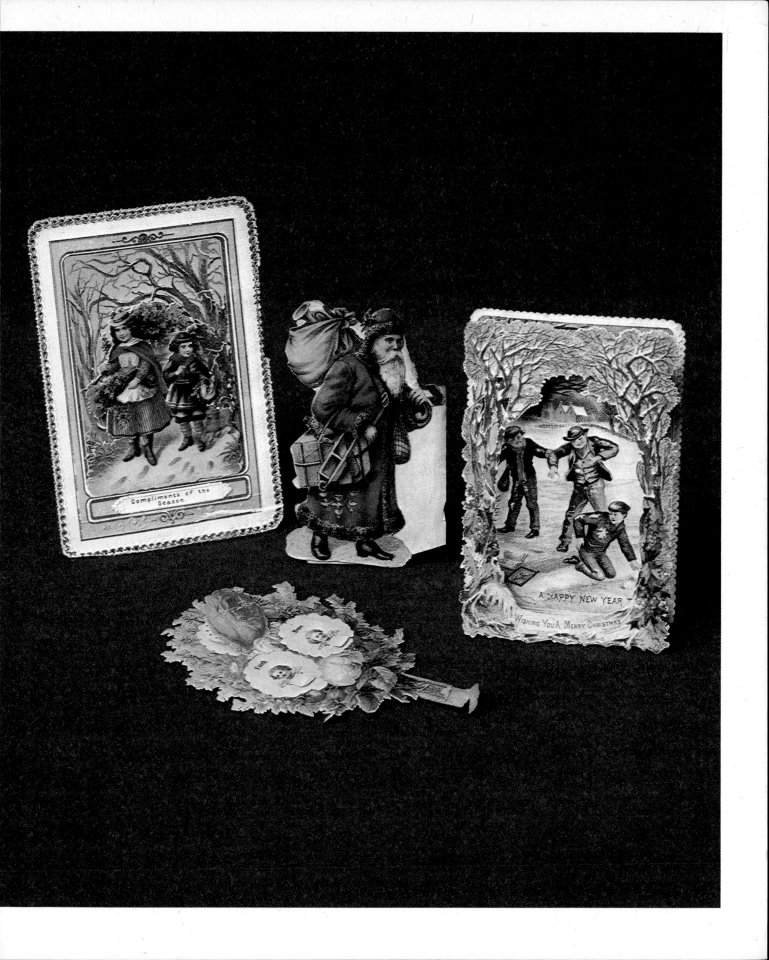

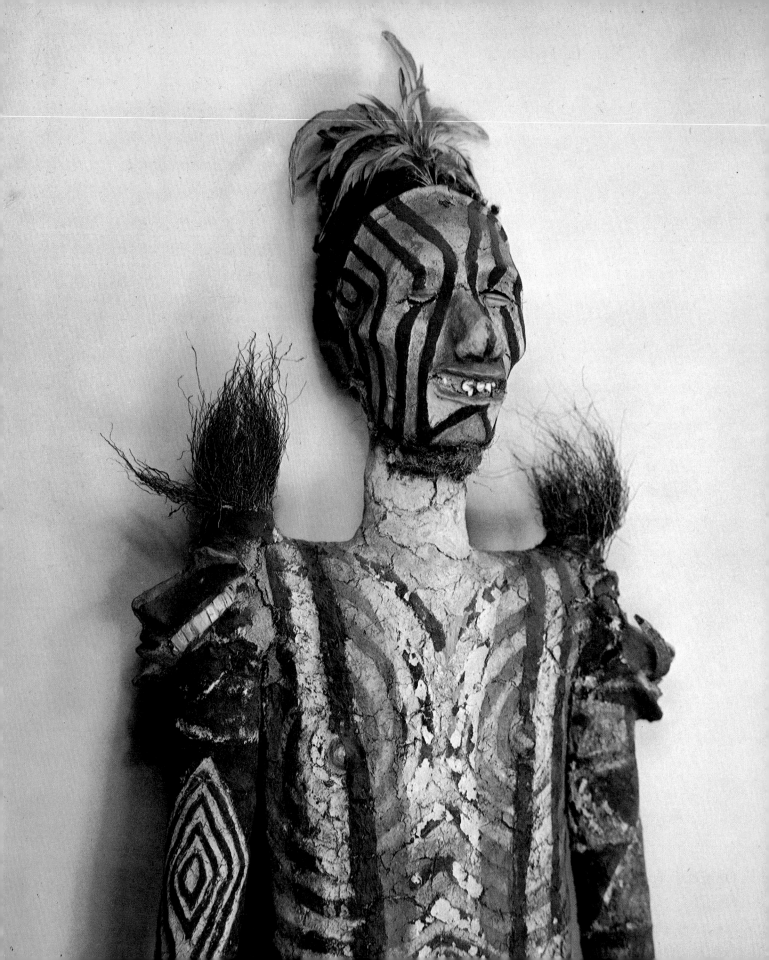

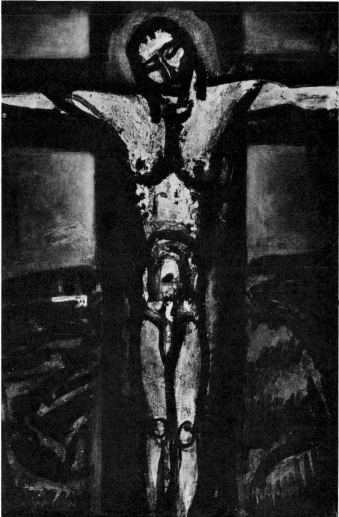

68 (left) The effigy of a dead man, with the head formed over his skull, from Malekula in the New Hebrides (Pitt Rivers Museum, University of Oxford: photograph by Chris Ridley)

69 (above) The 'Buddha of Kamakura', Japanese, thirteenth century (Japan National Tourist Organisation)

70 (right) SOUS UN JÉSUS EN CROIX OUBLIÉ LÀ by Georges Rouault, c.1927 (City Museum and Art Gallery, Birmingham)

stories close off the blank void of the past and enter upon the delineation of patterns and events which come eventually into the present. It is also easy to see that, in the final elaboration of an accepted, traditional religion or folklore, much else is added which enlarges on the initial contract between God and man. In the end, a collection of religious stories and beliefs will come to embrace the origins and meanings of the whole of the workings of the social contract on earth. This, apparently, is the social significance of art and religion's ability to articulate the past through stories and pictures.

However, something is missing from such a formulation. It lacks a vital dimension. It fails to take us into the heart of the significance of mythology. It suggests that myths were like allegories or parables – symbolic equivalents for other truths verifiable in other terms. This is quite wrong. As has

already been suggested, early religious art was not symbolic in the way that much later religious art has become. It was not illustrative. It was immediately real, qualitative, and concrete. At its most intense it stood for a moment of communication, understanding, and involvement akin to that in the Christian communion ceremony. It involved something quite unlike our own experience of looking at picture-books where images illustrate events in a written story.

The representation of God, or gods, and stories about them has been one of the most common uses of art since the beginnings of religious thought. Scales and styles have varied enormously, as have the social and economic conditions in which the works existed, but there has always been the element of focusing emotion and understanding on an object more enduring and more authoritative than the imagination

71 VIRGEN DE LOS DOLORES. A
Spanish processional figure used at
Seville (The Spanish National
Tourist Office)

of an individual and mortal man. We are apt to forget the
powerful religious experience of actually making the work
and then using it in a ceremonial setting.

We can see the importance of this context very clearly if we
look at a description of the significance of sculpture and
craft in the belief of Voodoo, which is a complex Haitian
version of African religion affected by contact with
Christianity and taken across the Atlantic by the slaves. It
comes from *Muntu*[7] by Janheinz Jahn, the German critic.
The *loas* he referred to are the Haitian gods, *Bon Dieu*, *Legba*,
Damballah – and many others – personifications of natural
forces or characters from the Voodoo underworld. Jahn took
the attitudes he described as being typical of all Africa:

According to African philosophy, the metal, the stone, the clay, out
of which the smith, the stone-cutter, the potter moulds a piece of
sculpture is a *kintu*, a 'thing', and nothing more. Only the piece of
wood that the wood-carver uses for his sculpture is something more
than other 'things': it comes from the tree, from the 'road of the
invisible ones', as they say in Haiti, from the vertical that unites the
water – *Nommo* of the depths – with the cosmos. As 'repository', as
the seat of the *loas*, the wood of such trees is a privileged *kintu*: the
Nommo of the ancestors has given it a certain consecration, a symbolic
value – just as a flag is a privileged piece of cloth: the force of respect,
a symbolic force has been invested in it. The respect, however, is
never for the wood itself, but for the *Muntu*-beings who have chosen
it as their 'seat'. Since it stands closer to the *loas*, the *orisas*, the
ancestors, it is favoured as a material – for the materials one works
with also have a hierarchy . . .

With the help of *Nommo*, the word . . . the goldsmith [like other
artists or craftsmen], makes an ornament out of a piece of gold. He
works magic. His manual skill is an addendum, an important
addendum, but what is decisive is the word, the 'magic formula',
which brings it about that the 'thing' is turned into something else,
what it is destined to be: an image.

It requires from us a feat of imagination to put ourselves
into a situation where the ceremonial activities around a
sculpture, and even the particular material it is made from,
may be more important in determining what it means than

72 A photograph by Sam Haskins
showing a contemporary Nalindele
mask made by the Mambunda of
Zambia (from *African Image* by
Sam Haskins, published in Britain
by Bodley Head Ltd)

the form it takes. What we have here is not a conjunction of meaning with appearance, but the insignificance of appearance as against a designated meaning. The art is a functional art, but a part of the mechanism of the function is exterior to the work and not integrated with its formal imitation.

This is an extreme example. But it does dramatize the degree to which mythological thoughts may be impenetrable to contemporary minds. We are not used to thinking in such a way. It is hard to grasp that a myth was not simply a story, but primarily a structure around which men could experience spiritual emotion, act and communicate.

In *Passion and Society*[8] Denis de Rougemont characterized a myth as a sacred story which endured because of the power of the truth it concealed from, or half-revealed to, profane eyes and ears. He saw the meaning of a myth as always different from its apparent theme. In his careful analysis of the true significance of the story of Tristan and Iseult he brilliantly identified the Manichean heresy which it concealed from the French medieval church. The real passion of the lovers was for death, thus to escape the irredeemably corrupt world. But he was drawing general conclusions from a rather special case. Most myths exist in a climate of social acceptance, not of rejection: they are generally an essential part of the fabric of society. There have always been 'mysteries' to protect the most holy truths, but a more reasonable, and simpler definition of a myth seems to be: a work of art or literature where a not always immediately obvious spiritual and social meaning takes precedence over both formal appearance *and* literary content.

73 (left) KUAN YIN. A Chinese sculpture in ivory, eighteenth century (The Graves Art Gallery, Sheffield)

74 (above) MINERVA. A Roman sculpture carved in Britain (Roman Museum, Bath)

In this context we can see that the deep existential meaning of the creation myths and the stories about gods is simply that they affirm the existence of meaning. They are themselves a part of the linguistic and visual structure of meaning. The relationship which they articulate with the past is a token of the importance of the present. By making the significance of the past a mythological reality in the minds of men, art and religion made possible dignity, self-esteem, and action in the present.

75 (left) THE DEVIL. From a set of glove puppets used for a *Punch and Judy* show (Museum of Childhood, Edinburgh)

76 (above) VENUS. An earthenware figurine, Staffordshire ware 1820, probably by Obadiah Sherrat (The Art Gallery and Museum, Brighton: Willett Collection)

JOSEPH
ÉLEVÉ AUX HONNEURS
DE L'ÉGYPTE.

L'Échanson à Joseph.
Cher Joseph, bonne nouvelle, Par mon zèle Le roi te fait appeler ; Quittes-là toutes les chaînes Que tu traînes, Viens à lui sans chanceler.

Joseph au Roi.
Quelle chose avez-vous, Sire, A me dire ? Que désirez-vous de moi ? Il n'est rien qu'avec la grâce Je ne fasse Pour obéir à mon roi.

Pharaon.
Il faut que tu pronostiques Et m'expliques Quelques songes que j'ai faits ; On connaîtra ton mérite Dans l'Egypte Par mes signalés bienfaits.

Sept vaches grasses et allègres, Par sept maigres Mes yeux ont vu dévorer ; Sept pleins épis par sept vides, Tous arides, Cela me fait soupirer.

Joseph.
Grand Prince, à sept ans fertiles, Sept stériles Aussitôt succéderont : Prévenez par l'abondance, L'indigence, Ou vos sujets périront.

Pharaon.
Joseph, je te fais le maître, Fai paraître Ta prudence à gouverner : Partage, pour récompense, Ma puissance, Je ne te veux point borner.

Joseph.
Que puis-je vous rendre, Sire, Pour l'empire Que vous me donnez sur tous ? Nonobstant cette fortune, Peu commune, Je veux être à vos genoux.

Pharaon.
Il suffit que tu me serves, Et conserves Tous les biens de mes états ; Si j'apprends qu'on te traverse, Qu'on t'exerce, J'en punirai l'attentat.

Jacob à ses enfants.
Nous voici dans la famine, Sans farine, Et sans un grain de froment ; Le bruit court qu'on en débite En Egypte, Allez-y promptement.

Les enfants.
Nous n'y connaissons personne, Qui nous donne Vers le prince un libre accès ; Nous perdons déjà courage, Ce voyage N'aura pas un bon succès.

Le Père.
Faites comme je vous propose Toute chose, Dieu vous sera provident ; Portez une bonne somme A cet homme Qu'on a fait surintendant.

Ses frères à Joseph.
Agréez, grand personnage, L'humble hommage Qu'en tremblant nous vous rendons ; Nous venons vous reconnaître Pour vrai maître Des biens que nous possédons.

Joseph.
Ce ne sont que des souplesses, Des finesses, Pour épier le pays ; Et si je ne vous accorde, Que la corde, Vous serez bien ébahis.

Ses Frères.
Que le ciel par sa justice Nous punisse, Si nous avons ce dessein ; Nous ne sommes venus vite En Egypte Que pour acheter du grain.

Joseph.
Je veux qu'on vous emprisonne, Et j'ordonne La torture sans merci ; Que chacun frère me dise Sans feintise, Si vous êtes tous ici.

Ses Frères.
Il reste encore notre père, Outre un frère Qui se nomme Benjamin ; Pour Joseph le pénultième, Notre onzième, Il fit une triste fin.

Ruben à ses Frères.
Vous voulûtes satisfaire La colère, Vendant Joseph vingt deniers ; Il est juste que Dieu venge Ce bel ange, Nous détenant prisonniers.

Ses Frères.
Souffrons tous la juste peine, De la haine Qui nous le fit vendre à tort, Et perdons toute espérance, Notre offense Mérite à bon droit la mort.

Joseph.
Juste ciel ! leurs pleurs, leurs craintes, Leurs complaintes, Me contraignent à pleurer ; Il faut donc que je me cache, Que je tâche De les faire renvoyer.

Trois fois saint Dieu de mon âme, Je me pâme Du plaisir que je reçois ; La joie excite mes larmes, O quels charmes ! J'ai mes frères avec moi.

Maître-d'hôtel, tout-à-l'heure, Sans mesure Allez remplir le sac de ces gens ; Tâchez avec adresse Et vitesse D'y fourrer l'argent dedans.

Ses Frères.
Monseigneur, que le ciel vous rende La guirlande Qui répond à vos bienfaits ; Vous méritez la couronne Que Dieu donne Aux hommes les plus parfaits.

Joseph.
Je tiens dans l'esclavage, Pour ôtage, Simon sage et benin ; Je prétends qu'il y demeure Jusqu'à l'heure Que je verrai Benjamin.

Réflexion.
Dieu permet que l'on t'abaisse, Qu'on t'oppresse, Garde-toi de perdre cœur ; L'adversité de ce monde, Te seconde Pour demeurer le vainqueur.

Si l'orage et la bonace, Par la grâce, Sont dans ton cœur bien d'accord ; Tu ne feras pas naufrage, Car l'orage Te conduira dans le port.

FIN.

ROMANCE DE JOSEPH. — *Air connu.*

A peine au sortir de l'enfance,
Quatorze ans au plus je comptais :
Je suivis avec confiance
De méchans frères que j'aimais.
A Sichem, au gras pâturage,
Nous paissions de nombreux troupeaux ;
J'étais simple comme au jeune âge,
Timide comme mes agneaux.

Près de trois palmiers solitaires
J'adressais mes vœux au Seigneur,
Quand saisi par ces méchans frères
(J'en frémis encore de frayeur).
Dans un froid et humide abyme
Ils me plongent dans leurs fureurs,
Quand je n'opposais à leur crime
Que mon innocence et mes pleurs.

Hélas ! près de quitter la vie,
Au jour enfin je fus rendu ;
A des marchands de l'Arabie
Comme un esclave ils m'ont vendu.
Tandis que du prix de leur frère
Ils comptaient l'or qu'ils partageaient,
Hélas ! moi je pleurais mon père
Et les ingrats qui me vendaient.

Fabrique de PELLERIN, Imprimeur-Libraire, à ÉPINAL.

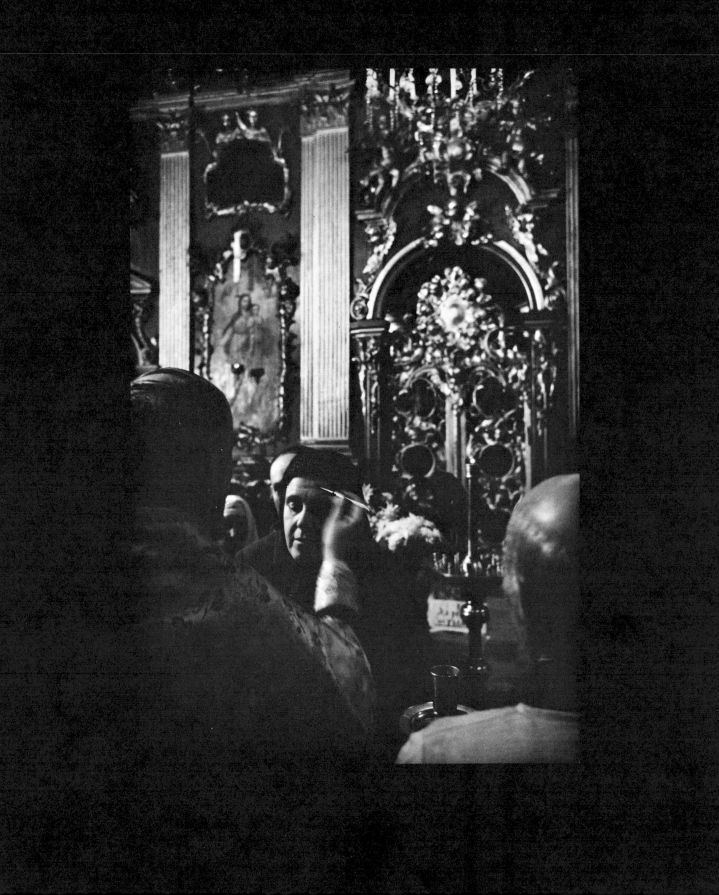

WORSHIP: Present

In the utter silence
Of a temple,
A cicada's voice alone
Penetrates the rocks

from THE NARROW ROAD TO THE DEEP NORTH[9] by the
Japanese poet Basho (1644–1694)

At the centre of the idea of active worship in the world is ceremony. In a series of formalized activities – like dance or drama or mime – the reality of religious philosophy is brought to earth so that it can affect life as it is lived in the present of each individual. From the necessities of such ceremonies have been born theatre and music and, perhaps also, the use of clothing as a symbol for unity, power, or status. In detail the functions of the ceremonies vary, and so, therefore, do the forms of movement and gesture, the words and the artefacts. The aim may be the union of a single worshipper with God: or it may be the reassertion in mass feeling of old or new truths. The outcome may be reassuring and purifying, or it may be dangerously hysterical. In any event, the resulting combination of forms is one of the most powerful uses of art so far devised by humanity.

We are used to thinking of religion and its associated rituals as occupying a particular and perhaps rather small place in what has now become a society composed of many activities, each highly differentiated. But in most periods, and for most people, religion and religious art had a monopoly of images and concepts: it provided the only terms in which men could think and feel.

In his book *The Age of Revolution*,[10] the Marxist historian, E J Hobsbawm, described this situation and the way in which it gradually changed after the Renaissance and with increasing speed following the French Revolution. He said that religion was first of all 'like the sky, from which no man can escape and which contains all that is above the earth' but that it became only 'like a bank of clouds, a large but limited and changing feature of the human firmament'.

For most of history and over most of the world (China being perhaps the main exception) the terms in which all but a handful of educated and emancipated men thought about the world were those of traditional religion, so much so that there are countries in which the word 'Christian' is simply a

80 (left) A photograph by Cornell Capa showing a contemporary scene in a church in Kiev, Russia (The John Hillelson Agency Ltd)

81 (above) A photograph by Takamasa Inamura from a series called 'Japan's Warriors of the Mind'. It shows a student monk saying a prayer before his meal in a monastery (Camera Press Ltd, London)

85

synonym for 'peasant' or even 'man'.

It is no accident that the central building in all European communities up to the time of the Renaissance was always a church. This was a piece of natural planning which indicated much more than the fact that Christianity was the ruling creed of the time. The siting of medieval churches is parallelled in other religions, going right back to the most primitive times and places. In all these cases, the church, temple, or other holy place was not simply a location where a man could come close to God. It was, even more, a social focus, a source of social meaning and reassurance, an intellectual and moral centre, a gathering point for human endeavours. Religion provided the framework in which such ideas could exist.

At the most local level, religion was and is an integral part of the lives of peasants all over the world. Whatever its ostensible subject matter, the religion of farmers is likely to be vividly related to the seasons, and to the cycle of birth, life, and death. The Christian religion has easily absorbed these elements, laying them alongside its more sophisticated message of redemption and the cure of souls. In fact, in medieval times, the impact of the church ceremony depended as much on mystification as on clarification. Here is G M Trevelyan's account from his great *English Social History*:[11]

The peasant as he stood or knelt on the floor of the church each Sunday, could not follow the Latin words, but good thoughts found a way into his heart as he watched what he revered and heard the

82 (below) A photograph by Arno Hammacher of a village church in the Italian Valtellina (Report Features Ltd, London)

83 (right) The west front of the thirteenth-century cathedral at Rheims (French Government Tourist Office: photograph by Jean Roubier)

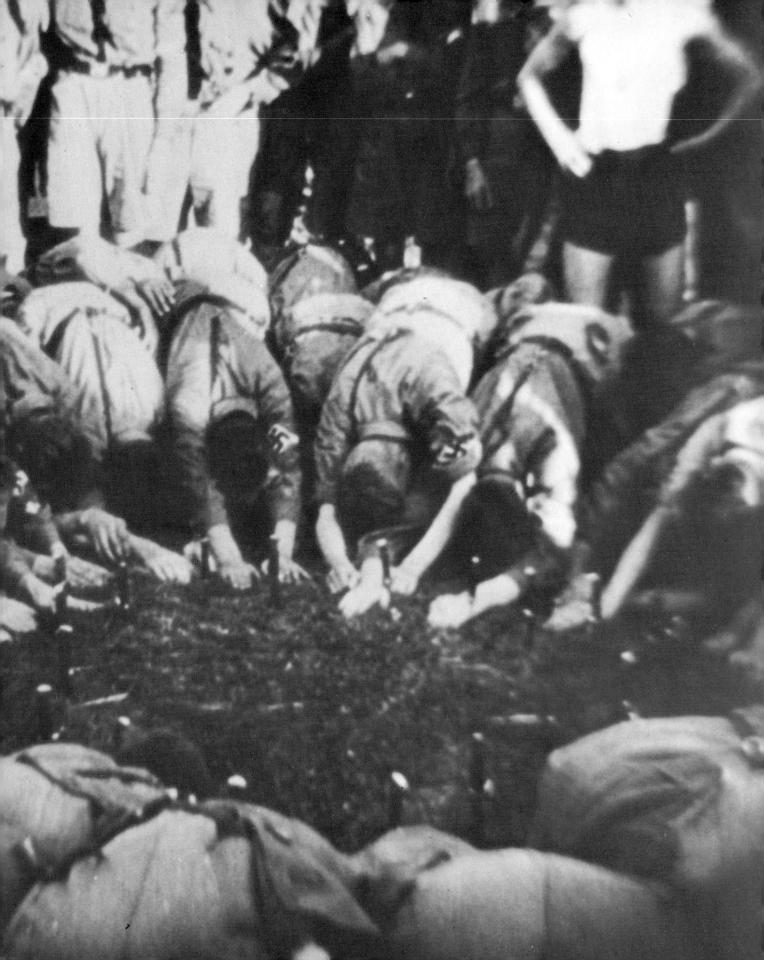

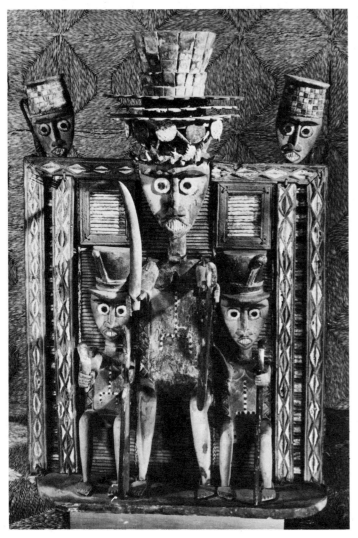

84 (left) Nazis worshipping their daggers. From Leni Riefenstahl's film *Triumph of the Will* made in 1935 (National Film Archive)

86 A Jewish Torah shield by R Fleischman. Czech, eighteenth century (State Jewish Museum, Prague: photograph by Vladimir Soukup)

85 (above) A Nigerian shrine (Pitt Rivers Museum, University of Oxford)

familiar yet still mysterious sounds. Around him blazed on the walls frescoes of scenes from the scriptures and lives of the saints; and over the roof-loft was the Last Judgement depicted in lively colours, paradise opening to receive the just, and on the other side flaming hell with devil executioners tormenting naked souls . . .

The peasant knew some of the sayings of Christ, and incidents from his life and those of the saints, beside many Bible stories . . . He never saw the Bible in English, and if he had he could not have read it.

There was nothing in his own home analogous to family prayers and Bible reading. But religion and the language of religion surrounded his life.

We can see that this was primarily an emotional and

communal experience. It was, like most ceremony, concerned with morale as well as with morals. The rituals bound people together in shared beliefs and provided the essential media for giving life a purpose. In a decadent sense, the same function has been served in our own time by Nazi ritual and, as we shall see later in Part Five, may even be considered to be a fundamental necessity before collective action is possible in any society.

In his book, E J Hobsbawm made a particular point of the way in which the secularists in France tried to provide themselves with an effective set of rituals and even an

87 (below) An audience worshipping the Beatles. Photograph by David Hurn (David Hurn/Magnum)

88 (top right) The French comedian, Fernandel, playing the part of the Italian priest, Don Camillo, in the film version of *Don Camillo's Last Round*, 1955. Camillo's enemy throughout the series of books and films is a Communist mayor. The series makes comedy from the division between secular and church power which still affects most of continental Europe. (National Film Archive/Films de France)

89–90 (bottom right) German votive offerings, nineteenth century (Horniman Museum and Library, London)

equivalent of the priesthood to proselytize and inspire the people:

The post-revolutionary generations in France are full of attempts to create a bourgeois non-Christian morality equivalent to the Christian; by a Rousseauist 'cult of the supreme being' (Robespierre in 1794), by various pseudo-religions constructed on rationalist non-Christian foundations, but still maintaining the apparatus of ritual and cults (the Saint-Simonians, and Comte's 'religion of humanity'). Eventually the attempt to maintain the externals of old religious cults was abandoned, but not the attempt to establish a formal lay morality (based on various moral concepts such as *solidarité*) and above all on a lay counterpart to the priesthood, the schoolteachers. [But] the French *instituteur*, poor, selfless, imbuing his pupils in each village with the Roman morality of Revolution and Republic, the official antagonist of the village curé, did not triumph until the Third Republic . . .

When religion changed from being the whole sky to being only a bank of clouds, it inevitably became involved in the nature of the revolutionary secular changes that were taking place. Much Protestant thought was sympathetic to the ideas of the industrial revolution and, in Britain at least, the Nonconformists had a special place in the development of working-class culture. More usually, however, the identification was between religion and conservatism: piety and the traditional social order. Here is a dramatic passage from the Italian *Civiltà Cattolica*:[12]

Give me a people where boiling passions and worldly greed are calmed by faith, hope and charity; a people which sees this earth as a pilgrimage and the other life as its true fatherland; a people taught to admire and revere in Christian heroism its very poverty and its very sufferings; a people that loves and adores in Jesus Christ the first-born of all the oppressed, and in his cross the instrument of universal salvation. Give me, I say, a people formed in this mould and socialism will not merely be easily defeated, but impossible to be thought of . . .

The formulation is much to the point. It shows a sophisticated awareness of the structural importance of cultural experience and of areas of power and influence that were about to be lost by the churches. The contemporary lessening of participation in ritual ceremonies is very largely a function of the diffusion of institutions throughout a secularized society. Religion no longer provides the only concepts which can explain to man in the present the nature of mankind and the meaning of life on earth. And the general lessening of effective ritual of every kind is a function of the multiplicity of interpretations abroad in society. A pluralistic society pays a price in confusion and alienation for its liberalism.

91 Three religious magazines for children produced towards the end of the nineteenth century. These were read in Presbyterian Scotland (Museum of Childhood, Edinburgh)

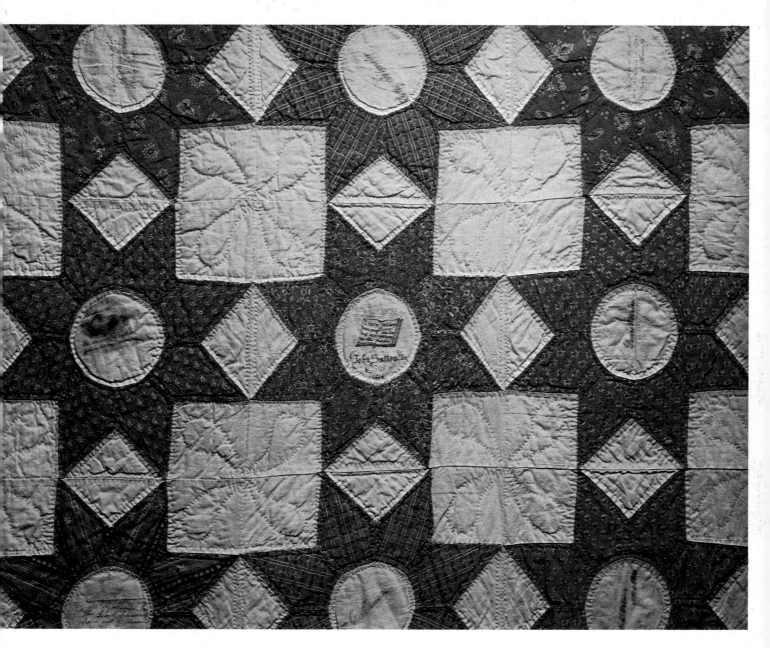

92 A 'Bible Quilt' made in the United States, 1846–47. In America, in the
mid-nineteenth century, the making of quilts was a social occasion in which
neighbours would join. This quilt, like so many other utilitarian objects in
the past, was decorated with religious themes. It has Biblical quotations
written on it, and also (as was common) the names of those who came
together to make it (The American Museum in Britain, Bath: photograph
by Chris Ridley)

WORSHIP: Future

Aidoneous! Aidoneous!
If such a petition may be heard:
Grant to our friend a passing with no pain,
No grief, to the dark Stygian home
Of those who dwell in the far invisible land.
Out of the night of his long hopeless torment
Surely a just God's hand
Will raise him up again.

from OEDIPUS AT COLONUS by Sophocles[13]

Death and human suffering can appear abhorrent to consciousness. They seem to degrade the individual and to close off his freedom of action. From the cultural point of view, death is a puzzle: here it is accepted as a natural part of the cosmological order; there rejected and reduced to the level of a vulgar bogeyman; elsewhere celebrated and deified like a gift. It can appear as nothing less than the gateway to immortality, or it can be the start of a terrible journey into the unknown. Death completes the cycle of past, present, and future and pervades every culture in one form or another, but its role is ambiguous.

Memento mori. 'Remember death.' This is a caution to humanity which many religions have embodied and which, in our own day, has passed from formal religion into the popular art of the horror film and sadistic comic. There is an extraordinary continuity of emotion about this aspect of death: a desire to touch and feel it, to experience the physical and psychic horrors associated with it. To be able to do this vicariously is a cultural project which the existence of art has quite literally made possible. Figures of death, disaster, and suffering stride through the mythologies of the world, half god, half demon: sometimes worshipped in serenity; sometimes in terror.

Here, from three continents, are celebrations of the power of death and destruction. The first is an ancient Egyptian song called a *Cannibal Hymn*:[14]

The sky is overcast, the stars are beclouded . . . the [very] bones of the earth-god tremble . . . when they see [this dead man] appear animated as a god who lives on his fathers and feeds on his mothers . . . [He] is the one who eats men and lives on gods . . . [He] is the one who eats their magic and devours their glory. The biggest of them are for his breakfast; their middle-sized are for his dinner; and the smallest of them are for his supper.

The next example comes from Central America, where the power of death is particularly strongly involved in the minds

93–95 (far left and top left) Welsh War memorials. Commemorating the men killed in two World Wars, they were all designed after 1918. From a series of photographs by Peter Jones

96 (left) LA MUERTE. A figure of Death used in rites of the Morada sect in New Mexico in the nineteenth century (The American Museum in Britain, Bath: photograph by Chris Ridley)

97 (above) An Aztec sculpture of a skull (British Museum)

of the living, and where the cult of death had immensely old beginnings. There, perhaps more than anywhere else, the ritual value of a ceremonial death was once seen to be to the taste of the gods. Although it is not easy for us to respond directly to the idea, our own valuation of Christ's crucifixion and of secular heroism which leads to martyrdom, can be seen to be of a piece with the same set of values. The following passage contains a description of part of the ritual of the penitential Morada sect of New Mexico. The words are by B de L Carey who reported[15] on the sect for the American Museum in Britain where some of the Morada artefacts (see page 94) are now on view:

The Brothers would have chanted their way through the Prophecies and Lamentations, each of which is represented by a candle, while the yucca scourges rose and fell in the dim light, and as the final candle at the apex, the one representing Christ, was finally extinguished as a symbol of His death, so the matracas – the noisemakers – rolled and thundered in the darkness as the earthquake did when He died. The Death Cart would merge with the Procession, filled with stones and its axle fixed so that it must be pulled by force – a good penance over a rough road, and *La Muerte* grinned from her perch as she was drawn by. This figure of death, clutching her bow and arrow, was one of the most common features of the old mystery plays adapted to the Penetente Rite.

Finally, an extract from an extraordinary celebration of retribution written by the Catholic Gerard Manley Hopkins:[16]

We shall die in these bodies. I see you living before me, with my mind's eye, brethren, I see your corpses: those same bodies that sit there before me are rows of corpses that will be. And I that speak to you, you hear and see me, you see me breathe and move, this breathing body is my corpse and I am living in my tomb. This is one thing certain of your place of death; you are there now, you sit within your corpses; look no farther; there where you are you will die.

In these examples it seems to be death the impersonal force which is recognized and articulated. In Part Three we shall examine the idea that death and destruction in nature

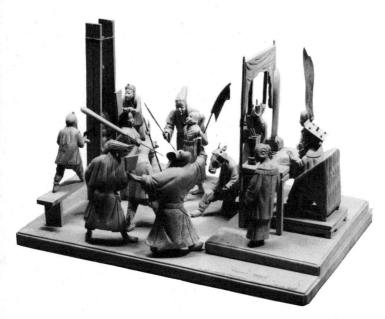

ΧΑΡΤΟΚΟΠΤΙΚΗ ΑΡΙΘ. 5

Η ΑΝΑΣΤΑΣΙΣ Ι. ΧΡΙΣΤΟΥ

ΣΧΕΔΙΑ ΓΙΑΝΝΗ ΡΟΜΑΝΟΥ

ΕΚΔΟΤΙΚΟΣ ΟΙΚΟΣ
Π. ΔΛΙΚΙΩΤΗΣ & ΥΙΟΙ
ΑΡΙΣΤΕΙΔΟΥ 6 ΑΘΗΝΑΙ

Lorde thow haste apoynted owte my lyfe
In length lyke as a span
Myne age is nothynge vnto thee
So vayne a thyng is Man

Man walketh lyke a shade and dothe
In vayne hym selffe annoy
In gettynge goods and cannot tell
Who shall the same enioye

This myrrour meete for all mankynde
To viewe & still to beare in mynde
And do not mys

For tyme brynges youthfull youthes to age
And age brings Deathe our herytage
When gods will ys

Consyder man howe tyme doth passe
And lykewyse knowe all fleshe is grasse
For tyme consumes the strongeste oke
So deathe at laste shall stryke the stroke
Thoughe lustye youthe dothe bewtye beare
Yet youthe to age in tyme doth weare
And age at length a death will brynge
To Ryche, to Poore, Emprour, & Kynge
Therfore still lyue as thow sholdst Dye
Thy Soule to saue from Ieopardye
And as thow woldst be done vnto
So to thy neyghbour alwayes doo
The heauenlye Ioyes at lenghe to see
Lett fayth in Chryste thyne Ancor bee

The Lorde that made us knoweth our shape
Our moulde and fashion iuste
Howe weake and frayle our nature is
And howe webe but duste

And howe the tyme of mortall men
Is lyke the wytherynge haye
Or lyke the flower righte fayer in feilde
That vadethe soone awaye

appeared to be an integral part of the concept of fertility and that, therefore, it was logical to deify the third aspect of existence which, after birth and growth, or spring and harvest, was death: the fallow months of winter. On another plane, the philosophical equivalent of this agricultural idea was the cyclic nature of beginning and end. It recognized the existence of a continuity greater than that implied by individual existence. Once again, we can identify in this an idea which took mythological guise but which was, at the same time, fundamental to the growth of coherent society. Only in such a framework would it be possible to give value to the lives and doings of future generations as yet unborn, and to ensure, for them, the conditions necessary for survival. The acceptance of death for the individual but life for mankind is, at root, the bed-rock belief which makes society possible.

But the celebration of death also ties another knot. In its inhuman grandeur it looks to the future. Yet it also stabilizes the past and gives it value. The heroic actions of men past

101 (left) MEMENTO MORI. An English painting, c.1610 (City of Norwich Museums: photograph by Hallam Ashley)

102 (below) A figure from Eisenstein's film *Que Viva Mexico*, 1931 (National Film Archive)

103 (right) A Spring festival 'resurrection' figure from Czechoslovakia. It is hung with fertility symbols (National Museum, Prague)

ensure the future and, at the same time, claim a memorial. What is more, they call forth compassion. This compassionate memorializing is something which art can do and which is a most moving part of the social function of culture.

The illustrations on page 94 show a series of war memorials from towns and villages in Wales. After the First World War these sprang up in every community in Britain: similar works were erected throughout Europe. They symbolized, at the time, a vivid sense of loss. Today their impact is more gentle. The striking thing about them is the lists of names. They are carved in stone or cast in long-lasting bronze. The durability of the materials is the essence of their meaning. They, like all monuments to the dead, exercise a strong fascination. Through them, we are assured of the continuity of life and the valuable quality of human striving.

Even a memorial to someone quite unknown and apparently unimportant is capable of touching a nerve and thus of expanding our own sense of time and locality. Here is the inscription from a Roman tombstone found in the north-east of England:

To the deified souls of the dead [and to the deified soul of] Aurelia Aia, daughter of Titus, born at Solona [in Yugoslavia], Aurelius Marcus [soldier] of the Century of Obsequens [erected this] to his most holy wife who lived 33 years without any stain.

The connexion is made and the picture of humanity enlarged.

104 The gigantic Sphinx at Gizeh. Egyptian, Fourth Dynasty (Egyptian Ministry of Tourism: photograph by S Afifi)

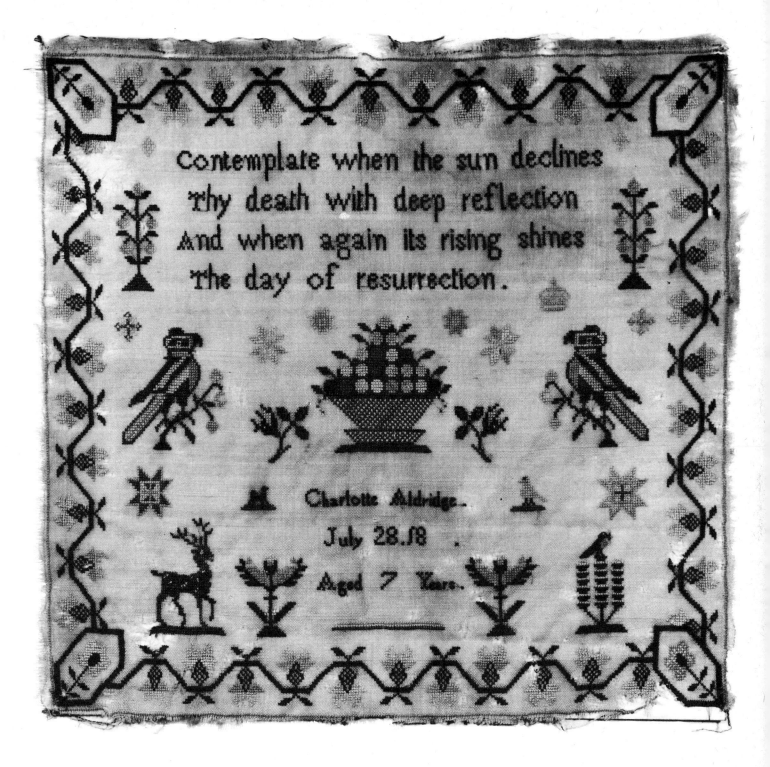

105 A sampler embroidered by Charlotte Aldridge in 1818 when she was seven years old (City Museum, City of St Albans)

106 (left) A memorial stone commemorating a warrior. Indian, seventeenth or eighteenth century (Vikram Dalal)

107 (above) RESURRECTION: TIDYING by Stanley Spencer, 1945. Writing of another painting in the same series Spencer said: 'I have tried to suggest the circumstances of the resurrection through a harmony between the quick and the dead, between the visitor to a cemetery and the dead rising from it' (City Museum and Art Gallery, Birmingham)

108 (right) Sign outside the Forest Lawn Memorial Park in the United States (Picturepoint, London)

109 A German pipe decorated with
a man and woman making love.
Even in the nineteenth century,
when sexual hypocrisy was at its
height, small personal utensils for
men – canes, snuff boxes, toilet
articles – were frequently decorated
with scenes which in other contexts
would have been thought indelicate
(Victor Arwas: photograph by
Chris Ridley)

Part Three
SEX

Great God of love, I crave of thee
If ever again I lay her low,
Ne'er let my lance untempered be,
Not all can nick it that will, heigho!

by the French poet François Villon (1431–1485)[1]

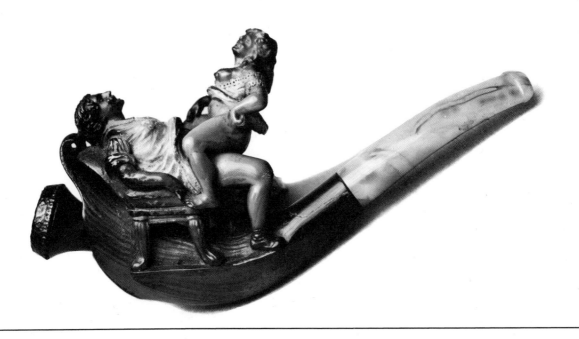

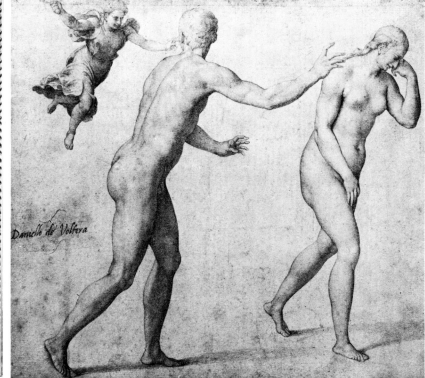

110 A terracotta lamp said to have been used for the ritual defloration of virgins. This Tantric object comes from Bastar State in India. (Gulbenkian Museum of Oriental Art, University of Durham)

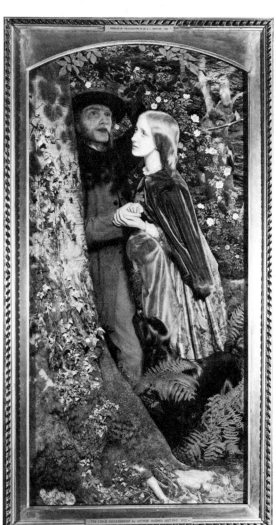

111 (left) THE LONG ENGAGEMENT by Arthur Hughes, 1859 (City Museum and Art Gallery, Birmingham)

112 (below) EXPULSION OF ADAM AND EVE FROM THE GARDEN by Daniele Ricciarelli (Whitworth Art Gallery, University of Manchester). Both the nineteenth-century painting and the Renaissance drawing demonstrate something of the negative attitude to sexuality thought admirable in the majority of Christian societies

The relationship between art, sexuality, and society is a particularly potent and subtle one. An analysis of it shows most clearly how art is involved in defining and communicating the morality developed by a particular society. It shows how art helps to build and make real the ideal images of 'male' and 'female' to which individual men and women try to conform. And it shows how art is used to locate and describe the place of sexuality in the broader picture of the world, the community, and the family.

What we are particularly concerned with here is to explore the emphasis given to the meaning of sexuality in different cultures, and to see how art embodies that emphasis in a variety of forms, media, and styles.

From the critical point of view, the aim is to focus on the function of art in determining the content of men's and women's lives. Sexuality is of special importance in this respect because it is at once so intimate and yet so closely controlled by social custom and morality.

Although some of the most gorgeous works of art have been made to provide a direct erotic stimulus, this is not necessarily the most significant role of art in relation to sexuality. The wider interpretation of the sex act, and of events like puberty, menstruation, and birth, within a system of cultural elaboration, has absorbed far more attention. When we look at various interpretations of the sex act, we can see at once how drastically such an experience is moulded by culture.

Perhaps the most dramatic comparison possible is that between a religious discipline which embraces copulation within itself, and one which rejects it as basically inhuman or evil. In these circumstances the meaning of sexuality for the initiate is completely transformed. In his introduction to the catalogue[2] of the London *Tantra* exhibition, Philip Rawson explained the role of orgasm in the religious development of Tantric holy men:

[Hindu Tantra cultivates] activities aimed especially at arousing the libido, dedicating it, and ensuring that the mind is not indulging in mere fantasy. All the concrete enjoyments and imagery are supposed to awaken dormant energies, especially the energy which normally finds its outlet in sexual intercourse. The energy, once aroused, is harnessed to rituals, meditation and yoga, turned back up within the human energy-mechanism, and used to propel the consciousness toward blissful enlightenment. Orgasm is in a sense an irrelevance, lost in the sustained and vastly enhanced inward condition of nervous vibration in which the union of the energies of man and world are felt to be consummated, their infinite possibilities realized virtually on the astronomical scale of time and space.

It is extraordinary how closely this picture of the positive function of sexuality echoes, but as a mirror-image, the positive function of chastity for the Christian mystic. In both cases the physical state is part of a regime leading towards enlightenment, and experienced as such by the seeker after wisdom. Ecstasy and transcendence attend both disciplines, but both are somewhat inaccessible or

mysterious to those caught up in a more everyday kind of existence. In *Tantra*, Rawson quotes, from an esoteric text called the *Karpurādistotram*, the following hymn-like words:

O Goddess Kālī, he who on a Tuesday midnight having uttered your Mantra, makes an offering to you in the cremation ground just once of a [pubic] hair from his female partner [Sakti] pulled out by the root, wet with semen poured from his penis . . . [he] becomes a great poet, a Lord of the World . . .

Such imagery, fostered with reference in Tantric art, would be the uttermost blasphemy in Christian iconography. The sensual energy of Tantric sculpture contrasts violently with the asexuality of much Christian imagery. In literary terms we think, for example, of the early chapters of St Teresa's *Life*, where she expresses her horror of sensuality and her rejection of the idea of earthly marriage. In the Christian framework, sexuality does not present the possibility of a path towards God: virginity does. In Tantra, liberation through sexual ecstasy is an essential step on the way.

Such polarities could be explored at great length. A more domestic, but equally dramatic example, is provided by comparing Victorian attitudes to adolescence and awakening sexual feelings with our own. We live in a post-Freudian age where the sexuality of children is widely recognized and discussed in the mass media. As a result, an activity like masturbation is no longer regarded with horror. It is seen as a perfectly normal part of growing up. Only in excess is it thought to be dangerous and, even then, it is not castigated as 'wicked'. The Victorians thought quite otherwise.

In *The Other Victorians*,[3] Steven Marcus drew a careful portrait of conventional nineteenth-century morals. We are by now well enough aware of Victorian middle-class inhibition and hypocrisy, but he saw the same phenomena in a more understanding light. In describing the prevailing horror of masturbation he identified not so much hypocrisy as a tragically complex mixture of attitudes leading to agonies of personal guilt. In a very direct sense, culture was affecting the concept which the individual had about the nature of his activity and the resulting experience.

In his book, Marcus used the work of William Acton as an example of the moral flavour of the period. Acton was a distinguished doctor who wrote an enlightened study of prostitutes but also produced a work which contained savagely repressive material on juvenile sexuality. This was called *The Functions and Disorders of the Reproductive Organs*. In the following paragraph Marcus discusses Acton and quotes from him:

Acton continues his observations by saying that the chief danger in early intellectual development is that boys will read works, expecially 'classical works', which are almost

'certain to excite sexual feelings'; and although he has no wish to be 'prudish or to believe that boys can or ought to be altogether kept from the risk of reading improper stories or books', the dangers of such a course must be faced.

Next Marcus quotes a whole section from Acton:

He reads in them of the pleasures, nothing of the penalties, of sexual indulgences. He is not intuitively aware that, if the sexual desires are excited, it will require greater power of will to master them than falls to the lot of most lads; that if indulged in, the man will and must pay the penalty for the errors of the boy; that for one that escapes, ten will suffer; that an awful risk attends abnormal substitutes for sexual intercourse; and that self-indulgence, long pursued, tends ultimately, if carried far enough, to early death or self-destruction.

This is a bleak landscape, the reality of which we can only half imagine, or glimpse through the more robust folklore of our own childhoods. Marcus's vision of the interlocking cultures of repression and guilty satisfaction is appallingly convincing. It leads one to look with more sympathy on Victorian pornographers than on Victorian moralists, though the significant thing is that nineteenth-century culture produced the work of both and ground out the content of the individual imagination between the two. Marcus sees these two – restrictive moralists and pornographers – as being totally interdependent, the one the inevitable outcome of the other in a culture of guilt.

Marcus's own comment on these aspects of Victorian sexual culture reflects directly the theme of the present book. 'What,' he asks; 'at a given moment in the history of culture, is the nature of "observation"; and correlatively what is the nature of "experience"?' Drawing on his research, he gives this answer: 'Both observation and experience are extremely selective, that is, extremely preconditioned, processes'.

113 The illustrations are from the cover of a nineteenth-century magazine called *The Laughable Adventures of the Single Man Lodger* published by R March and Co. Such generally available publications were on the fringe of the vast world of Victorian pornography (John Johnson Collection, Bodleian Library)

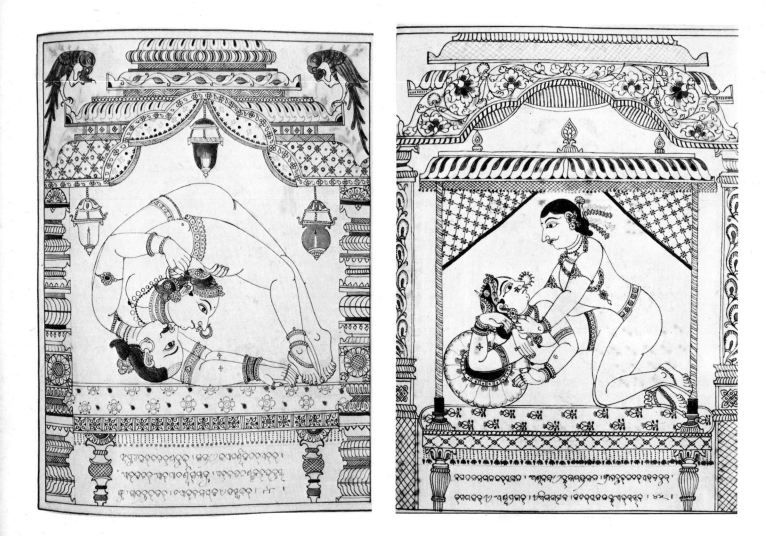

Take, as a further example, the representations of sexuality shown on these pages. Each reflects not only the visual style of the culture from which it comes, but also varying attitudes to sensuality and lovemaking. The ecstatic fleshiness of the European material contrasts strongly with the carefully ordered formality of the Japanese print and the graphic, almost matter of fact explicitness of the Indian manual.

What we have so clearly demonstrated in all these cases is the fact that culture weighs heavily on the individual, controlling the content of his life, and that, as suggested by Ruth Benedict, selectivity is an integral part of the function of culture. It is this phenomenon that makes coherent society possible. Clearly, at various times and in various places, societies have been able to tolerate the most violently differing aspects of sexuality and to value them. It has not been possible to value them all at the same time in a single society.

Ruth Benedict was careful to distinguish between the simple, static cultures which

114–115 Two from a series of drawings showing the postures of Love. Indian, from Orissa, nineteenth century (Private collection/Oriental Institute, Baroda)

116 Covers of American science fiction magazines (Eduardo Paolozzi: photograph by Chris Ridley)

117 An Italian sculpture called YOUNG SLAVE GIRL by Fortini, c.1895 (Victor Arwas: photograph by Chris Ridley)

118 A Japanese woodcut by Harunobu (Private collection)

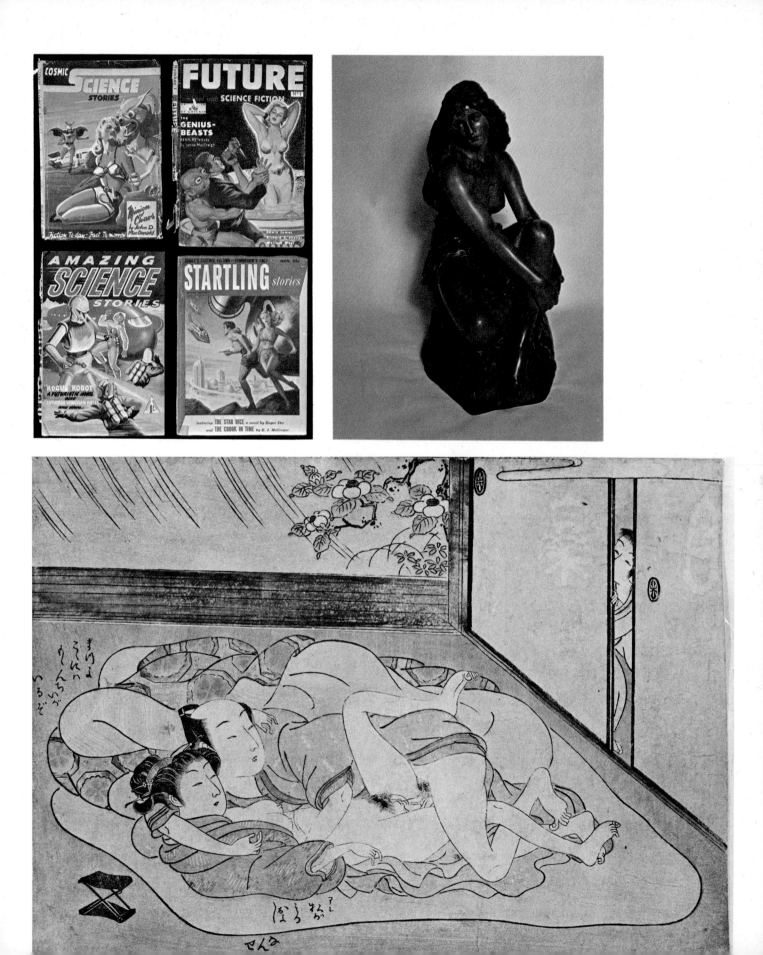

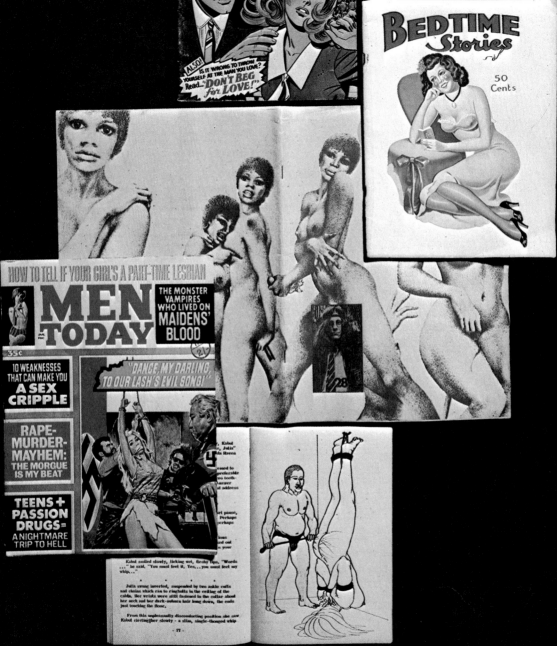

have been studied by anthropologists, and our own pluralistic, constantly evolving society.

But it is easy to see how social groups and classes mirror the same kind of selectivity and how, even while containing tremendous variety, certain themes are emphasized by our society as a whole. And it is not only overtly sexual themes that affect sexuality. General philosophical changes are important, as are changes in economics. In the course of the past hundred and fifty years, for example, we have partly dismantled the Christian superstructure of the after-life and built a humanist/pagan one celebrating youth. In the same way, we have enormously magnified and ritualized the importance of technology and monetary values while trying to change (with little success) from a culture of war to a culture of peace. As we shall see, all these things are reflected in our attitudes to sexuality and in the words and images that we use to support and make them effective.

What the remainder of this part of the book sets out to do is to put our own particular attitudes into perspective and into the context of other attitudes and times. The three sub-sections, 'Gods and Goddesses', 'Men and Women', and 'Dreams' represent broad categories, but they stand for radically different basic interpretations of the significance of sexuality. Thus they show the selectivity of cultures, and the astonishingly wide range of possible human responses. The intention throughout is to illuminate the use of culture in defining the image of man and woman and, therefore, its effect on individual lives, in the past and in the modern world.

119 (far left) Contemporary English and American magazines on romantic and sexual themes. In the centre is a spread from *Schoolkids Oz* (Ken and Kate Baynes: photograph by Chris Ridley)

120 (left) Russian poster showing a woman munitions worker. It is by A Kokorekin and was produced in 1942 (Imperial War Museum)

121 (right) A stocking with the slogan 'Votes for Women' used by the British suffragettes (The London Museum)

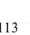

SEX: Gods

The force that through the green fuse drives the flower
Drives my green age; that blasts the roots of trees
Is my destroyer.
And I am dumb to tell the crooked rose
My youth is bent by the same wintry fever.

from a poem by Dylan Thomas[4]

The next verse of the poem by Dylan Thomas quoted at the head of this chapter begins 'The force that drives the water through the rocks/Drives my red blood . . .' It takes us to the centre of one of humanity's most profound feelings: that there is a harmony of energy between men and nature. In terms of sexuality, it is extremely ancient. As already suggested in Part Two, it must have been born as the natural and logical feeling of hunters and farmers that the fertility of man and the fertility of the world were inextricably the same.

Except in terms of poetry and symbol, it has become a most difficult idea for us to enter. Orgies with a serious magical and social purpose are something intensely remote from European thought, and from the whole of technological civilization. The idea of impersonal, indiscriminate sexuality seems to us to be degrading, at total variance with humanist ideals of freedom and individuality. It is hard for us to appreciate a vision in which orgiastic activity would seem an unadulterated good. Only in pornography do we find, in our own culture, a fantastic elaboration of the sexual act as an anonymous end in itself, and here the inversion of social and personal response is complete.

Contemporary pornography is an art of cathartic escape. It relates very precisely to the idea of romantic agony: to the idea of the individual who tastes everything even above and beyond the law. Thus its groundbed is European, and its swollen sexuality is of a piece with other aspects of European expressionism. Pornography is private: the old orgiastic cults were public and social. The comparison is worth pursuing because it provides yet another example of the way in which art and culture inform individual experience.

In her book, *Daily Life in Ancient India*,[5] Jeannine Auboyer insisted on the strong family morality that already existed in Indian society a thousand years ago. It is therefore particularly interesting to look at the survival of what must· once have been genuinely orgiastic festivals, and to try to

122 (left) A YAB-YUM IMAGE OF A TERRIBLE FORM OF THE BODHISATTVA VAJRAPANI IN UNION WITH HIS FEMALE WISDOM. A Tibetan sculpture dating from the sixteenth century (Victor Lownes: photograph by Chris Ridley)

123 (above) Phallic statuettes used as good luck charms. They were made in Egypt during the Graeco-Roman period (Gulbenkian Museum of Oriental Art, University of Durham, Wellcome Collection)

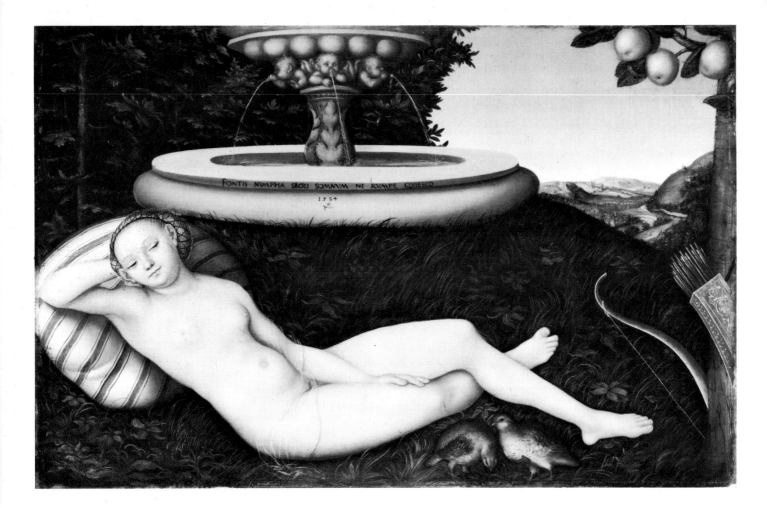

make their meaning clear. Writing of the sequence of public religious celebrations that took place throughout the year, she described the saturnalia (what is today called *Hōli*) which took place every February or March:

[it was] the survival of a primitive fertility ritual, combining erotic games, 'comic operas', and folk-dancing. During the course of these festivities, men and women of every class chased each other through the streets and parks, armed with gold-painted syringes filled with water dyed red or orange, with which they squirted each other indiscriminately. Large urns filled with coloured water were positioned at various points, to allow the participants to recharge their weapons.

Two weeks after *Hōli*, there was another, related festival in which fertility was again the key theme. This time it was the god of love, Kāma, who was the centre of the celebrations:

[it was] an occasion which demanded massed illuminations. And now, too, the swings which had been stored away the previous autumn at the onset of the monsoon were brought out again and set up in every garden. On the third clear day of the month of *Caitra* (March–April), girls and young women competed with each other on the swings in honour of the goddess Gauri; the higher they went, the bigger would grow the new shoots and the finer would be the harvest.

In their swinging, so suggestive of the movements of love, the girls were representing the course of the sun across the heavens. They were copying actions once carried out by the high priest himself. In *Tantra*, Philip Rawson writes of such ceremonies as embodying a philosophy of 'sexual generosity'. Of *Hōli* he says:

[people] once used to sing extremely erotic songs and participate in promiscuous sex, [it] probably symbolizes a kind of generous spreading abroad and exchange of this [creative and beneficial cosmic] energy, when it was at its seasonal height. A connected imagery must have underlain the violently erotic songs and dancing once performed in so many Hindu temples before the divine icon, as well as the custom of religious prostitution which used to flourish widely in India.* In such contexts, as in parallel 'primitive' customs,

*In fact, at a later period than that discussed by Jeannine Auboyer.

124 (left) THE NYMPH OF THE FOUNTAIN by Cranach the Elder, 1534 (The Walker Art Gallery, Liverpool: photograph by John Mills)

125 (above) A still from Fellini's film *Juliet of the Spirits* made in 1965 (National Film Archive/distributed in UK and Eire by Connoisseur Films Ltd)

126 (below) A panel from an ivory toilet box. It is Indian, c.1640, and shows varied scenes of lovemaking (Gulbenkian Museum of Oriental Art, University of Durham)

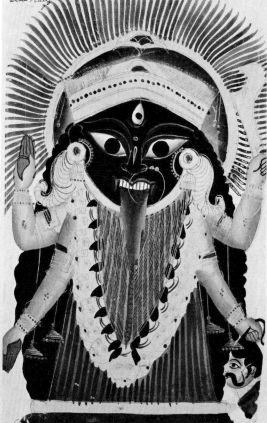

127 (left) A phalliform pillar. It represents an ancestor, 'a dead person in the ground', and comes from Nigeria (Department of Antiquities, Nigeria)

128 (above) OKAME, the Japanese Goddess of mirth, laughs when an old man's nose reminds her of a penis (Victor Arwas: photograph by Chris Ridley)

129 An icon of the terrible Goddess Kālī. From Calcutta, nineteenth century (Victoria and Albert Museum)

the more copious the expenditure of pleasure and sexual juice the better.

Notice how firmly these celebrations were bedded in their social and economic purpose, and how they relate to a broader picture, the cosmos and methods of influencing nature. The impersonality of the orgy had not got anything to do with personal agony or ecstasy, but with the representation of natural forces incomparably bigger than the individuals involved.

It is surely the same kind of framework that Euripides was trying to expound in his great play *The Bacchae*.[6] In it, the possession of the maenads by succeeding periods of blissful peace and apparently sadistic destructiveness is the demonstration both of a psychological truth and of its absorption into the observed reality of wind, rain, sun, and sky. When the herdsman reports to Pentheus what he has

seen of the maenads on the mountain he tells first of their obvious harmony with the natural world: 'They let down their hair over their shoulders; those whose fawnskins had come loose from their fastening tied them up; and they girdled the dappled fur with snakes which licked their cheeks. And some would have in their arms a young gazelle, or wild wolf-cubs, and give them their own white milk – those who had infants at home recently born, so that their breasts were still full. And they wreathed their heads with garlands of ivy and oak and flowering bryony.' But the violence which he then saw was also meant as a harmony with nature: this time with death and rending force rather than tender motherhood. The Bacchae fall on a herd of cattle and tear them with their bare hands: 'You could see Agauë take up a bellowing young heifer with full udders, and hold it by the legs with her two arms stretched wide. Others were tearing our cows limb from limb . . . and bulls, which one moment were savagely looking along their horns, the

119

next were thrown bodily to the ground, dragged down by
the soft hands of girls . . .'

When pursued the Bacchae cry:

Come, Dionysus!
Come, and appear to us!
Come like a bull or a
Hundred-headed serpent,
Come like a lion snorting
Flame from your nostrils!

Swoop down, Bacchus, on the
Hunter of the Bacchae·

Smile at him and snare him:
Then let the stampeding
Herd of the Maenads
Throw him and throttle him
Catch, trip, trample him to death!

The images which this calls to mind may be alarming in the
extreme. But they are not really reminiscent of the unbridled
violence of much contemporary pornography. Euripides is
building a universal symbol, not a sexual fantasy.

It is no accident that De Sade appears as a kind of 'father' of
modern pornography. It is not so much that violence is the

130 (below) THE RAPE OF THE SABINES, a drawing by Ceri Richards, 1947
(Marlborough Fine Art (London) Ltd/Frances Richards)

131 (right) A Roman phallic ornament with bells dating from the first
century. It is thought that these beautiful little bronze mobiles may have
been charms to be hung in gardens to bring good luck and fertility (British
Museum)

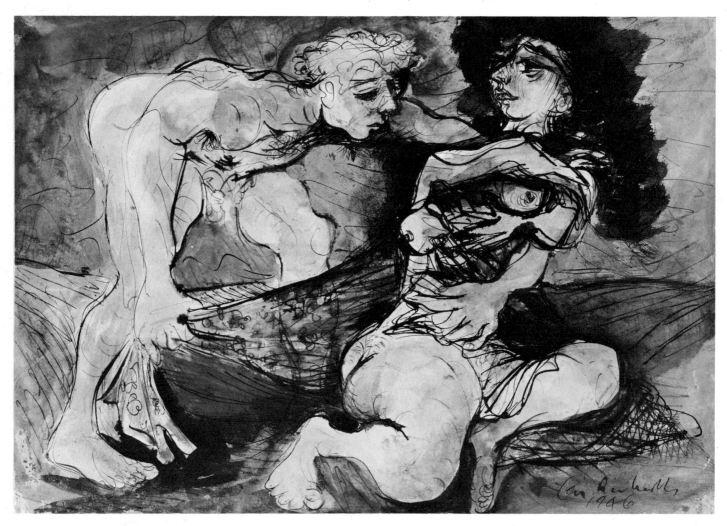

key to all such dreams, but that De Sade links his use of violence with an elaborate philosophy of individual satisfaction; one which rejects all duty and concern for others in the pursuit of the most extreme experiences for the self. The romanticism of the idea is at once recognizable, as is its ultimate aridity and rejection of life.

The viewpoint in pornography is not principally that of the characters, or their response to what it is that is happening to them, and absolutely not their relation to the world. In a very extreme way, the central character in pornography is the reader and his satisfaction with the dream world which is being created. It is this that explains the flimsiness of plot and the lack of individuality of the people in most pornographic words and pictures. They are not supposed to have personal attributes: if they did, the fantasy of total self-satisfaction would be destroyed.

This does not mean that pornography is inevitably aesthetically bad or culturally insignificant. Long before the present debate about its effects, Richard Hoggart, in *The Uses of Literacy*,[7] carefully identified and described the power and nature of mass-produced sex and violence novels, and even himself invented (because of copyright difficulties) a characteristic passage. Saying that 'the gangster writers have to ensure the thrill is actually communicated' he effectively showed us what he meant:

By now her dress was torn down to the stomach and her négligée ripped and soiled. As her almost naked breasts rose and fell, Lefty, from near the stove, watched out of the corner of his eyes and every so often spat deliberately into the embers. After a while the red waves of pain began to overwhelm her, but just before she went under she saw Lefty get up with a horrible look in his eyes . . . She began giving little agonized gurgling sounds and her legs twitched in spasms.

Similar scenes of violent rape have become a classic of the mass media, repeated endlessly in magazines, novels, and films. Their effect is significant, but quite unlike the orgiastic sexuality of the old agricultural cults or the bloody frenzy of the maenads. Here there is no outward-facing window onto

132 (left) VIETNAMESE BROTHEL, a photograph by Philip Jones Griffiths from his book *Vietnam Inc*. It is striking how a realistic photograph of this kind, showing what is a stock situation in pornography, can divest the subject of any glamour and show instead the terrible reality of such a breakdown of human relations (Philip Jones Griffiths/Magnum)

133 (below) Back cover and spreads from contemporary American comics which deal with sex, violence and a variety of unpleasant and obscene situations. These magazines seem to combine an element of satire with a genuinely raw edge of sadism. They are frequently brilliantly drawn (Eduardo Paolozzi: photograph by Chris Ridley)

reality, only an inward-facing, private stimulation. Hoggart wrote:

With the gangster-fiction writing we are not aware of a larger pattern. We are in and of this world of the fierce alleyway-assault, the stale disordered bed, the closed killer-car, the riverside warehouse knifing. We thrill to those in themselves; there is no way out, nothing else; there is no horizon and no sky.

The contrast is absolute. When embodied in positive cultural forms, the sexuality of fertility religions is inevitably all horizon and all sky. Where sex, suffering, and death come together it is a part of the vast cyclical nature of the seasons.

Sex in pornography is disintegrated: while it could still be seen as a part of the natural world it was integrated on the highest possible level, relating the sexual act of man the individual, to the general and underlying spiritual sexuality of the universe. When man's sexuality could become simply his own moral burden and not a gift which, in pagan cultures, he shared with gods and goddesses, the way was open for this great force to be embodied not only in marriage but in a corrosive context of public guilt and private satisfaction.

134 (left) A contemporary bookshop in Old Compton Street, London, photographed by Chris Ridley

135 (below) Girls taking part in a Festival of Light demonstration in London. It was directed against pornography. Photograph by J Koudelka (J Koudelka/Magnum from the John Hillelson Agency Ltd)

136 Detail of a plate from a series of lithographs showing alleged German atrocities in the First World War. It was produced as propaganda during 1915 (Imperial War Museum)

138 (left) A standing stone at Porthgain in Pembrokeshire, Wales. Such stones, which were erected in many parts of Europe in the Bronze age, were probably intended to encourage the gods who controlled the fertility of crops and animals: often farmers still plough round them carefully and leave them standing. Photograph by Roger Worsley

139 (above) HERCULES. This enormous figure cut in the chalk downs of Dorset in Southern England is known locally as the Cerne Abbas Giant. It dates from Romano-British times and is one of the most obviously priapic European god-images still in existence from early times. Above his head is a flat area called the 'Frying Pan' where maypole dancing used to take place at Easter. Photograph by Roger Worsley

140 (right) The horned forecourt of a chambered tomb at Belas Knap in Gloucestershire, England. It is thought that the portal probably represents the vagina of the Earth Mother Goddess. In the neolithic period this was the actual entrance: in later times, as here, the main portal was false and the actual burial was in small chambers set into the side of the mound. Photograph by Roger Worsley

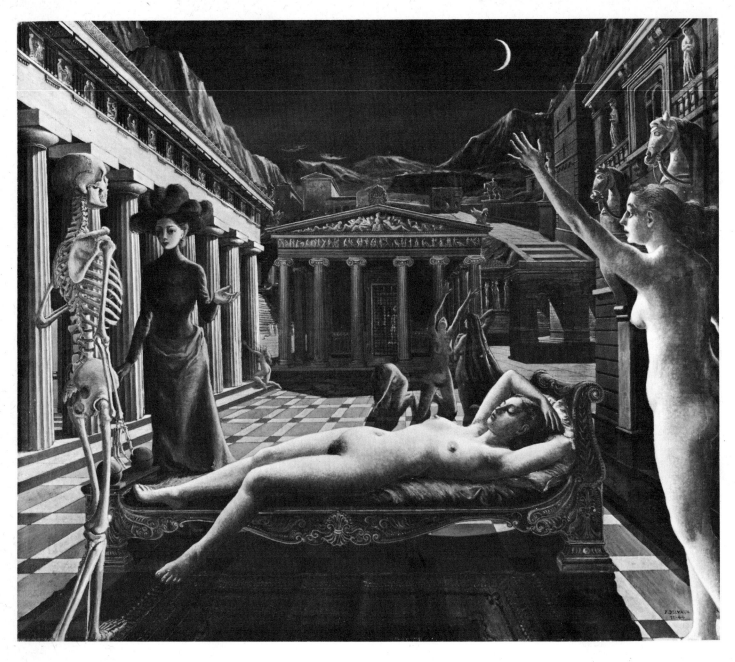

141 (above) VENUS ASLEEP by Paul Delvaux, 1944 (Tate Gallery, London)

142 (right) Adam and Eve painted on a Lambeth delftware dish or charger made about 1690 (City of Museum and Art Gallery, Birmingham/Taylor Bequest: photograph by Chris Ridley)

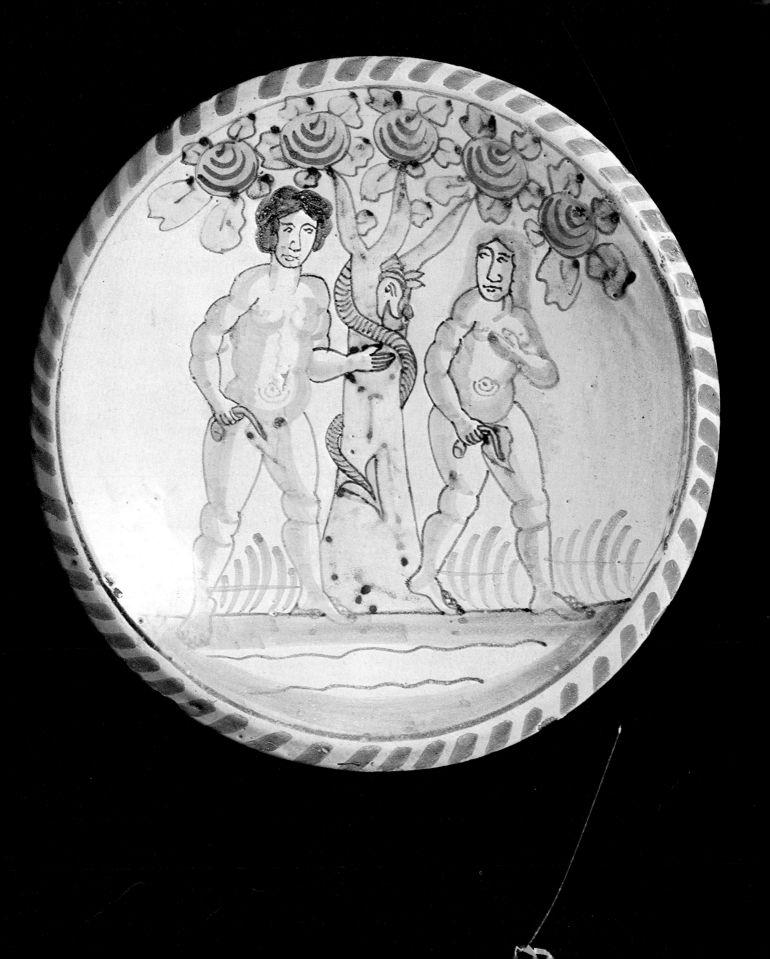

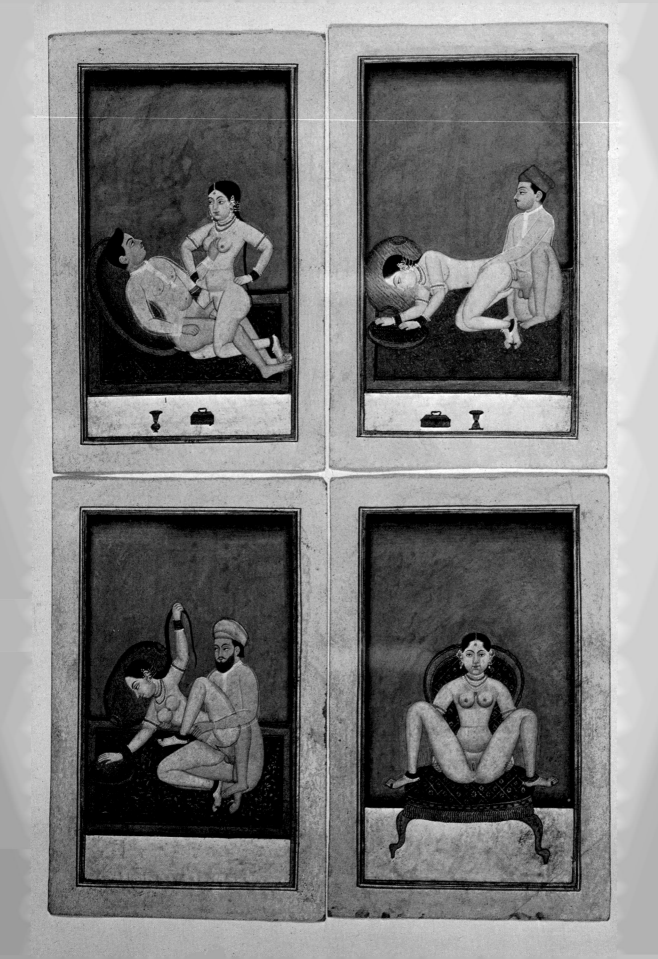

SEX: Men and Women

I am he, you are she, you are she, I am he;
I am the sky, you are the earth;
I am the song, you are the verse.
Come, we shall marry and give children to the world!
Loving, agreeable, joyful in heart,
may we live for a hundred autumns!

words to be spoken by the bridegroom at an Indian
wedding about a thousand years ago[8]

143 (left) Illustrations from a series of paintings demonstrating love
postures. Small 'instructional' paintings of this type are common in Indian
aristocratic culture. Often they are fine aesthetically: they always lack any
element which could be described as pornographic

144 (above) A poster by Herb Lubalin for a competition sponsored by the
Visual Graphics Corporation in the United States (Icograda Audio/Visual
Archive, Bolton)

The most familiar interpretation of human sexuality is that
which sees it as the high point in the relationship between
man and woman. Here art is involved not only in making
vivid the style and conventions of the relationship, but in
developing the images of 'male' and 'female' through which
people see their own identities. In all cultures this definition
of gender is important. Clothes, ceremonies, and
entertainment combine to point up the customary
differences of behaviour and attitude expected from men and
women. By doing so, they help to determine how men and
women actually act, and how they experience the reality of
their own and each other's sexuality.

It is in marriage ceremonies that the social function of art in
relation to this interpretation of sexuality is most clearly and
movingly displayed. A wedding is a ritual meeting between
the couple and the community and, in the majority of
societies, it marks the culminating point where fully adult
roles – male and female – are given and accepted. Sexuality
and gender in this setting are interpreted in a very complete
sense. They are seen as an aspect of development and
maturity: as part of a serious and responsible life.

In terms of marriage, the present century is imbued with an
interpretation of sex which sees it primarily as a high point
in the relationship between two lovers, leading to the
establishment of a family group. This is the idea which
underlies a vast production of popular culture, which guides
much of our behaviour, and which helps to construct our
relationships. But it is important to recognize that this is not
the only interpretation of marriage possible. In other places,
at other times, art has been just as effective in expressing
other ideas and alternative sets of moral values.

Marriage takes on the colour and preoccupations of the
society in which it is located. It adapts to the character of the
prevailing practical and spiritual requirements. Such basic
economic and social contrasts as that between monogamy

and polygamy profoundly affect the content of marriage and the folklore and customs which surround it. Whether inheritance is matrilinear or patrilinear changes the image of man and woman, and their response to one another. In the past two hundred years, a series of hard-won feminist victories concerning the rights and status of women has transformed the balance of activities within marriage. One result has been to alter completely our understanding of the Christian marriage ceremony. Its present religious and secular significance contrasts sharply with that which it had when women were legally subservient.

Even although the conventional 'European/American' family remains the fundamental unit of all industrially advanced countries, it no longer contains so exclusively the images of the soft and 'helpless' woman and the hard and breadwinning man. These were the roles as defined by European bourgeois culture and they depended on the continuance of the economic and spiritual realities of nineteenth-century middle-class existence. They are far from universal. There exist societies where exactly the opposite polarity would be true. In fact, the possible roles for men and women in the community, and in relation to each other, seem practically unlimited in their variety except that it is men who have to provide the sperm for intercourse and women who have to nurture the foetus in their bodies.

But society selects from this variety what it will value. It is a further example of the essential selectivity of culture. In this case, the function of the selectivity is to make possible a coherent relationship between men and women and to provide a comprehensible framework for behaviour, whatever it may be in that particular society.

A society like that of the Dobu in Melanesia, where cunning and treachery were highly regarded virtues, naturally presented the relationship between men and women in the same terms. Marriage in that particular matrilinear culture was far from being a matter of trust or companionship. The husband and wife distrusted and feared one another and he often suspected that she was trying to bewitch or poison him. Marriage was grudgingly undertaken in an atmosphere of mutual recrimination. Here is how Ruth Benedict, in *Patterns of Culture*,[9] described the betrothal ceremony, speaking first of the bridegroom to be:

Nevertheless he is never thought of as being ready to undertake the indignities of marriage, and the event is forced upon him by the old witch in the doorway, his future mother-in-law. When the villagers, the maternal kin of the girl, see the old woman immobile in her doorway, they gather, and under the stare of the public the two descend and sit on a mat upon the ground. The villagers stare at them for half an hour and gradually disperse, nothing more; the couple are formally betrothed . . . Immediately his mother-in-law gives him a digging-stick with the command 'now work'.

But compare this with the meaning of marriage in a society where duty is all important and where the role of the wife is, in an essential sense, defined by that of her husband. These

145 Decoration from a pyxis showing a Greek wedding procession. It is by the 'Marlay Painter', c.440 BC (British Museum)

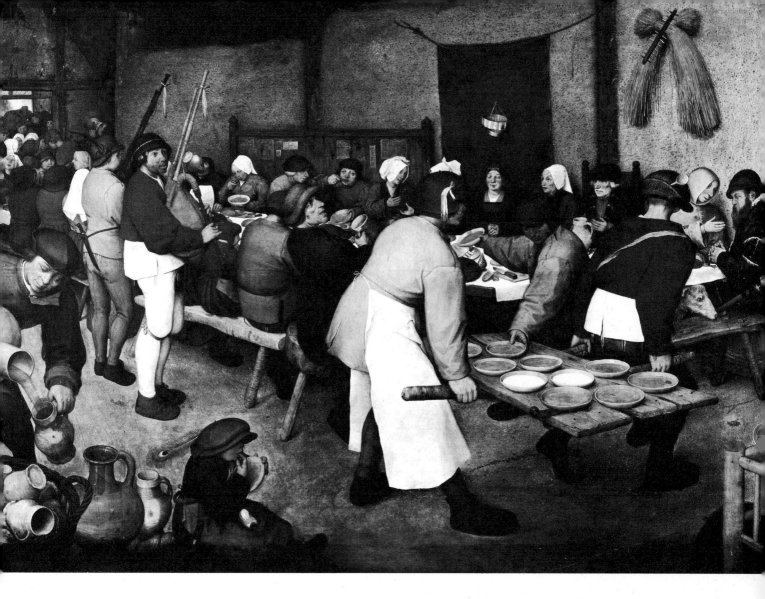

146 PEASANT WEDDING by Pieter Bruegel, c.1567 (Kunsthistorisches Museum, Vienna)

147 A cartoon from the immensely popular ANDY CAPP series by Reg Smythe which appears regularly in the London *Daily Mirror*. This newspaper is Britain's best-selling tabloid (*Daily Mirror*)

134

148 (left) A Japanese woodcut showing a portrait of a 'famous virtuous woman'. It is from a series in a version of *The Story of Kenjo Reppunden* by Ichiyusai Kuniyoshi (1798–1861). All the women illustrated did their duty and defended their honour in a variety of demanding situations (City of Sheffield Art Galleries)

149 (right) BRIDAL GROUP, a ceramic sculpture by Arnold Machin made by Wedgwood in 1945 (The Art Gallery and Museum, Brighton)

were the conditions traditionally found in Japan where, as well, the concept of suicide as an honourable act was highly developed. What follows is a letter from a wife to her husband who is about to leave for the war. It dates, not as one might imagine, from the days of the Samurai, but from the period immediately preceding the Second World War and is taken from a book on the *kamikaze* volunteers by A J Barker called *Suicide Weapon*.[10] The wife has donned her wedding kimono, and when the letter is finished she cuts her throat:

To my dear husband:

My heart is filled to the brim with gladness. I cannot find words to congratulate you. Before you depart for the front tomorrow, I leave this world today. Please do not worry about your home, for there is no longer anything to make you worry. Powerless as I am, I am doing what little I can so that you and your men may fight with heart and soul for the country. That is all I wish and no more.

Thanks to your kindness, my life has been happy. Though this world is ephemeral, the next world, it is said, is eternal. Some day you will come to join me there. I shall be waiting for you.

They say it is very cold in Manchuria. Please take care to keep warm. I enclose herewith forty yen. When you reach the front, please distribute it among the soldiers.

I pray for your success.

Your wife.

Even within concepts of marriage that seem to us to be less remote, there is likely to be discontinuity. Take, for example, the splendid marriage formula quoted at the head of this chapter. It is spoken by the bridegroom at a wedding in India over a thousand years ago:

I am he, you are she, you are she, I am he;
I am the sky, you are the earth; I am the song, you are the verse.
Come, we shall marry and give children to the world! Loving, agreeable, joyful in heart, may we live for a hundred autumns!

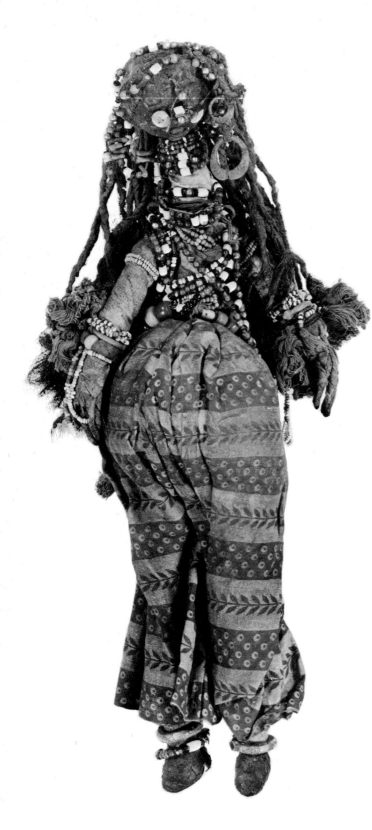

150 (left) A maternity doll from the Sudan, c.1880 (Museum of Childhood, Edinburgh)

151 (top right) A still from the film *Sunday Bloody Sunday* directed by John Schlesinger, 1971. The film explores a triangular relationship. The central figure is the young man who has homosexual relations with the older doctor and heterosexual relations with the younger woman. Both are afraid of losing him (National Film Archive/United Artists)

152 (bottom right) High romance! A still from *Gone With the Wind* directed by Victor Fleming in 1940 (National Film Archive/MGM/EMI)

153 (far right bottom) A WOMAN LEADING HER SHEEP HUSBAND. This cheap bazaar painting from Calcutta illustrates an Indian proverb and reflects the power of the wife in Indian society (National Museum of Wales, Cardiff)

The flavour of this seems very accessible. It states clearly the conjunction between mutual love and children and has, in addition, an element of ecstatic poetry which links with our own ideas of romance. The transcendental imagery 'I am the sky, you are the earth' strikes us as a justifiable hyperbole to describe the feelings of the lovers in their state of heightened awareness: their state of being 'in love'. In Western terms, it is like Romeo saying to Juliet 'The more I give you the more I have' or Donne's extravagant simile for the body of his mistress 'O my America my new-found-land . . . My Myne of precious stones.' But, by itself, this interpretation is surely wrong or, at least, incomplete. We are seeing too much of our own tradition, not enough of India. We lay too much emphasis on personal poetry and romance at the expense of wider family duty and religion.

At that time, religion suffused every aspect of life in India. Outside the cities, and apart from the courtly existence led by a small minority for whom sexual adventures were a central part of life, family morality was very strict. Promiscuity was frowned upon. A tight network of responsibilities bound every member of a family to every other and, through these relationships, to the community at large. Here is how Jeannine Auboyer described the wife's role in such an Indian family:

The mistress of the house, too, was an important figure, with considerable influence and standing in the family circle. She was the first to surround her husband with marks of respect and, when addressing him, always called him 'son of the venerable (father-in-law) . . .' She treated him as her master and tried to fulfil his every wish. In return, he treated her, simultaneously, as wife, mother, friend, and adviser. As soon as she had borne him a son, it was the fact of her motherhood that was uppermost in the consideration of the whole 'clan', for now she incarnated the family hearth . . .

In that society, the most everyday activities – dressing or cooking, for example – had their ritual forms. Inevitably, therefore, the most intimate details of sexual behaviour were

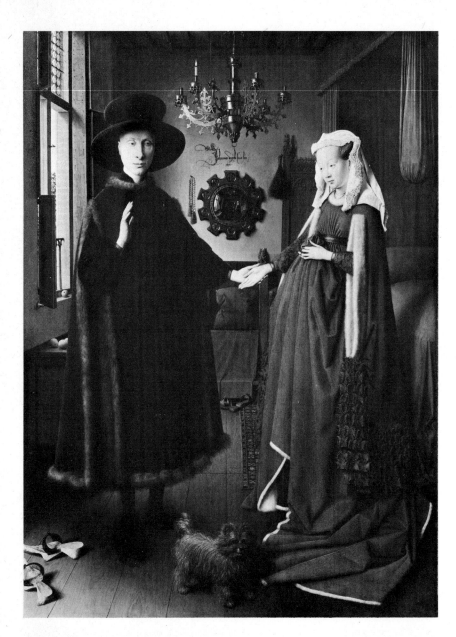

154 (left) THE MARRIAGE OF GIOVANNI ARNOLFINI by Jan Van Eyck, 1434 (The National Gallery, London)

155 (above) THE GREENGROCER'S STALL by Thomas Rowlandson, 1805 (City Museum and Art Gallery, Birmingham)

156 (below) A knitting-needle holder, given in Wales as a love token. Such presents were not only charming in themselves: they also symbolized the economic role of the girl who received them (Welsh Folk Museum, St Fagans)

also prescribed. They were related to the great scheme of the universe and to the journey of the individual soul through successive reincarnations. The couple, at their wedding, could not but acknowledge their inheritance of this pattern, and the place of their relationship within it. Their lives encompassed the personal tie of husband and wife but they saw it absorbed into an accord with the necessities of religion and duty towards society.

The same grand perspective traditionally occurs in the Christian wedding service where the state of matrimony is presented as a sacrament ordained by God for the furtherance of mankind and the human community rather than as a vehicle for romantic satisfaction. In ancient India, as in Europe in most centuries past, the normal circumstances of marriage were as much dynastic and economic as romantic. But this did not mean that bride and groom entered the relationship unwillingly, or that they were inevitably unhappy as a result of being chosen for each other by their families. Quite the contrary. The intersection of duty and affection must have been especially poignant in a way which it is now hard for us to understand.

Christina Hole gave an insight into the terms and experience of these 'planned' marriages in her book *The English Housewife in the Seventeenth Century*:[11]

When so many financial and social questions had to be considered [lands, social position, inheritance, dowries, etc.], it was perhaps inevitable that the whims and fancies of the two most nearly

concerned were somewhat lightly regarded. The children of the poor might marry for love, for no property was likely to change hands in consequence, but with the gentry it was far otherwise . . .

However, there were safeguards:

It is true that it was not customary to force an unwilling child into a really distasteful union, and when such a thing did occur it was frowned upon by public opinion . . . Dr Fuller [in *The Holy State and the Profane State*, 1642] . . . strongly advised against such marriages because 'Tis to be feared they that marry where they do not love, will love where they do not marry'.

And she went on:

If all this seems inhuman and mercenary to us now, it was not so regarded then. It was a father's sacred duty to settle his children in life as well as possible, and the earlier he did it the better. If the two young people were attracted to each other before the wedding, that was all to the good, but it did not really matter very much. Marriage on its personal side was not an affair of fancy but of religion and duty, loving-kindness and good faith . . . in the result it seemed that these apparently cold-blooded notions were justified. Nothing in the letters and diaries of the time is more notable than the strong marital love and confidence which their pages so often enshrine.

The picture which a culture presents of marriage is one of the main ways in which participants understand what it means to be a man and a woman. The ceremony – the formal moment – is the apex; but a small amount of reflection will serve to show that every culture is saturated with material which illuminates the nature of gender within the accepted

157 An illustration from a book by Beatrix Potter (Frederick Warne & Co Ltd, London and New York)

158 A cartoon by the American humorist James Thurber from *Vintage Thurber*: copyright © 1963 Hamish Hamilton, London

'It's Our *Own* Story *Exactly*! He Bold as a Hawk, She Soft as the Dawn'

social framework. Great classics of illustration and story-telling surround the life-long journey of men and women from courtship to marriage, to honeymoon, birth, family life, old-age, and the acceptance of new roles as parents-in-law and finally as grand-parents. In articulating these fundamentally sexual roles, art not only reflects what people do: it provides them with models on which to base their own lives, and through which to recognize and organize their own mutually shared experiences.

159 (below) A pin-cushion. This kind of good-luck charm was given to sailors by their sweethearts. From South Devon, nineteenth century (Horniman Museum and Library, London: photograph by Chris Ridley)

160 (right) A Chinese bridal crown decorated with kingfisher feathers (Horniman Museum and Library, London: photograph by Chris Ridley)

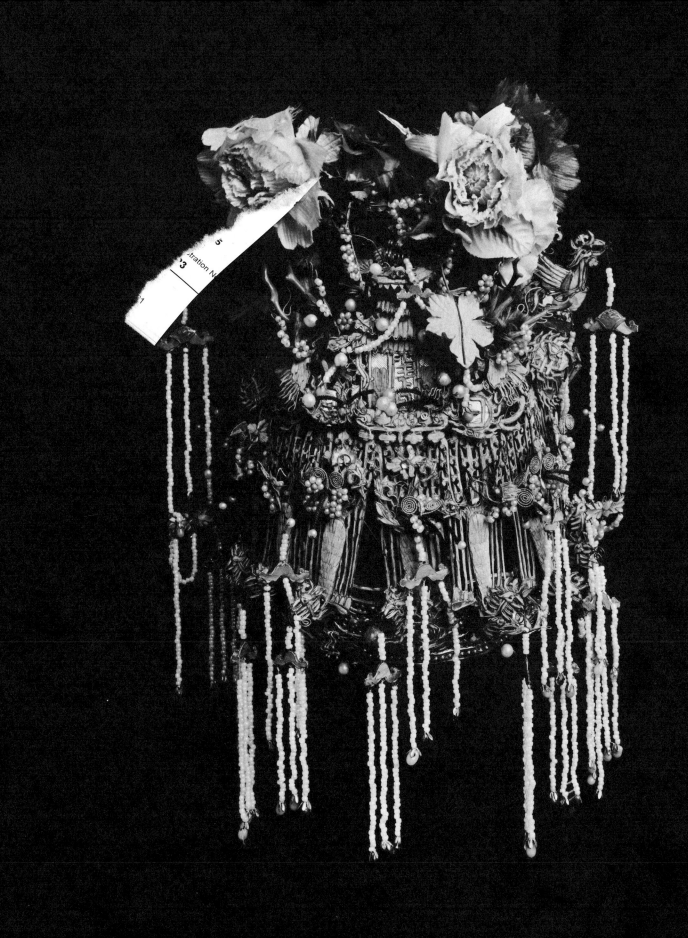

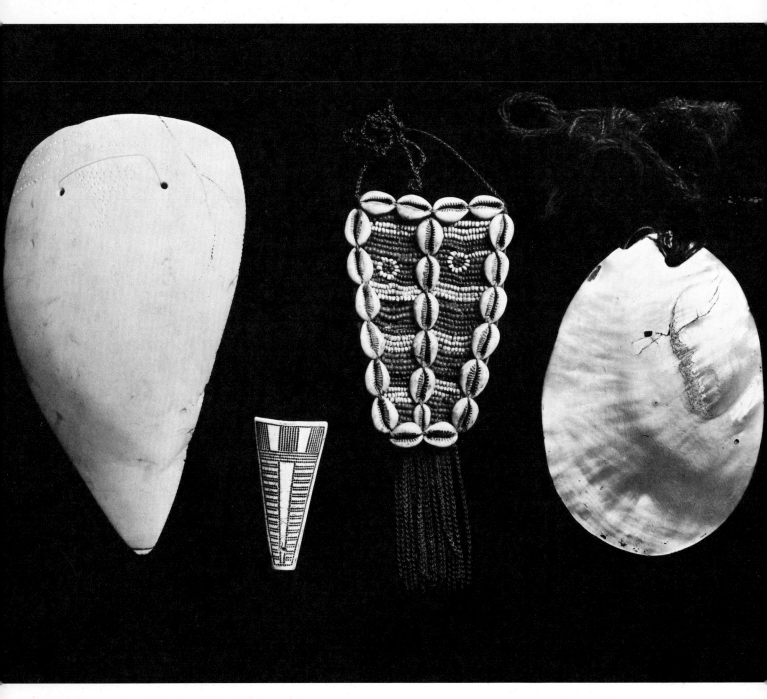

161 Four female pubic shields. From left to right they are: in ornamented shell from the Torres Straits; in porcelain imported into West Africa from Vienna; in leather with beads and cowrie shells from East Africa; and in mother of pearl from South Australia (Horniman Museum and Library, London: photograph by Chris Ridley)

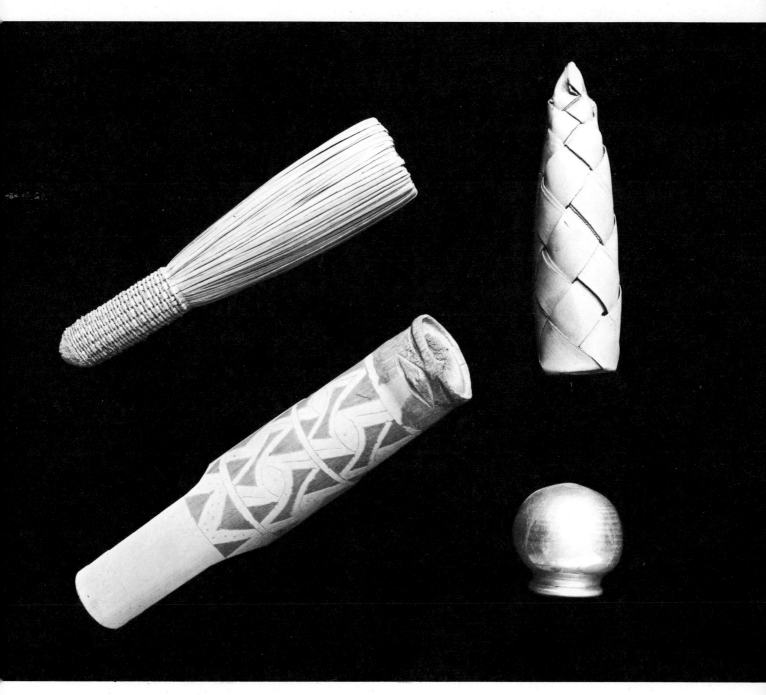

162 Four male protective sheaths. From left to right they are: in rush from Africa; in plaited palm from Nigeria; in cane from New Guinea; in aluminium imported into South Africa from Europe (Horniman Museum and Library, London: photograph by Chris Ridley)

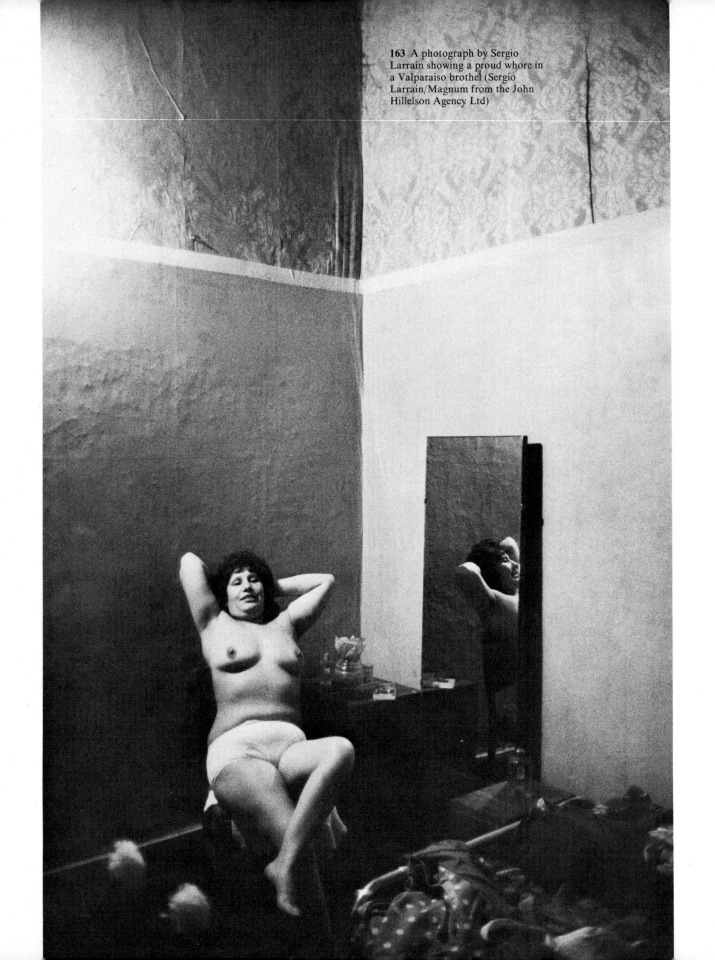

163 A photograph by Sergio Larrain showing a proud whore in a Valparaiso brothel (Sergio Larrain/Magnum from the John Hillelson Agency Ltd)

164 A photograph by George Rodger showing a proud Nuba warrior in Africa (George Rodger/Magnum courtesy *National Geographic* Magazine)

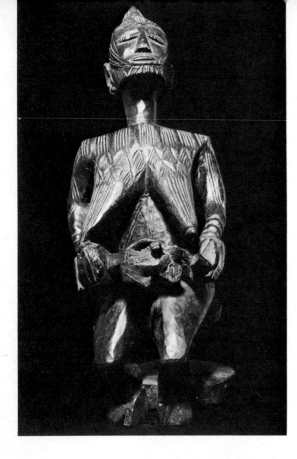

165 (left) A maternity sculpture belonging to a women's fertility society. It comes from Nigeria and was used at the Ngorongoro Festival of the Afo people (Horniman Museum and Library, London: photograph by Chris Ridley)

166 (bottom left) A British Labour party poster published after the First World War (John Johnson Collection, Bodleian Library, Oxford)

167 (below) A poster by the German left-wing artist Käthe Kollwitz. It opposes anti-abortion laws (The Lords Gallery, London)

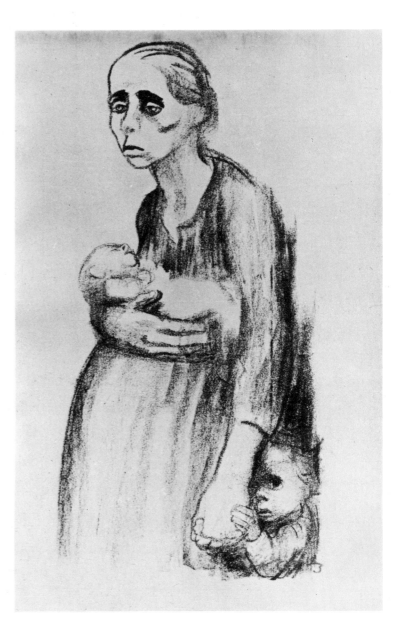

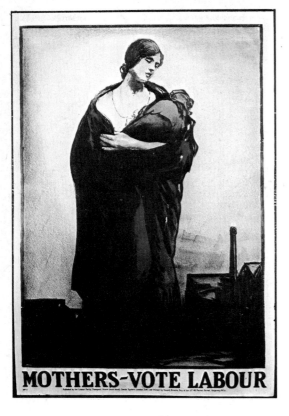

MOTHERS—VOTE LABOUR

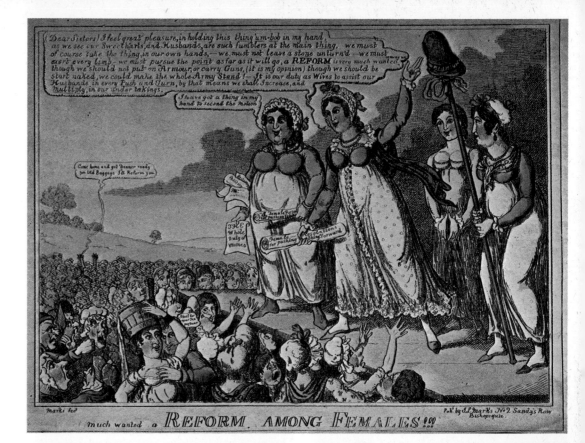

168 MUCH WANTED A REFORM AMONG FEMALES!!! An English cartoon by J L Marks, 1819. It attacks the idea of political rights for women (James Klugmann Collection: photograph by Chris Ridley)

169 (right) The heroine of the *Red Detachment of Women* from a Chinese 'modern revolutionary dance drama'. The scene shown is described in the following way: 'Refusing to be enslaved by the despot landlord the Tyrant of the South, Wu Ching-hua, daughter of a poor peasant, is beaten black and blue. She stands with head and chest high, her eyes blazing with hatred'. (Ken and Kate Baynes)

170 (far right) This beautiful German 'gallant' figure dates from the nineteenth century. Its seductive and submissive air, its aristocratic aura, mark a total contrast with 169 (Victor Arwas: photograph by Chris Ridley)

SEX : Dreams

The elaboration of sexual fantasy has been one of the most important cultural effects of the development of mass printing, film, and television. Here sexual elements are frequently removed from a direct connexion with attainable experience and are used instead for their power to entertain, advertise, or make propaganda. In this context, the image itself is the content of the dream and the source of the sexuality. Such material has created, in industrial society, a world of the imagination which touches people and products with its erotic glamour, and which is experienced alongside and within everyday life.

These satisfactions have been criticized from an extraordinarily wide variety of standpoints. Methodists and Marxists have joined in denouncing what they take to be a completely spurious world of manipulated desire. Most of all it is the sociologists of the New Left in Europe and America that have attacked the phenomenon of 'eroticization'. They see in it nothing less than a deliberately fashioned tool of capitalism designed to replace the older and more naked forms of oppression. The attempt has been made to show that the sexual images of contemporary entertainment and advertising are not only a commercial fantasy but also a method of enslavement. If this view was justified, it would provide a most vivid example of culture's ability to attack the interior life of men as well as to enlarge it.

The proposition is worthy of close examination.

In an article, 'Work and Consumption',[12] which he contributed to *Towards Socialism* in 1965, André Gorz characterized the operations of the 'consumer society' in the following terms:

As Marx foresaw, advanced capitalism has found itself confronted with the problem of moulding human subjects into the shapes required by the objects it has to sell . . . It has resolved this problem

171 (left) VAMPIRELLA. Made from a mass-produced plastic kit for the Paolozzi exhibition at the Tate Gallery, London, in 1971 (Eduardo Paolozzi: photograph by Chris Ridley)

172 (above) An Austrian art nouveau inkwell in the form of a mermaid with an octopus (Victor Arwas: photograph by Chris Ridley)

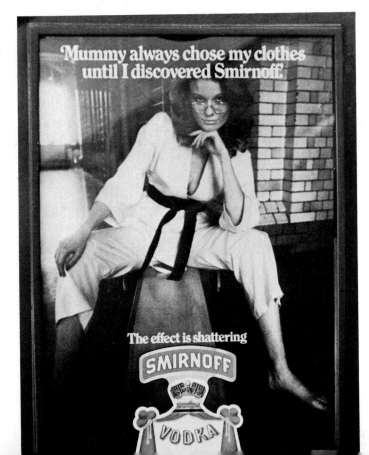

by conditioning people to what it is most profitable to produce – not only in respect of their personal needs, but also in the way they see the world, the way they conceive the state, society, civilization and its co-existence with other societies and civilizations.

It would be easy to argue that something very similar has happened in Soviet Russia in the wake of rapid industrialization, technological advance, and the growth of nationalistic chauvinism. But the point here is that this style of criticism is directed against the specific form of 'coercion' developed in the West where an exotic sexuality is a key element in entertainment and advertising. Here, from *Sexuality and Class Struggle*,[13] is Reiche's formulation of the mechanism:

. . . it becomes evident, when one observes the manipulation of needs, and of situations producing pseudo-satisfaction in the commodity market, in communications, and in sexuality, that exploitation is not now confined to its direct physical form but relies upon a gigantic apparatus of created needs which are constantly being manipulated to get people to comply with meaningless social goals . . . The present structure: manipulative optimization of needs which accord with the needs of the system, abolition of the difference between primary and secondary needs, and *thereby* maximization of exploitation . . .

Today the concept of 'oppression' no longer denotes specific persons but an impersonal situation: the whole set of circumstances which permits the barbarity of killing indiscriminately, and on a massive scale, from an aeroplane with no personal contact with the enemy. Similarly impersonal is the oppression by which the ruling class is in a position to dispense satisfactions at will to the rest of society: satisfactions which range from real, through the pseudo, to the wildly unreal.

There is in this a real insight into the nature of capitalism and into the way in which human needs are subsumed to economic necessity. But this economic domination of imagery is not peculiar to the twentieth century. What is more, Reiche seems to leave out of account the complex cultural ancestry of the present explosion of erotic themes. And he is unable to recognize any aesthetic or psychological worth in what is, after all, the offshoot of a dramatically libertarian revolution in people's attitude to sexuality.

175–176 (above) Covers for *Playboy* magazine dating from 1954 (left) and 1971. The art director of this consistently best-selling magazine is Art Paul (Playboy Inc, Chicago)

177 (right) A poster by Alphonse Mucha for 'Waverley Cycles', 1897 (Grosvenor Gallery, London)

In this broader sense, where did the dreams have their source?

It appears necessary to bring together three strands of development. The first is scientific and has its roots in the enlightenment. The second is romantic and has its roots in popular art. The third is technological and has its roots in the inventive genius of eighteenth- and nineteenth-century engineering.

It is significant that the revolutionaries in France were sympathetic to speculative science and that it was they who established the great institutions which were to give French scientists primacy in Europe over a long period. It was not that the scientists themselves were necessarily Jacobins –

many were not political radicals at all – but that the ethos of science in an era of stifling clericalism and decaying autocracy was like a breath of fresh air. More: it was directly destructive of the intellectual foundations on which were built the old European monarchies. When a member of the revolutionary Convention said, 'Let us never forget that long before we did, the sciences and philosophy fought against the tyrants', he was thinking of the powerful union between conservatism in thought and feudal oppression in society.

Throughout the nineteenth century, science made a series of discoveries which shook the hegemony of the long-established Christian order. Darwin's theories were bitterly contested, and the beginnings of psychology and the idea of birth control struck at fundamental aspects of the old morality.

178 (left) A scientific drawing by Leonardo da Vinci showing an embryo in the uterus. It was drawn in 1513 (reproduced by gracious permission of Her Majesty The Queen)

179 (below) THE GREAT SEA SERPENT OF 1848. A cartoon showing Liberty attacking the crowned heads of Europe (Mansell Collection)

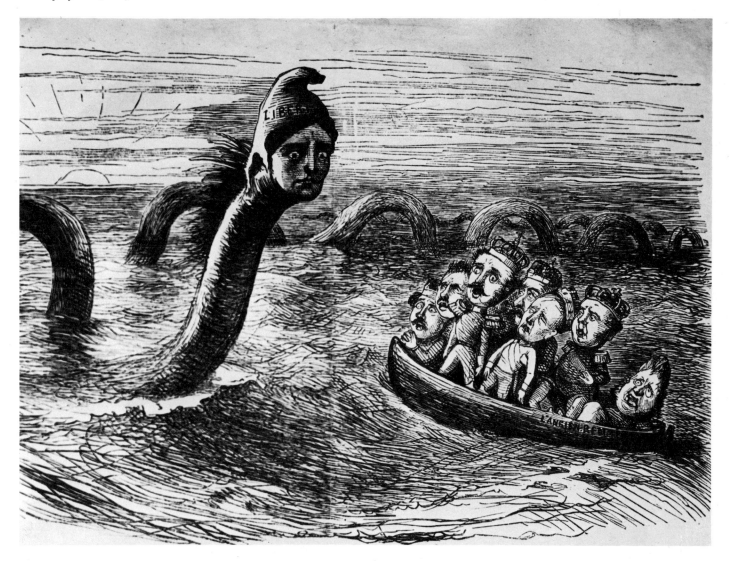

But one of the greatest contributions that science gradually made to popular thought was to clear away some of the most appalling fears and repressions surrounding sexuality. After Freud, it was impossible ever again to accept unthinkingly any too simplistic a morality, or to be only horrified by the spectres of sensuality. It was these discoveries which led to wholly beneficial changes in attitudes, and to the open presentation and discussion of fundamental sexual themes in the mass media. On any reckoning these developments have to be considered radical and liberating even where their specific setting is commercial and their sharp outline is blurred.

But we are dealing here with popular thought, not with science as a separate discipline. The liberty of scientific knowledge found a ready parallel in pre-existing aspects of folk art where sensuality and egalitarianism had lain dormant and half-hidden for centuries. There existed elements of robust vulgarity and healthy disrespect coupled with a burning interest in sensationalism. It was these characteristics which were so brilliantly exploited in the savage cartoons of the early nineteenth century and which are still readily available as a source of fiercely powerful imagery.

180 (left) A cartoon from a series of 32 by the French artist Paul Hadol. Made at the time of the Paris Commune in 1871 they show *La Ménagerie Impériale*: the ruling élite of France as birds and animals (Victoria and Albert Museum)

181 (above) Gerald Scarfe's famous cartoon showing Harold Macmillan in the role of Christine Keeler, one of the girls in the Profumo scandal

182 (right) A satirical print by Thomas Tegg. It is English and dates from the time of the Napoleonic wars against France (City of Sheffield Art Galleries)

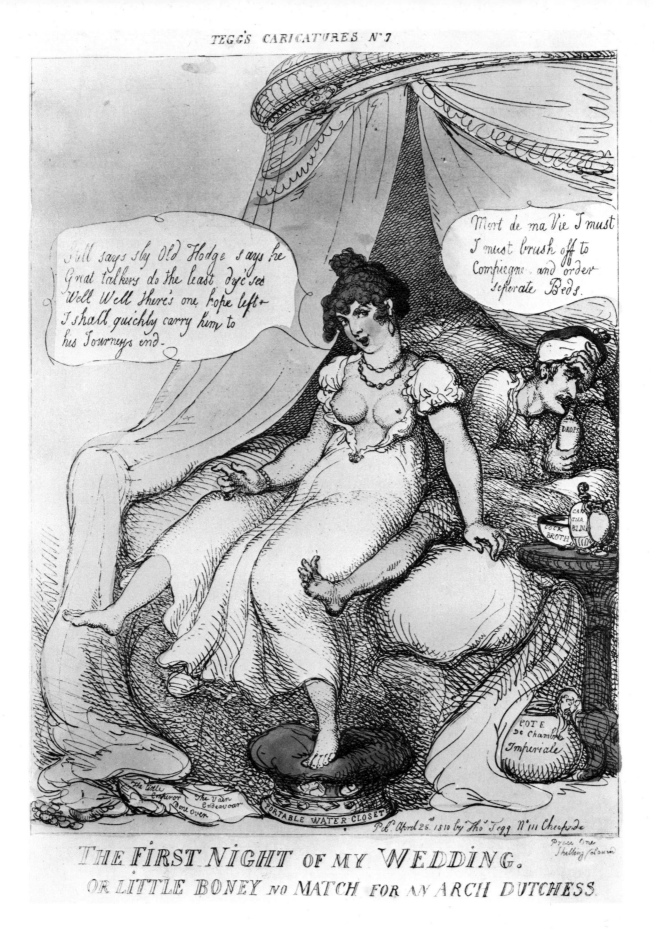

GOOD CUTTING THE HEAD OFF.

GOOD CUTTING THE BODY IN PIECES.

However, it is the alignment of these ancient peasant and proletarian themes with Romanticism that provides the key to a vast area of European and American popular art, first for the bourgeoisie and then disseminated through the mass media. It is in this conjunction that we can find the ancestry of the horror film, the violent war story, the tale of sexual adventure, and the whole world of exotic settings and heightened 'Gothic' responses. E J Hobsbawm made the point clearly in *The Age of Revolution*:[14]

The arts which depended on the support of the poor were hardly of great interest to the romantic artist, though in fact the entertainment of the poor – penny dreadfuls and broadsheets, circuses, sideshows, travelling theatres, and the like – were a source of much inspiration to the romantics, and in turn popular showmen reinforced their own stock of emotion-stirring properties – transformation scenes, fairies,

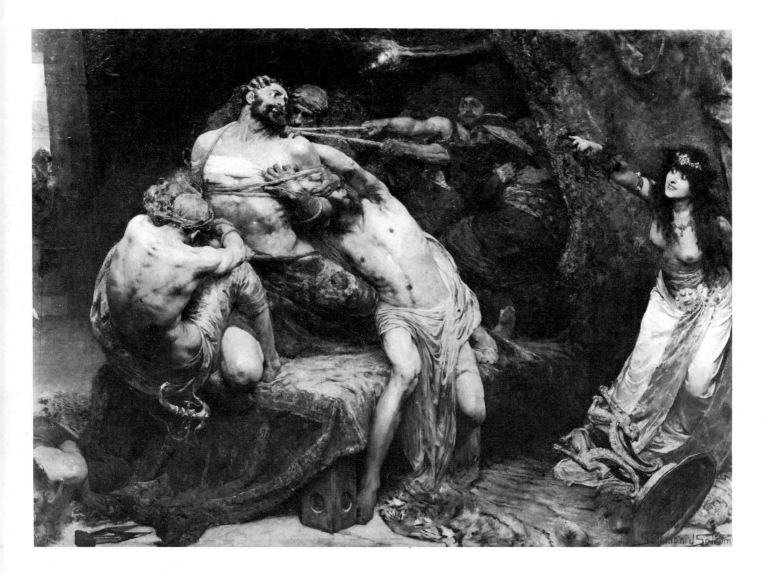

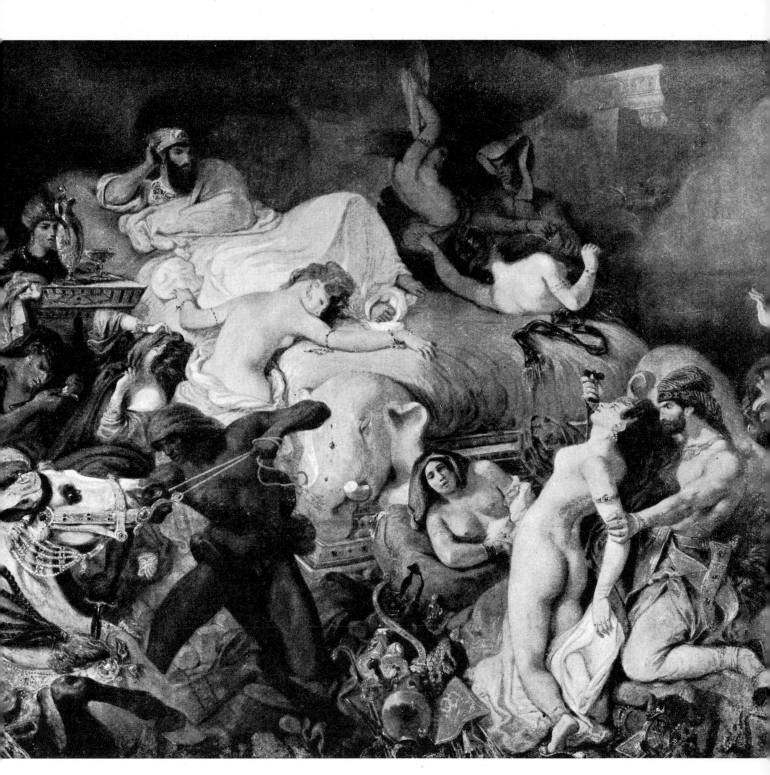

183 (top left) Details from an English broadside about a sadistic murder, 1842 (John Johnson Collection, Bodleian Library, Oxford)

184 (bottom left) SAMSON AND DELILAH by the English Victorian painter S J Solomon (The Walker Art Gallery, Liverpool)

185 (above) THE DEATH OF SARDANAPALUS by Eugène Delacroix, 1827 (The Louvre)

last words of murderers, brigands, etc. – with suitable goods from the romantic warehouses.

The original breeding ground for these dreams was very precisely set in a particular social alignment of the sexes. Against a domestic background that was in its outward appearance and sexual reality decidedly unromantic, the dream world found a natural home. In nineteenth-century middle-class marriage the wife could fill her bored practicality and stunted sex-life with exotica, while the husband sublimated his desires or found release in a pornographic world outside the home.

Much of the resulting art has been underrated. It is frequently dismissed as trivial or unhealthy or both. In fact, it was functional. It ameliorated the conditions of life, and introduced into the otherwise bleak sexual climate of nineteenth-century existence valuable rations of sensuality and adventure.

When the libertarian aspects of science encountered the satisfactions of Romanticism there was created a powerful

186 (left) A detail from one of a series of French prints satirizing the contrast between the romance of the *can can* and the reality for those who performed it. Called *Le Chancre* this illustration shows illness and injury caused by the physical exertion required by the high kicking of the dance. The *can can* was considered highly erotic in the late nineteenth century: it was entertainment directed at middle-class men (Victor Arwas)

187 (right) LA PARISIENNE by Paul Renoir. An exquisite portrait of a pretty bourgeoise girl (National Museum of Wales, Cardiff)

sexual time bomb. What set it off was less commercial exploitation than the vast extension of technology into the media of communication. It was this which created cheap magazines and the popular cinema, which put radio and television into the majority of homes, and which has allowed erotic imagery to become commonplace. In many ways it is a development which is highly relevant to contemporary society. It combines, in a characteristic way, aspects which are the result of idealism and libertarianism with atavistic fears and desires: it depends on technology and it powerfully affects the content of our imaginations.

What we can say here is that something far more complicated is being played out in the extension of erotic imagery than a simple capitalist sales drive. Advertising did not itself create the Romantic themes which it employs: these were well-established fantasies with plebeian as well as bourgeois origins, some immensely old. What seems more likely is that we are seeing the powerful after-effects of our 'discovery' of the subconscious, and that culture is struggling to find a form for the vast cloud of previously unacknowledged hopes, fears, and longings which have been released upon the world.

188 (left) Part of a scene from Robert Aldrich's film *The Dirty Dozen* (National Film Archive)

189 (right) Jane Fonda as Barbarella in Vadim's science fiction fantasy based on an adult comic strip (Paramount Pictures Ltd)

190 A still from *Footlight Parade*, an American film directed by Lloyd
Bacon in 1933 (National Film Archive/United Artists)

191 Covers of a cinema trade promotion booklet for the American film
Night Life of the Gods, c.1935 (John Johnson Collection, Bodleian Library,
Oxford)

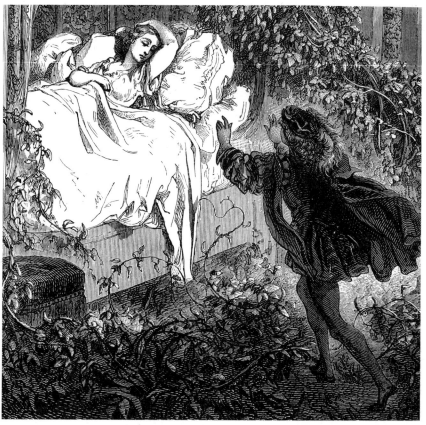

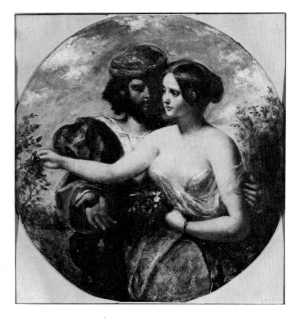

192 (top left) ROMEO AND JULIET, a Victorian water-colour by Ford Madox Brown (Whitworth Art Gallery, Manchester)

193 (above) Detail of an illustration by Gustav Doré to *The Sleeping Beauty* (Mansell Collection)

194 (left) GATHER THE ROSE OF LOVE WHILE YET 'TIS TIME, a painting by William Etty, c.1848 (City Museum and Art Gallery, Birmingham: photograph by Chris Ridley)

195 (right) Poster for a play produced in Oxford late in the nineteenth century (John Johnson Collection, Bodleian Library, Oxford)

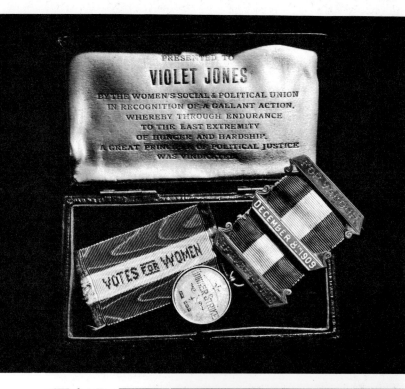

196 (left) A sampler worked in Holloway prison in 1912 by the suffragette Janie Terrero. It commemorates the names of those women who were forcibly fed (The London Museum: photograph by Chris Ridley)

197 (above) A poster published by the suffragettes' organisation, the WSPU. It protested against the Government's treatment of suffragettes who became ill because of forced feeding. Under the 'Cat and Mouse Act' they could be released only to be rearrested later (The London Museum: photograph by Chris Ridley)

198 (above right) A medal presented to Violet Jones. The WSPU gave medals to those who suffered for the cause of 'votes for women'. It was indeed 'a great principle of political justice' and those who fought for it made brilliant use of graphic art in their very long and bitter campaign (The London Museum: photograph by Chris Ridley)

199 (right) A photograph of a foetus by Lennart Nilsson. It comes from *The Everyday Miracle – A Child is Born*, originally published in 1965 by Albert Bonniers Forlag, Stockholm. Illustrations from the book have appeared in mass circulation women's magazines all over the world

200 (left) GOOD SENSE, a lithograph by the contemporary German artist Hans Bellmer (Victor Arwas: photograph by Chris Ridley)

201 (bottom left) Joke false bosoms. These can be purchased in England by mail order from joke and theatrical suppliers (Peter Jones: photograph by Chris Ridley)

202 (opposite: top left) A souvenir in the form of an erotic doll (Peter Jones: photograph by Chris Ridley)

203 (opposite: top right) Pipe and cigarette holders in the shape of a girl's head, torso and legs. They are ivory and were made in France in the nineteenth century (Victor Arwas: photograph by Chris Ridley)

204 (opposite: bottom) MISS MARIE LOUISE O'MURPHY, the famous erotic painting of Louis XV's mistress by François Boucher (Alte Pinakothek, Munich)

Part Four
WORK

Who built Thebes of the seven gates?
The history books give the names of kings.
Did kings carry the lumps of rock?

from QUESTIONS OF A READING WORKER[1] by Bertolt Brecht

Our experience today is that of being at the end of an era. We are on the brink of changes as dramatic and as far-reaching as those which accompanied the industrial revolution. We are in transition from the age of industry to the age of automation. The painfully acquired disciplines of work as appropriate to the rise of capitalism and communism and the nineteenth-century factory system are today challenged in Europe, America, Russia, and Japan by shortening hours and increasing productivity. The focus in people's lives seems to be moving decisively away from work and is concentrating instead on play.

Yet the nineteenth century and the culture it produced are still major formative influences on our ideas and attitudes. The present worry over what people are going to do with 'leisure', and people's actual experience of the dilemma, comes partly from that deep entwinement of work and morality that was a part of the meaning of life in the years following the industrial revolution. Our own need for skilled specialists and the linking of merit with ability have served to perpetuate these values into the present in a particularly confusing way. The schizophrenia between competition and equality affects every aspect of life and art and has its origins in just those opposing concepts of self-help and mutuality which crystallized early in the industrial revolution.

As short a time ago as 1963 it was still possible for Philip O'Connor to write, in a particularly penetrating book called *Vagrancy*, that 'As in criminal legislation, punishment of poverty has been found to have no therapeutic value. But though recent legislation springing mainly from the Beveridge Report* has gone a long way to recognizing this, it would be silly to imagine that so ingrained and traditional an ideology, one which, moreover, is morally pleasurable to the successful, has been abandoned.' In the nineteenth-century framework: 'The doctrine of free will is social blackmail levelled at the incompetent poor; their culpability was the "enterprising" rich man's virtue. In his heyday, the poor were punished for their poverty, and the rich were blessed.' A moment's thought will show how the basic attitude documented by O'Connor lives on as one of the mainsprings of people's actions and is reflected strongly in, for example, the education systems of all technologically advanced countries.

Throughout this book the event of industrialization appears as a key one, transforming art and society and their relationship to one another. The application of technology to life and the interaction of technology with culture clearly are a genuine watershed marking off two distinct styles of life. In the valleys of Lancashire and Yorkshire, in the developing industries of Birmingham, Newcastle, and Scotland, and in the Welsh mining and ironworking villages and towns, a new series of practical techniques was developed during the eighteenth century that, when combined with the egalitarian philosophy of the French Revolution, laid the foundation of modern thought and politics throughout the world.

We have travelled a very long road from the time when the mass of people could be called every foul name imaginable by the most educated minority of the day. It is over a century and a half since Burke called them the 'swinish multitude', and in the

206 ACHTUNG RESERVIERT! A cartoon by Ronald Searle satirizing German industrialists. It is from *Haven't We Met Before Somewhere* published by William Heinemann

*The Beveridge Report was the basis for reforming the social services in Britain in the years immediately following the Second World War. Its provisions are paralleled more or less precisely in the majority of industrialized countries.

Achtung Reserviert!

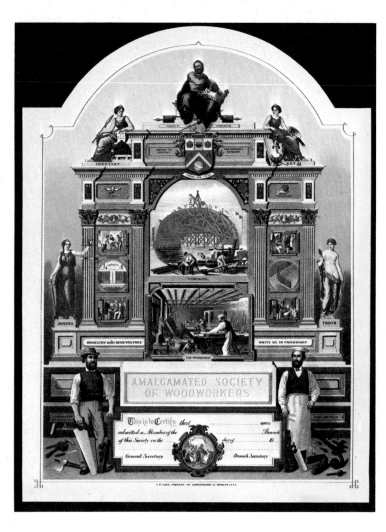

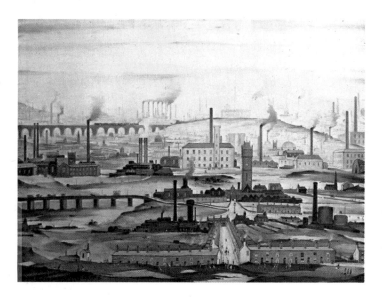

207 (opposite: top left) Membership certificate of an English trade union, the Amalgamated Society of Woodworkers. The certificate was still in use recently (Amalgamated Society of Woodworkers)

208 (opposite: top right) A China Pictorial photograph showing a decorated inaugural train crossing the new Nankin-Pukow Bridge, 1968

209 (opposite: bottom left) INDUSTRIAL LANDSCAPE by L S Lowry, 1955 (Tate Gallery, London)

210 (opposite: bottom right) An illustration from *Knight's Cyclopaedia of the Industry of all Nations*, 1851. It shows Manchester textile mills (Mansell Collection)

211 (above) The reverse of a clandestine medal commemorating the 'Peterloo Massacre' in Manchester in 1819. It attacks the role of the troops in putting down a peaceful demonstration by working people (James Klugmann Collection: photograph Chris Ridley)

212 (above right) A French agricultural diploma dated 1877. It shows a number of the mechanical farm appliances that were then in use (The University of Reading, Museum of English Rural Life)

intervening years the people themselves suffered every kind of hardship in the dreadful transition from a mainly rural to a mainly industrial world. But in suffering, and in struggling to establish recognition for the fact that they were, after all, human beings, they left the mark of their own character and experience on the changes that were gradually made and on the art, politics and society of the present.

Every area of human activity demonstrates the changes that flowed from these events, but it is work that holds a central position on the stage. The changing nature of work and the struggle for the wealth that resulted from it are the whole cloth from which the history of the last 200 years has been cut. The emphasis here is therefore on art's role in clarifying, interpreting and supporting these changing social relationships – the relationship between a man and those who work with him; the relationship between employers and employed; the relationship between employers and employed and society as a whole.

In this network of relationships it is easy to identify the operation of sociological concepts and to see how, for example, the interaction of the economic, political, and cultural systems with technology affected the experience of individuals. It is also easy to follow out the traces that these upheavals left in the fine art of their day. But here our central aim is more precise and more immediate. In Parts Two and Three, art has appeared principally as a stabilizing force in society. In relation to work we meet it in a revolutionary situation and see it acting as a revolutionary medium. It appears in the guise of Marxist dialectic. First it reinforces the worker's perception of his identity and status; then it articulates his experience of the social meaning of work; and finally it symbolizes the reality of class differences and becomes a functional element in struggle and revolution.

In such a context it is wrong to see art as simply an 'illustration' of events: it is itself an event. When, in 1798, William Blake wrote 'The Beast and the Whore rule

213 THE DINNER HOUR, WIGAN a painting of a scene in industrial Lancashire by Eyre Crowe, 1874 (City of Manchester Art Galleries)

without control' he was not 'illustrating' that this was a terrible period in British society, or that primitive capitalism was leading to the disruption of previously accepted value systems. Instead, he was *creating* an awareness by what he wrote; he was articulating for himself and others; he was directly involved in the social relationships of his day and what he wrote was part of them.

Blake's time in Britain, and even more so in France, saw a great assertion of popular feeling in favour of a more egalitarian society. A vivid literature and a robust graphic tradition emerged which, until very recently, have been almost totally neglected by art critics and historians. But here again what was produced was not an 'illustration': it was part of the battle and actually did affect the course of events and ideas.

Although the late eighteenth-century industrialists needed more educated workers,

176

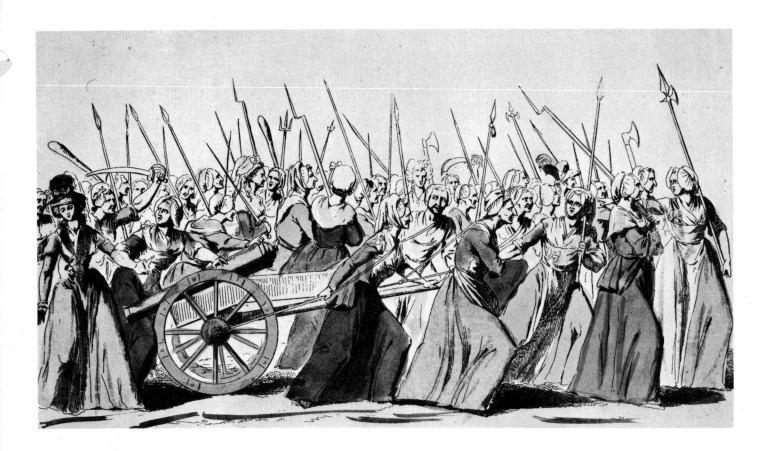

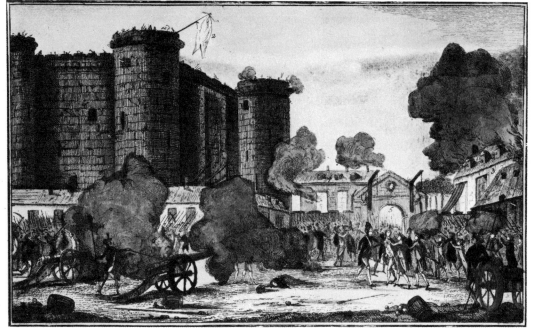

215 (above) TO VERSAILLES! TO VERSAILLES! A French print of an important event in the early days of the Revolution, 1789 (British Museum)

216 (left) A French print showing the storming of the Bastille in Paris (British Museum)

they feared the ability to read and write. Radical ideas were very much alive, and underground printers produced thousands of books and leaflets attacking corruption, exploitation, and inequality. Many of their ideas had to wait a hundred and fifty years before they became the accepted order of society. In 1793 Tom Paine's *Rights of Man* was banned in Britain as seditious libel: it is estimated that by that time 200,000 copies had been sold. The population was then only about ten millions! The book was read everywhere and, at Paine's trial *in absentia*, the Attorney-General complained that it was 'thrust into the hands of subjects of every description, even children's sweetmeats being wrapped in it'.

Radical pamphlets, cartoons, and symbols served to create unrest at the harshness of the times, but they did much more than that. They helped to give to the common people a literature, imagery, and political philosophy that had connexions in other classes but which were distinctively their own.

In continental Europe the emerging tradition was very specifically revolutionary in character. In Britain and America it was directed more at discovering a continuity with traditional rights and extending them into the future. Aspects of the extraordinarily widespread European revolutions of 1848 and of the Paris Commune have a direct ancestry with communism but the thought of Tom Paine and the history of British trade unionism have not. Culturally this is a significant difference of emphasis. Paine and St Just both reviled the monarchy and the aristocracy – St Just said that 'the kings shall flee into the deserts, into the company of the wild beasts whom they resemble' – but Paine's picture of a future world had no socialism about it.

When writing of the 'Napoleonic myth' in *The Age of Revolution*,[3] E J Hobsbawm identified the even greater symbolic power of the 'unsuccessful' revolution that his rule displaced:

He had destroyed only one thing: the Jacobin Revolution, the dream of equality, liberty and fraternity, and of the people rising in its majesty to shake off oppression. It was a more powerful myth than his, for after his fall it was this, and not his memory, which inspired the revolutions of the nineteenth century, even in his own country.

We know at once the visual imagery on which this myth depends: it has such deep roots in contemporary industrial culture. In *The Making of the English Working Class*,[4] E P Thompson tells us that, in 1792, a procession in Sheffield had the following characters and symbols parading in it:

A caricature painting representing Britannia – Burke riding on a swine . . . the pole of Liberty lying broken on the ground, inscribed 'Truth is Libel' – the Sun breaking from behind a Cloud, and the Angel of Peace, with one hand dropping the RIGHTS OF MAN, and extending the other to raise up Britannia.

It is easy to recognize these idealistic symbols and to identify their source in the

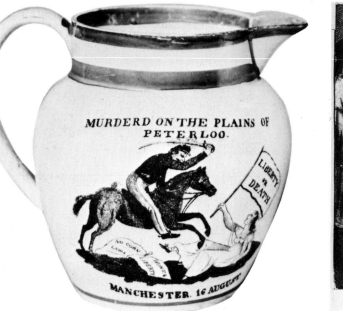

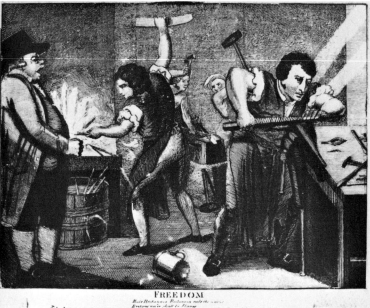

FREEDOM

217 (above) A jug commemorating the 'Peterloo Massacre'. The soldier on horseback is riding down a demonstrator carrying a banner with the slogan 'Liberty or Death' (James Klugmann Collection: photograph by Chris Ridley)

218 (above right) FREEDOM. An English engraving which quotes ironically 'Rule Britannia, Britannia Rules The Waves, Britons Never Shall be Slaves' while showing wage slavery in the newly emerging factories. It is contemporary with the French Revolution (James Klugmann Collection)

pamphlets and political cartoons of their time. It is also easy to trace their longevity, and the consistent reappearance of their style in such things as trade union banners and membership certificates, later cartoons, and revolutionary posters and pamphlets. What we have here is the beginning of one of the greatest elements in the popular art of the nineteenth and twentieth centuries. And, because it relates art decisively to social change, one of the most significant for the future. In a world dependent on mass communication and bureaucracy, but drastically opposed to inequality of every kind, the old radical underground of words and images must inevitably be fascinating and inspiring. It is the one great and effective example of an art enmeshed in a brutal era which helped ordinary men to realize the possibility of achieving a more humane society.

"Portentous, unexampled, unexplain'd!
———— What man seeing this,
And having human feelings, does not blush,
And hang his head, to think himself a man?
———— I cannot rest
A silent witness of the headlong rage,
Or heedless folly, by which thousands die——
Bleed gold for Ministers to sport away."

THESE ARE

THE PEOPLE

all tatter'd and torn,
Who curse the day
wherein they were born,
On account of Taxation
too great to be borne,
And pray for relief,
from night to morn:
Who, in vain, Petition
in every form,

Who, peaceably Meeting
to ask for Reform,
Were sabred by Yeomanry Cavalry,
who
Were thank'd by THE MAN,
all shaven and shorn,
All cover'd with Orders—
and all forlorn;
THE DANDY OF SIXTY,
who bows with a grace,
And has *taste* in wigs, collars,
cuirasses, and lace:
Who, to tricksters and fools,
leaves the state and its treasure,
And, when Britain's in tears,
sails about at his pleasure:
Who spurn'd from his presence
the Friends of his youth,
And now has not one
who will tell him the truth;
Who took to his counsels, in evil hour,
The Friends to the Reasons of lawless Power,
That back the Public Informer, who
Would put down the *Thing*, that, in spite of new Acts,
And attempts to restrain it, by Soldiers or Tax,
Will *poison* the Vermin, that plunder the Wealth,
That lay in the House, that Jack built.

219–220 Pages and a detail from
The Political House That Jack Built
by William Hone. This book,
illustrated by George Cruickshank
and published in 1819, circulated
very widely in Britain (James
Klugmann Collection)

221 (below) A DIVINE IMAGE by William Blake, 1794. This is a plate which Blake made for his *Songs of Experience* but did not use. It is one of his most direct attacks on the industrialisation of the age in which he lived (British Museum/from *William Blake's Engravings* by Geoffrey Keynes, published by Faber & Faber Ltd)

222 (right) A token, dated 1792, showing the Ironmaster John Wilkinson, one of the new breed of industrialists who were then coming to power in Britain (City Museum and Art Gallery, Birmingham)

223 (below) An illustration showing miners waiting for relief outside the workhouse at Merthyr in the South Wales coalfield. It is from an issue of the *Illustrated London News* published during 1875, a year marked by a great miners'strike (Mansell Collection)

224 (right) A photograph of Isambard Kingdom Brunel by Robert Howlett, c.1857. The great engineer is standing with justified arrogance in front of the anchor chain of his ship the *Great Eastern* (Institution of Civil Engineers)

225 (left) A group of Welsh ironworkers (Welsh Folk Museum, St Fagans/D Phillips)

226 (below) A detail from a large, somewhat naive painting by Inigo Thomas. It carries the following inscription: 'A plain representation of the teams [of horses] and trams [waggons] of coal, brought down to Pillgwenlly by Samuel Homfray, Esq. on Tuesday 18th December, 1821 Weight of Coal 79 tons 10 cwt' (National Museum of Wales, Cardiff)

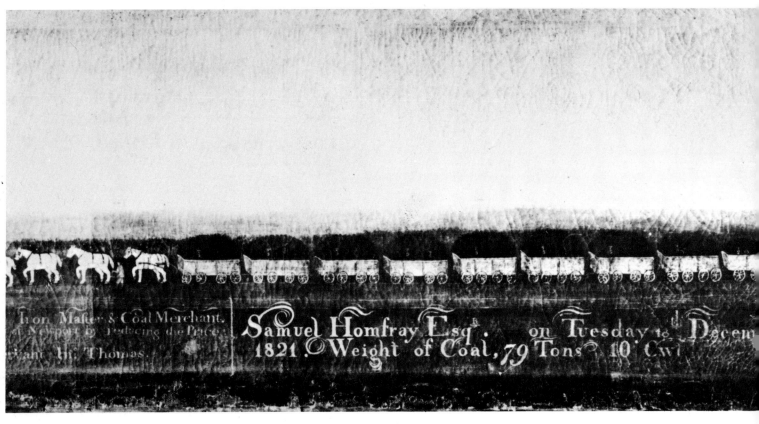

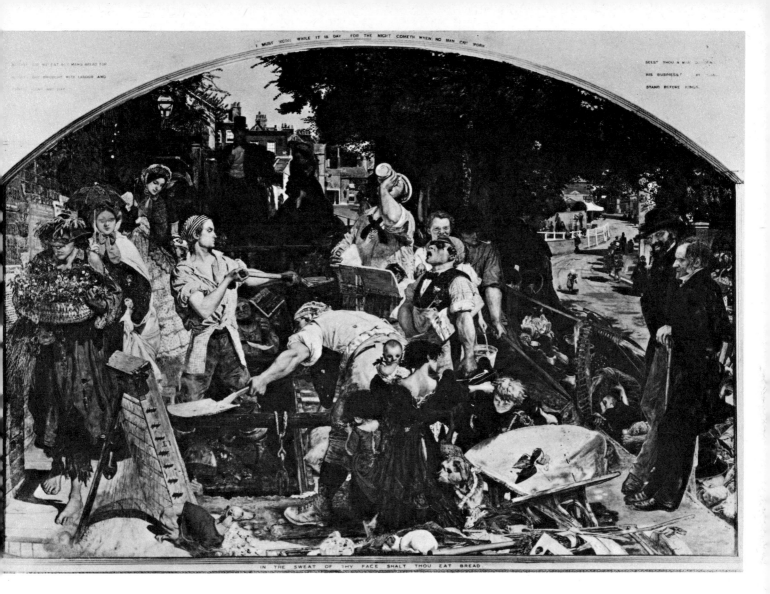

227 WORK by Ford Madox Brown. This painting, which took Brown ten
years to complete, epitomises both the Victorian respect for work and the
nature of a certain kind of radicalism in nineteenth-century England. It
celebrates honest toil and denigrates luxury. It is high-minded yet is also
humorous, being full of little literary jokes. Here is an extract from
Brown's description of the meaning of the picture: 'The pastrycook's tray,
the symbol of superfluity, accompanies these . . . [the ragged flower seller]
who has never been *taught* to *work* [and the idle rich] . . . I could never
quite get over a certain socialistic twinge on seeing it pass unreasoning as
the feeling may have been' (City of Manchester Art Galleries)

WORK: Identity

Mr Bun the Baker; Mr Bones the Butcher;
Mr Block the Barber; Mr Bung the Brewer;
Mr Chip the Carpenter; Mr Grits the Grocer;
Mr Dose the Doctor; Mr Pots the Painter;
Mr Tape the Tailor; Mr Soot the Sweep;
Mr Dip the Dyer.

The heads of the families in the game of HAPPY FAMILIES

Children find it easier to put on and take off identities than grown-ups. They play 'shops' or 'trains' or 'buses' or 'spacemen', learning, in the process, about the identities that are appropriate to each activity. Art and observation combine to make their games an important part of growing up. They observe the patter of the bus conductor: the differences in style and conversation between the butcher and the postmistress: the more rugged approach that goes with digging holes or the serious masonic mumbo jumbo that is necessary to start an express train. They see that the people who carry out these activities are distinctive kinds of men and they glimpse the network that associates people with occupations. They sense something of their parents' attitudes to the hierarchy implicit in the network. Experiencing the reality of the situation through play-acting takes up a lot of their time.

Children's books and illustrations are full of characters formed and defined by their occupations. Sometimes these are romantic and far outside the child's experience. Quite often they are completely fairytale. Perennials, like woodcutters, swineherds, dairymaids, and goosegirls, exercise a fascination that comes from unfamiliarity – from being a 'story' – rather than from any connexion with experience.

Cinderella's miraculous transformation from slavery to princess is a universal symbol for a glittering change of fortune. But it is told in social terms that now hold good only in that strange never-never-land of fairy stories where it is always yesterday and everyone lives in a world of gingerbread houses and frog princes. But even in this remote kingdom, it is recognized that a man's occupation is also a description of his character. In all manner of ways children are brought to recognize this fact and to accept that it is true.

Take this old nursery rhyme, which is an occupational ABC,

228 (left) Playing cards for the game of *Happy Families*. This particular series is known as 'Jaques Original Happy Families' (Castell Bros Ltd: photograph by Chris Ridley)

229 (above) MRS TIGGY-WINKLE, an illustration from the book about a washer-woman hedgehog written and illustrated by Beatrix Potter (Frederick Warne & Co Ltd, London and New York)

and see how the links in its alphabetical chain begin to set up the complex social structure that gives to each identity its special place and meaning:

A was an archer, who shot at a frog,
B was a butcher, and had a great dog.
C was a captain, all covered with lace,
D was a drunkard, and had a red face.
E was an esquire, with pride on his brow,
F was a farmer, and followed the plough.
G was a gamester, who had but ill-luck,
H was a hunter and hunted a buck.
I was an innkeeper, who loved to carouse,
J was a joiner, and built up a house.
K was King William, once governed this land,
L was a lady, who had a white hand.
M was a miser, and hoarded up gold,
N was a nobleman, gallant and bold.
O was an oyster girl, and went about town,
P was a parson, and wore a black gown.
Q was a queen, who wore a silk slip,
R was a robber, and wanted a whip.
S was a sailor, and spent all he got,
T was a tinker, and mended a pot.
U was a usurer, a miserable elf.
V was a vintner, who drank all himself.
W was a watchman, and guarded the door,
X was expensive, and so became poor.
Y was a youth, that did not love school,
Z was a zany, a poor harmless fool.

'S was a sailor, and spent all he got' reminds us of the cliché combination of characteristic with occupation that is the staple of much adult humour. In Britain, we all know that capitalists are bloated and that all officers and gentlemen are gallant. Millers are jolly and pawnbrokers are mean. Different, but equally strong, conjunctions exist elsewhere.

Similar, but less easy to explain, is the aura of hilarity that goes with some occupations – and the aura of dissipation that goes with others. Oddly, the figure of the plumber seems, at one time in British popular folk lore, to have combined both these attributes and, in a music hall act, Arthur Rigby (described by Colin McInnes in his book *Sweet Saturday Night*[5] as the plumber's poet) used to sing:

I'm the plumber – I'm the plumber
A very handy man in winter or in summer;
I can wipe a joint with ease,
But – well, touching ladies knees,
It isn't in my line – I'm the plumber!

But this 'very handy man' contradicted the innocence of his song by the implications of his gestures. The plumber now retains only his incompetence: he has surrendered his image of randiness to the milkman, who pops in with a pinta.

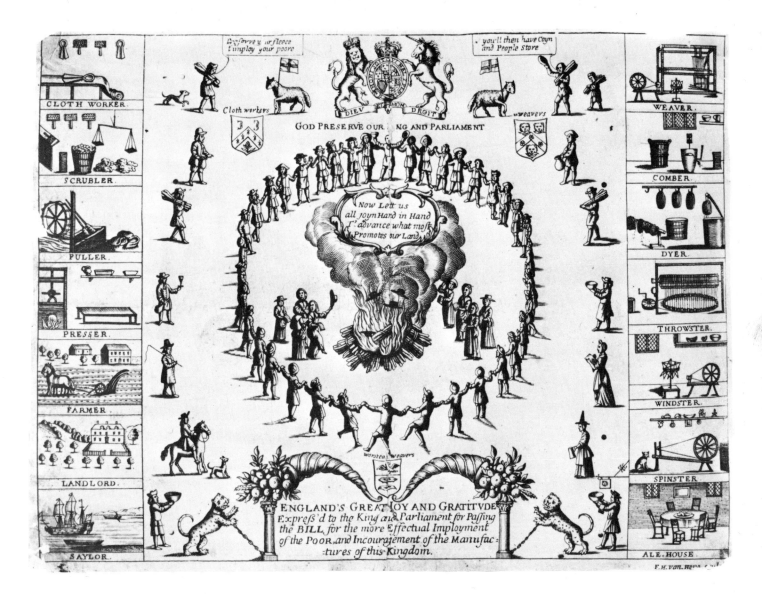

230 (left) A scene from the British television serial for children called *Camberwick Green*. The stories centre round the typical trades of a small village (BBC TV)

231 (above) A broadside on the English woollen trade from the time of Charles II. It shows vividly the interdependence of the work identities within a particular trade (Mansell Collection)

232 (right) A photograph by Chris Ridley showing children playing at builders on a Manchester building site

233 End paper from a 'Wonder Book'. The Wonder Books, which many thousands of English middle-class children must have read at the turn of the century and later, are a fascinating piece of popular culture. They embody the attitudes of the period with its belief in progress and the 'wonders' of science. In them the moral value of work is clear, but each has endpapers which give comic relief. Significant, however, is the source of the comedy – the working man himself (Ward, Lock & Co Ltd)

Yet there is no single stereotype for any one occupation. A stereotype of the kind we have been discussing helps to locate a particular job in the welter of human characteristics and the structure of society, but an individual's own position in that structure will contribute to the set of stereotypes that he holds in common with his fellows. Iona and Peter Opie, in their book *The Lore and Language of Schoolchildren*,[6] show how this works for the clash between the child and authority. Remember first how the British are thought to believe that 'our policemen are wonderful' and the sturdy reassurance provided by the image of the slow-moving village constable, then consider what the Opies have to say:

No matter with what awe a boy may privately regard the police, his vocal attitude is one of amiable derision. In juvenile song the upholder of the law has the worst of every encounter. The 'friendly policeman passing by' is inevitably the one who receives something unmentionable in his eye. He falls, in one song, into the corporation muck cart, and cannot swim; he falls, in another song, over a fence, improbably bursting his belly on a lump of jelly . . .

Perspective and relationship are all important in determining the meaning and content of occupational stereotypes!

One of the effects of the industrial revolution has been to make it easier for people to move from one work identity to another. The process began long before the eighteenth century, but the changing structure of society after that time naturally accelerated what was already beginning to happen. The variety of work available today and the possibility of movement from job to job would have been inconceivable in the fixed social pattern of medieval Europe. Then the allocation of jobs among social groups, and the significance of the jobs themselves, were not simply static: they were frozen into self-perpetuation as reflecting the will of God. The art of the time interpreted and reinforced this God-given permanence.

It is hard for us to penetrate fully the nature of medieval thought and to share in the great network of symbols and occult meanings through which the people of the day found the relevance of their lives. But it is important to see that their system made a link between the earthly and the transcendental that was a valuable thing, and which is now irretrievably lost in the trickling away of faith. We can sense through the mystery plays, for example, how on great occasions shepherds would have been able to merge their own occupational identity with that of the Biblical shepherds and so see a special link between their work and God's scheme for the world. The ability to see the image of the divine reflected in the mundane surface of life is one of the most striking characteristics of the period before the

234 BUILDING THE FIRST LOCOMOTIVE by W Heath Robinson, 1935. This is one of a series of humorous drawings from *Railway Ribaldry*, a book published by the Great Western Railway as a part of its centenary celebrations (Ian Allan Ltd)

Dumquid adheret tibi sedes iniqui
tatis: qui fingis laborem in precepto.
Captabunt in animam iusti: t san
guinem innocentem condempnabut.

Renaissance, and it gives a particularly profound aspect to their representations of work. Sower, hunter, farmer, priest, or king take an identity related to the irrevocable passage of the seasons and the irrevocable reality of Christ and the Christian church.

Take this extract from a twelfth-century Latin Bestiary[7] which, in speaking of the bee, catches the medieval flavour: a combination of practicality, morality, and religious sanction:

How right the Scripture is, in proclaiming the bee to be a good worker, when it says: 'Go to the bee and mark its handiwork and copy the operation thereof'. In what remarkable industry does the bee deal, when our kings and commons take its produce for the sake of their health!

Worthy it is to be desired of all men and dear to them! Do you hear what the Prophet says? 'He sends you verily that you may follow the example of that little bee, and that you may imitate its labour.' See how industrious, how agreeable it is. What it manufactures is desired and sought after by all, nor is this valued by men for the sake of variety, but in its unvaried deliciousness it grows sugary with equal sweetness for kings and commons alike.

So the bee was fixed in the eternal pattern, and to have a particular job, especially at the bottom of the social ladder, was almost to be a species; to share an occupational identity so strong that it predetermined one's life. But it was, as well, a part of God's plan.

The Renaissance decisively changed the emphasis by highlighting the secular significance of a man's work identity. The possibility of profit came more clearly into focus. With it gradually began the evolution of those ideas linking 'self-help' with religion that came to full expression in the nineteenth century: ideas that are so clearly exemplified in Samuel Smiles's great work on the engineers. However, in many parts of society and very much so in the country, the movement between an individual and his work was still

strong, even though its meaning was interpreted in a different way. Life was full of reminders of this link, as shown by this quotation from Christina Hole's book *The English Housewife in the Seventeenth Century*:[8]

On the day itself she was dressed in fine new garments by her bridesmaids, crowned with myrtle, and led to church by two bride-men carrying branches of rosemary. Her path and that of the groom was strewn with flowers and sweet herbs, or with emblems of the young man's trade. A carpenter had shavings spread for him and a shoemaker leather parings; grass was strewn for a farmer, and for a butcher the way was lined with sheepskins, while the procession was headed by two men carrying decorated lambs . . .

From this time on, into the start of the nineteenth century, the great craft guilds did everything they could to maintain the identity of their crafts and to show to society that they, and therefore their members, were of importance. Art was one of the main tools they used to make their claim real and intelligible. Often they employed a fine sense of magnificence and theatre in their processions and in the banners, badges, clothes, and ceremonies of their officers. But as the crisis of the industrial revolution mounted, so the stability of the old social order was shattered and long established work identities went into the melting pot while new ones emerged, often with great force and vigour. New men – mill owners, navvies, mechanics, engineers – came on the scene and their characters found a place among the occupational stereotypes of the late eighteenth and early nineteenth centuries.

Before the nineteenth century men and masters often belonged to the same guild and shared within a hierarchy in the single identity of their craft or trade. Workshops were usually small and there was not necessarily any conflict of interests between the employer and those he employed. There was at least the possibility of an identity of interests within the master's enterprise. In the country there existed the shreds of a social contract based on a a community of values

193

rather than exploitation. All this can be found in broadsheets and cartoons at the start of the industrial revolution as representing an ideal based on established custom. With industrialization such mutuality often collapsed entirely and became only a dream to be fought for.

So it was not only that new men emerged, and that old trades like that of the hand-loom weavers vanished. In addition there was the necessity to articulate a whole new pattern of class identities and interests around the work situation itself. We are now so familiar with the results that we take them very much for granted, but at the time they were novel and they were dramatically argued out in the popular art of the period.

First there was the polarization of employers and employed. The masters identified with their organizations, the men with theirs. What resulted was a work identity based on a subtle combination of moral, political, and class differences. It was new because of the way it cut across the interests of a particular occupation: or rather because of the way it directly related the situation in one occupation to larger political and social groupings.

Then there emerged the identity of the individual company and the involvement of its employees in that identity. A particularly fine example of this is provided by the railways at the end of the nineteenth century when they were at the height of their power and prosperity. The workers employed by these great capitalist joint-stock companies were an industrial elite and felt themselves to be so. They had a fierce loyalty to their employers.

In uniforms, locomotive and carriage liveries, coats of arms, and distinctive forms of lettering were symbolized the differences between the companies and the reality of their competition. For the engine drivers, porters, and guards this rhetoric was something which occupied an important place in their lives, cutting across class identity and barriers to create a community of interest within the enterprise. It was the re-establishment, on a different scale and on different

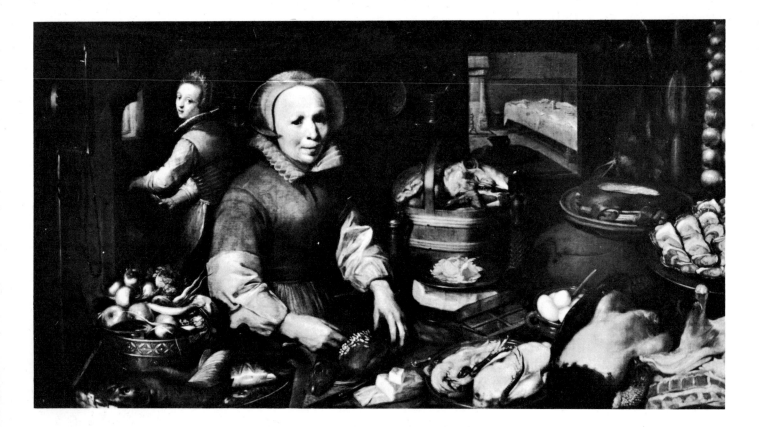

240 (above) KITCHEN SCENE, a Dutch painting attributed to Pieter Aertsen, second half of the sixteenth century (City Museum and Art Gallery, Birmingham)

241 (left) A still from the film *Diary of a Chambermaid* (National Film Archive/Twentieth Century-Fox Film Co Ltd)

terms, of the identity between men and masters that had existed earlier.

Today we are so remote from the idea of identity as it was understood in medieval times that it is hard to recognize any connexion. The change from a static to a constantly altering society has decisively affected the significance of work and the identity that goes with it. In the twelfth century the chain of occupations linked the serf to the King and to God, but its profundity was matched by its rigidity.

Now, identity – which is an inherently stabilizing notion – is involved in an unstable social order. It is caught up in competition and status. The pressure of new occupation on old, the blurring of class barriers, and the vanishing of a clear hierarchy of roles, have all combined to create confusing and contradictory emotions about identity. Behind our own interpretation of the link between a man's occupation and his character lies the past like a hall of distorting mirrors, assuring us of continuity yet giving us, at the same time, a repertoire of irrelevant as well as relevant images.

242 (left) Lt Uhura, the spacewoman navigator, in the American television series *Star Trek* (BBC TV)

243 (above) 'A cook' as depicted in an English cartoon by John Tenniel, 1868 (Mansell Collection)

ALTISSIMVS
CREAVIT DE TERRA MEDECINAMET VIR
PRVDENS NON ABHOREBIT ILLAM
ANNO DOMMINI 1623

244 (above) A photograph by Chris Ridley showing the lettering on the shopfront of a trade union office in Wigan. The picture was taken in 1969

245 (left) A medical practitioner's signboard, 1623 (The Wellcome Trustees)

246–249 (right) Steel specimens made late in the nineteenth century at the vast Crawshay works in Merthyr. Their purpose was to demonstrate the high quality of the material being produced there (Merthyr Tydfil Corporation: photographs by Al Campbell)

WORK: Experience

*Therefore the LORD God sent him forth
from the Garden of Eden,
to till the ground from whence he was taken*

from Chapter 3
of the First Book of Moses, called GENESIS[10]

250–252 Three from a series of drawings of shipbuilding made on Clydeside in Scotland by Stanley Spencer during the Second World War (Imperial War Museum)

On the face of it, art's role in recording experience is relatively straightforward and easy to understand. It is at this point that it seems most like simple story-telling. But in relation to a subject as entwined in social considerations as work, the situation is not necessarily so easy to interpret. Why tell it? Who told it to whom? Did they understand the story or, more to the point, *what* did they understand by the story?

It is a common mistake to imagine that the representation or retelling of experience is essentially to convey to somebody something they do not know already. It may be that, but as important a function is to be found in the response which goes 'so it happened to him too' or 'yes, it happens to all of us' or even 'isn't that just like life'.

Art is as often articulating and symbolizing the truth of already shared experiences, as it is presenting genuine novelty. An old man will frequently enjoy reading about the times when he was young, the places he lived in, and the events that he lived through. It is as if one of the things that art does is to hold up pictures of other people's experiences, other people's morals, other people's emotions, in the hope that, if they are enough like our own, they will reassure us that our own are real and have a place in the world.

This 'cementing together' by the rehearsing of experiences is one of the classic roles of art. If we look at the *Gododdin*,[11] a heroic Scots poem originating in the sixth century, this aspect of its function is very clear. Each lay celebrates one of the Scottish or Welsh warriors who went to fight the Saxons at Catraeth, who were housed and fed at Eidyn by the King, made their boasts and finally died. Here is a typical one:

The man went to Catraeth with the day; he drank up the mead-carousal at midnight. Hapless was his expedition, the lament of his fellow warriors, the fiery killer. No great man whose boasts were so expensive . . . sped forth to Catraeth; there was none who

put the enemy to flight from the stronghold of Eidyn so utterly as he, Tudfwlch the tall, from its land and its steadings; he slew the Saxons every seventh day, long shall remembrance of his valour last, and memories of him among his fair company. When Tudfwlch arrived, the strengthener of his people, the son of Cilydd, there was a slaughter-ring in the place of spears.

In the morality of the time nothing was more honourable than warfare. The work of the fearless and ferocious knight with his retainers was at the pinnacle of the social order. Each lay rehearsed this morality with the insistence and repetitiveness of a pop song, reinforcing the values of courage, skill at arms, and death on the battlefield. Here the telling of the stories, the repeating of the experiences, was inextricably mixed with the function of 'cementing together'. In a real sense, the heroic period of any society, whether Homeric Greece or sixth-century Scotland, depended upon the existence of the bard. It was he that vivified the myths and gave reality to the warriors' hungry desire for immortality in the minds and memories of men.

It is easy to see how the telling of such stories can be a natural extension of the idea of identity discussed previously. They rehearse the rules of conduct that go with a particular role in society, and serve to relate them to the larger picture of ethics and values. Nineteenth-century anecdotal paintings present this function of art at its most blatant, but in far more subtle forms it pervades an astonishing proportion of art and literature.

In a rather different way soap-operas, whether in literary form or on radio, film, or television, perform a similar function. Their stories are often made up of the permutation of a few basic human situations seen against a recognizably realistic background. The drama in these people's lives is slightly heightened above the normal, but the resonance with everyday experience is there. The extraordinary longevity of series such as the American *Dr Kildare* programme cannot really be explained solely in terms of their aesthetic quality as television or radio. The feeling of recognition and the reassurance of shared values must also be very much involved.

It is noticeable that these series often have an occupational theme. Medicine is a favourite, though the office, the farm, or the factory are equally as serviceable. But the occupation is not the essential subject matter, however scrupulously it may be presented. At the centre of the story are the small moral and social dilemmas which are the mainstream of most people's lives. It is strange that these series, and the related but different comedy series, have received either minimal or scornful attention from most critics. Certainly

the principal characters often provide easy targets for parody, but something important is going on when a work of art produces stereotypes that almost everyone knows about and that many people identify with.

But the articulation of experience can also have quite another context. It can serve a deliberately polemical purpose. Ever since the onset of the industrial revolution the 'experience' entailed has been couched in two violently contrasting modes which have themselves overlaid ordinary people's perceptions.

In 1787 Robert Burns was refused admission by the doorkeeper of the great Carron Works in Scotland; afterwards he scratched the following lines on a window pane:

We cam na here to view your warks,
In hopes to be mair wise,
But only, lest we gang to Hell,
It may be nae surprise . . .

That view of industry as a kind of hell and of the work in it as unnatural and degrading is a consistent theme in art and literature. It appears vividly in, for example, Doré's engravings and Zola's novels. Sometimes it is a view linked closely with philosophical and political thought, sometimes it comes to not much more than a romantic thrill at the drama of a steelworks in the night. Sometimes it is used only to serve as the background of an otherwise conventional story. A similar attitude often underlies the apocalyptic visions of science fiction in which the arrogance of technological man is finally shown to be hollow. At its best it maintains links with objectivity and is impelled forward by anger at the destruction of traditional human values and relationships.

Here is the other voice:

Soon shall thy arm UNCONQUER'D STEAM! afar
Drag the slow barge, or drive the rapid car;
Or on wide-saving wings expanded bear
The flying-chariot through the fields of air.
– Fair crews triumphant, leaning from above,
Shall wave their fluttering kerchiefs as they move . . .

This is from Erasmus Darwin's *The Botanic Garden*[12] published a few years after Burns's visit to the Carron Works. His 'fair crews triumphant' are the epitome of the optimist's interpretation of the powerful linking of rationalism, science, and industry. It might even be described as the 'official' view and, in the form of propaganda, it has at

253 (above left) The membership certificate of the United Kingdom Society of Coach Makers, 1913 (Workers Educational Association, Cardiff Branch)

254 (above right) The membership certificate of The National Amalgamated Tinplate Workers of Great Britain, 1892 (Trades Union Congress)

255 (right) A detail from the membership certificate of the National Agricultural Labourer's Union, c. 1872 (James Klugmann Collection)

times been terribly debased. A thousand text-books echo the dream: a thousand documentaries on the miracles of science embody its emptiness. But it was also the foundation of the splendour of nineteenth-century engineering and of the confidence of the society which supported it.

What we can perhaps never recapture is the sheer wonder and poetic imagery in which this attitude was embodied before the disaster of the First World War. It was an attitude that affected small things as well as big – ephemera as much as monuments. The National Museum of Wales, for example, has a remarkable collection of postcards showing industrial scenes dating from the turn of the century. These were sent just as we would today send pictures of an old castle or a cathedral. There is one, unfortunately undated, sent from South Wales, to an address in Devon, that shows a lump of coal higher than a man. It was hewn at Gelli Colliery and apparently won first prize in a Chicago exhibition. The message is familiar even if the subject on the front is not. 'Dear Bill', it starts, 'I thought I would just write a line to say I received your kind letter and also little Bet's . . .'

What supported this kind of experience was the idea of progress. It allowed for an intimate linking between work and a vision of civilization and posterity. As an attitude it is not to be despised. It vivifies hard and difficult work as a challenge rather than as a task, and it gives to the individual worker a pattern into which his own endeavour can fit. Paradoxically, it has been an integral part of both Puritan and Communist ideology: one that has well served the heroic stage of industrialization in Russia and China as well as in Europe and America.

Although optimists and pessimists both often tried to be objective, there was a big difference of motivation between them and those who set out simply to record. But even here the overlaps in intention are complex and fascinating. To attempt to document the humble lives of the poor was itself the result of an attitude towards society.

It is important to recognize how even the most deliberate attempts at objective recording, whether in art or literature, are caught up in the central problem of selection. The possibility of communicating at all seems to depend on there being an understandable orientation on the part of the story-teller or reporter. The problem is particularly acute where something as elusive as experience is the subject matter. Whenever insight has to fuse with observation, the scrupulousness and sensitivity of the interpreter need to be beyond question. His relationship to the events is added to

256 (above) MINERS' WIVES, a painting by Ben Shahn, 1948 (Philadelphia Museum of Art, given by Wright S Ludington: photograph by Alfred J Watt)

257 (opposite: top) RAIN, STEAM AND SPEED, GREAT WESTERN RAILWAY, J M W Turner's splendidly Romantic painting of a Victorian train (The National Gallery, London)

258 (opposite: bottom) A panel from the *Little Nemo* strip cartoon by Winsor McCay: it shows a view of the enormous Chicago stockyards (Ray W Moniz)

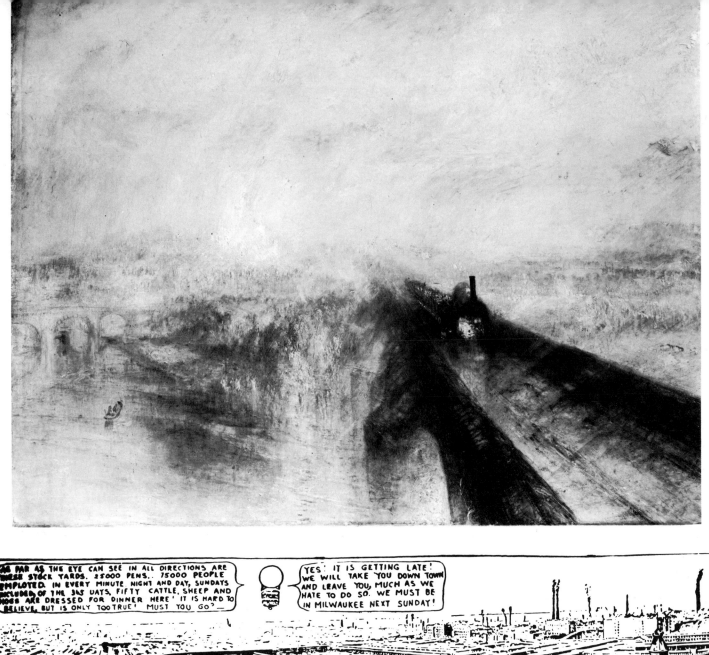

259–261 Three examples from a series of lithographs by the English artist J C Bourne which were published in 1839. They show scenes during the building of the London and Birmingham Railway in 1837. This was one of the first main lines to be completed in Britain and vast teams of navvies gathered to work on it. The centre illustration shows Tring cutting being made. It depicts the primitive pulley system that was widely used for raising loaded barrows up the sides of such earthworks. This was dangerous: men were sometimes killed on the job (Syndics of the Cambridge University Library)

those relationships inherent in the events themselves.

To demonstrate the subtlety of interpretation possible within the idea of 'telling it as it is', it is worth while to quote and illustrate two sets of linked visual and literary material.

The first is from Henry Mayhew's *London Labour and London Poor*,[13] a work which is one of the very first examples of systematic social analysis and which is here placed alongside J C Bourne's plates depicting the building of the London and Birmingham Railway. Mayhew is recording the story of a navvy told in his own words; Bourne what he himself saw while the work was going on. This is what the navvy had to say:

I have been a navvy for about eighteen years. The first work that I done was on the Manchester and Liverpool. I was a lad then. I used to grease the railway wagons, and got about 1s 6d a-day. There we had a tommy-shop, and we had to go there and get our bit of victuals, and they used to charge us an extra price. The next place I had after that was on the London and Brummagem. There I went as a horse-driver, and had 2s 6d a day. Things was dear then, and at the tommy-shop they was much dearer . . . What the contractors, you see, can't make out of the company, they fleece out of the men . . . If we didn't eat and drink at the tommy-shop we should have no work . . . I went to work on the London and York. Here we had only 2s 9d a day, and we had only four days' work in the week to do besides . . . I stopped on this line (for work was very scarce, and I thought myself lucky to have any) till last spring. Then all the work on it stopped, and I dare say 2000 men were thrown out of employ in one day. They were all starving, the heap of them or next door to it. I went away from there over to the Brummagem and Beechley branch line . . . I left the Brummagem and Beechley line, about two months before Christmas before last, and then I came to Copenhagen-fields, on the London and York – The London end, sir; and there I was till last March, when we were all paid off, about 600 on us; and I went back to Barnet. Whilst I was there, I hurted my leg, and was laid up a month. I lived all that time on charity; on what the chaps would come and give me. One would give a shilling, another sixpence, another a shilling, just as they could spare it; and poorly they could do that, God knows! I couldn't declare onto the sick fund, because I hadn't no bones broken. Well, when I come to look for work, and that's three week's agone, when I could get about again, the work was

262 THE WORKING SHAFT, KILSBY TUNNEL by J C Bourne. In this illustration light comes down the ventilation shaft of the tunnel to show the working conditions of men and animals (Syndics of the Cambridge University Library)

all stopped, and I couldn't get none to do . . . I went to a lodging-house in the Borough, and I sold all my things – shovel and grafting tool and all, to have a meal of food. When all my things was gone, I didn't know where to go . . . If I could get any interest, I should like to go away as an emigrant . . . This country is getting very bad for labour; it's so overrun with Irish that the Englishman hasn't a chance in his own land to live. Ever since I was nine years old I've got my own living, but now I'm dead beat, though I'm only twenty-eight next August.

The second is from James Agee's *Let Us Now Praise Famous Men*,[14] an extraordinary study of the work, lives, and homes of a group of sharecropper families in America in 1936. It includes a brilliant series of photographs by Walker Evans which supplement and enlarge the text rather than illustrate it. Here is Agee on overalls. He is not, like Mayhew, recording a story told directly to him: he is trying instead to place himself inside an experience which he knows exists but which has probably never been articulated before.

. . . But overalls are a relatively new and local garment.

Perhaps little can be said of them, after all: yet something. The basis: what they are: can best be seen when they are still new; before they have lost (or gained) shape and color and texture; and before the white seams of their structure have lost their brilliance.

Overalls.
They are pronounced overhauls.

Try – I cannot write of it here – to imagine and to know, as against other garments, the difference of their feeling against your body; drawn-on, and bibbed on the whole belly and chest, naked from the kidneys up behind, save for broad crossed straps, and slung by these straps from the shoulders; the slanted pockets on each thigh, the deep square pockets on each buttock; the complex and slanted structures, on the chest, of the pockets shaped for pencils, rulers, and watches; the coldness of sweat when they are young, and their stiffness; their sweetness to the skin and pleasure of sweating when they are old; the thin metal buttons on the fly; the lifting aside of the straps and the deep slipping downward in defecation; the belt some men use with them to steady their middles; the swift, simple, and inevitably supine gestures of dressing and of undressing, which, as is

207

263–264 (opposite page) Photographs of a sharecropper community by Walker Evans from *Let Us Now Praise Famous Men* by James Agee and published in Britain by Peter Owen Ltd. The photographs were originally made in the context of the work done by the American Farm Security Administration (FSA) during the period of Roosevelt's New Deal. Altogether, FSA commissioned over 270 000 pictures from various photographers. As a whole, they are one of the most remarkable graphic records of the life of the poor ever to have been put together. Roy Emerson Stryker was in charge of the programme: with justice someone called him 'a press agent of the underprivileged'

265 Photograph of a sharecropper by Walker Evans (Peter Owen Ltd, London)

less true of any other garment, are those of harnessing and of unharnessing the shoulders of a tired and hard-used animal.

They are round as stovepipes in the legs (though some wives, told to, crease them).

In the strapping across the kidneys they again resemble work harness, and in their crossed straps and tin buttons.

And in the functional pocketing of their bib, a harness modified to the convenience of a used animal of such high intelligence that he has use for tools.

And in their whole stature: full covering of the cloven strength of the legs and thighs and of the loins; then nakedness and harnessing behind, naked along the flanks; and in front, the short, squarely tapered, powerful towers of the belly and chest to above the nipples.

And on this façade, the cloven halls for the legs, the strong-seamed, structured opening for the genitals, the broad horizontal at the waist, the slant thigh pockets, the buttons at the point of each hip and on the breast, the geometric structures of the usages of the simpler trades – the complexed seams of utilitarian pockets which are so brightly picked out against darkness when the seam-threadings, double and triple stitched, are still white, so that a new suit of overalls has among its beauties those of a blueprint; and they are a map of a working man.

So far we have been much concerned with reservations about the linked ideas of story-telling and recording experience. At the core of the questioning has been the part played by the recorder, his assumptions, motivations, and relationship with society. The reservations are important. To be critically aware of them helps to illuminate the role that art and artists play in the life of the community. For all that, the articulation of experience does happen and is the essential link in the perceptual chain which makes it possible for art to influence life.

The wrapping together of experience with other preoccupations is characteristic and, on any viable theory of art and society, quite inevitable. The variety of material that is involved in interpreting the industrial revolution is

266–269 Photographs of a sharecropper community by Walker Evans
(Peter Owen Ltd, London)

enormous and it operates at various levels in society. As well as sociological masterpieces like Mayhew's book, Dickens's novels, or the socialist novels of the thirties, there is a mass of popular art concerned with every kind of work and every sort of response to it. The range of experience is wide. It can be found in things as different as the desperate prayer that the Walloon coal-miners of Liège used to shout to the cage operator as a signal for him to lower them into the pit, or the reports of British Royal Commissions on conditions in early factories. It includes the petty life of a city clerk as recorded in George and Weedon Grossmith's hilarious *The Diary of a Nobody*, and such momentous books as Engels's study of working-class life, which helped to change the world by describing its condition.

But what comes through most dramatically is the powerful cry for help which came from the common people and which led them to struggle and to develop self-help and self-identity as the only solution to their problems. It is right that this sequence on 'Experience' should end with a raw expression of that pain and confusion. Here, to stand for a vast literature, is a single verse from the *Jone o' Grinfilt*[15] ballads, written by a Lancashire weaver-poet at a time when the handloom weavers were being forced into poverty and destitution, and about contemporary with the Battle of Waterloo in 1815:

Eawr Marget declares, if hoo'd clooas to put on,
Hoo'd go up to Lunnon to see the great mon;
Un' if things didno' awter, when theere hoo had been,
Hoo says hoo'd begin, un' feight blood up to th'e'en,
 Hoo's nought agenth's king, but hoor loikes a fair thing,
 Un' hoo says hoo can tell when hoo's hurt.

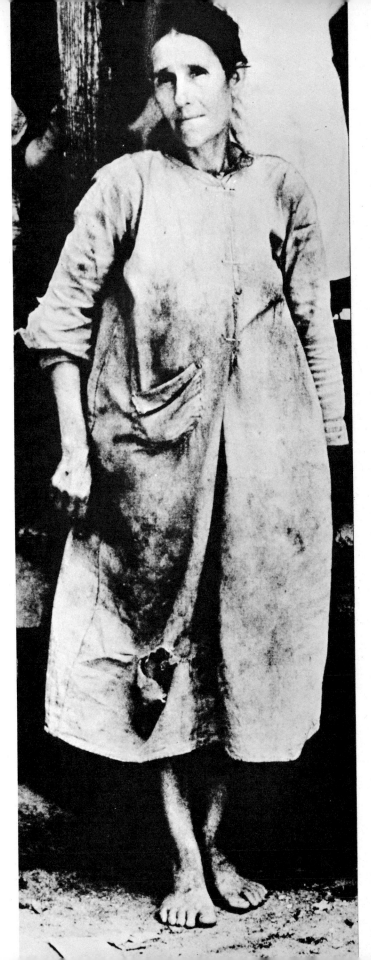

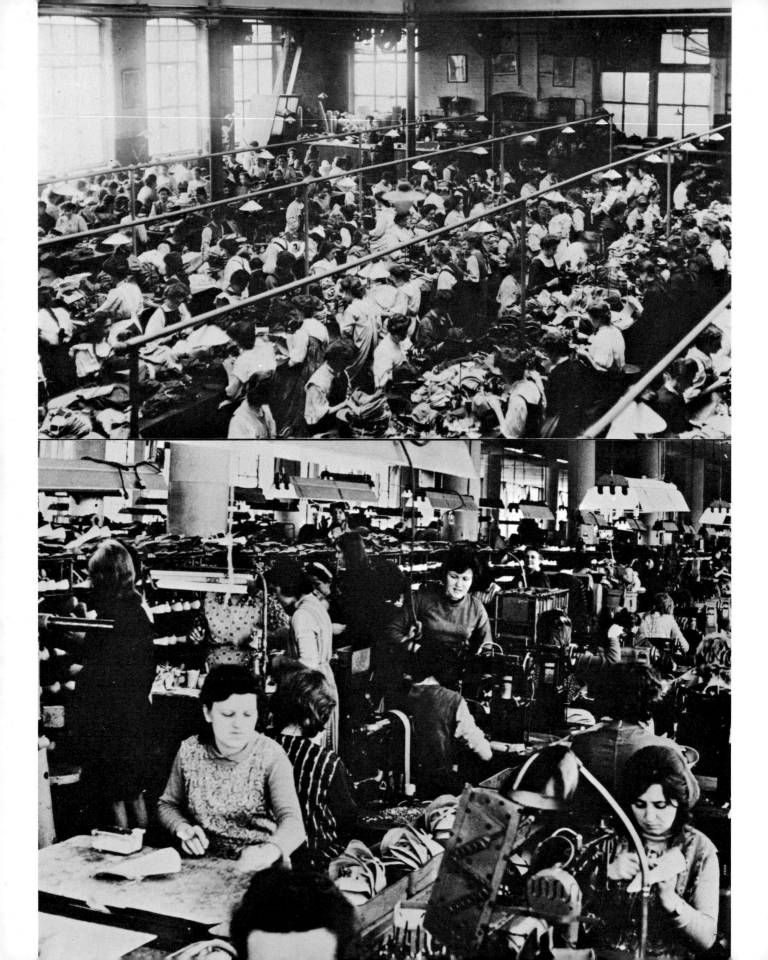

270 (opposite: top) Photograph of workers in a Manchester hatting
factory, 1909 (Radio Times, Hulton Picture Library)

271 (opposite: bottom) Still showing workers from the Czech film *A Blonde
in Love* (National Film Archive)

272 (above) Still showing office workers from the American film *The
Apartment* (National Film Archive/United Artists Corporation Ltd)

273–276 Illustrations from *Life and Adventures of Michael Armstrong the Factory Boy*, 1840. This novel by Frances Trollope told of a child apprentice and was a fierce attack on the abuses of child labour in the textile factories. Since the industrial revolution fiction has consistently dealt effectively with such themes, mixing social protests with entertainment by recording the experience of individual characters in narrative form (British Museum)

WORK: Struggle

Mais quand notre règne arrive
Quand votre règne finira.
Alors nous tisserons le linceul du vieux monde
Car on entend déjà la révolte qui gronde.
C'est nous les canuts
Nous n'irons plus tout nus

from a Lyons silkweavers' song

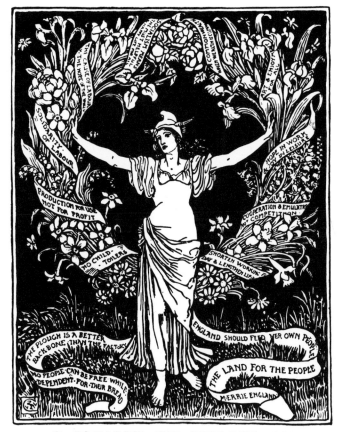

·A·GARLAND·FOR·MAY·DAY·1895·
· DEDICATED·TO·THE·WORKERS·BY·WALTER·CRANE ·

277 (left) A 'round robin' dating from 1896. These signatures appear on a *Notice to Cease Contracts* sent to the Melingriffith Tinplate Works in South Wales. The intention was to prevent the identification of the ringleaders in the dispute. Almost certainly most of the signatures were written by a single hand (British Steel Corporation, South Wales Group)

278 (above) A GARLAND FOR MAY DAY by Walter Crane, 1895 (Mansell Collection)

'A was an archer, who shot at a frog, B was a butcher, and had a great dog . . .' In the section on 'Identity' this ABC of occupations was given as an example of how the identity associated with a job only takes on meaning when seen as part of a whole network of identities mapping out the character of a social structure in terms of work. As an ideal dream this network is one of total mutuality, having a simple wonder similar to that found in perpetual-motion songs like *There's a Hole in My Bucket*, or in expanding songs like *This is the House that Jack built*. In this vision all trades and professions are dependent upon one another and therefore of equal value and importance.

When Jean de Brunhoff's admirable but bourgeois elephant, Babar, became King of the elephants, he set out to establish a new city based on the model of French middle-class civilization, calling it Celesteville after his wife. Celesteville had everything a modern city should have and it therefore provided an environment adapted for work as much as for play. But the elephants accepted the idea of mutuality in their new-found roles:

> The elephants who
> were too old to go to school
> each chose a profession or trade.
> For example:
> Tapitor was a shoemaker, Pilophage an officer
> Capoulosse a doctor, Barbacol a tailor,
> Podular a sculptor,
> and Hatchibombotar swept and watered the roads,
> Doulamor was a musician, Olur a mechanic,
> Pontifour a farmer, Fandago a scholar,
> Justinien a painter and Coco a clown.
> When Capoulosse had holes in his shoes
> he took them to Tapitor, and
> when Tapitor was ill Capoulosse attended him.
> If Barbacol wanted to put a statuette
> on his mantel-piece he told Podular,
> and when Podular's jacket was worn out
> Barbacol measured him for a new one.

279 (left) Pages from *Babar The King* written and illustrated by Jean de Brunhoff. The book is published in Britain by Methuen & Co Ltd (Photograph by Chris Ridley)

280 (right) A page from *The Soviet Calendar 1917–47* (Mansell Collection)

In glorious weather the Grand Fête took place. At the head of the procession marched Arthur and Zephir and the band. Cornelius, wearing his retrimmed hat, followed; then came the soldiers, and the arts and crafts guilds. All the elephants who were not in the procession watched the memorable pageant.

Justinien painted Pilophage's portrait,
and Pilophage defended him against his enemies.
Hatchibombotar kept the streets tidy,
Olur repaired motor-cars,
and, when they were tired
Doulamor played to them.
After solving difficult problems,
Fandago ate fruit grown by Pontifour.
As for Coco
he made them all laugh.

Later in *Babar the King*,[16] Babar, mounted on his wonderful mechanical horse, presided over a procession at a Grand Fête. As he saluted with his trunk, the arts and crafts guilds marched past in grand array with their banners fluttering in the breeze, soldiers and a brass band at their head. In their midst they carried a proud banner 'Each for All – All for Each'.

But contrast the interdependence of roles inherent in the idea of mutuality with this dialogue in Volney's *Ruins of Empire*[17] which people in Britain were reading at the time of the French Revolution:

PEOPLE. What labour do you perform in the society?
PRIVILEGED CLASS. None: we are not made to labour.
PEOPLE. How have you acquired your wealth?
PRIVILEGED CLASS. By taking the pains to govern you.
PEOPLE. To govern us! . . . We toil, and you enjoy; we produce and you dissipate; wealth flows from us, and you absorb it. Privileged men, class distinct from the people, form a nation apart and govern yourselves.

At that time the ordinary people working in the new industries had virtually nothing which we would today recognize as political rights. They won them only after a bitter struggle which was, in its own way, as virulent as real warfare and which only began to be effective after 1848. The war was conducted without the conventional paraphernalia of uniforms, but it involved none the less flags, banners, and processions: art was used in a great variety of ways to symbolize aims, ideals, and identity of interests. What was being articulated was the strife between classes rather than that between nations, but the means used to make the conflict understandable and moving were surprisingly similar.

Rights were one issue. Another was the castigation of the new economic system as itself destructive of human values and relationships. The attack on capitalism, and later on every kind of large technological bureaucracy, was the other great motivating force in the struggle for mutuality. In his *Selected Essays*[18] Karl Marx wrote:

Money degrades all the gods of man and converts them into commodities. Money is the general and self-constituted value of all things. Consequently it has robbed the whole world – the world of mankind as well as nature – of its peculiar value. Money is the being of man's work and existence alienated from himself, and this alien being rules him, and he prays to it . . . contempt for theory, for art, for history, for man as an end in himself, is the real conscious standpoint and virtue of the monied man. The generic relation itself – the relation of man to woman, etc. – becomes an object of commerce.

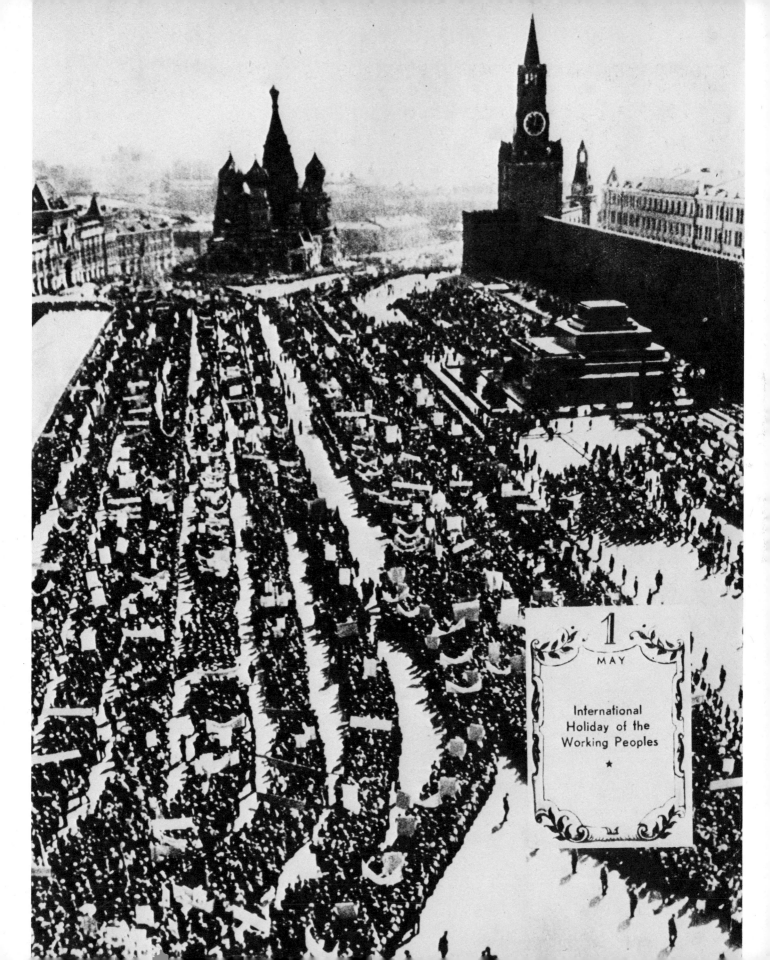

International
Holiday of the
Working Peoples
★

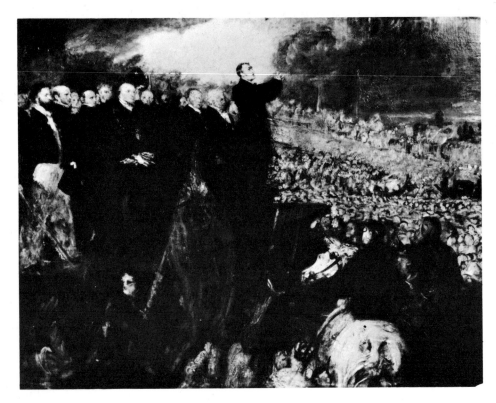

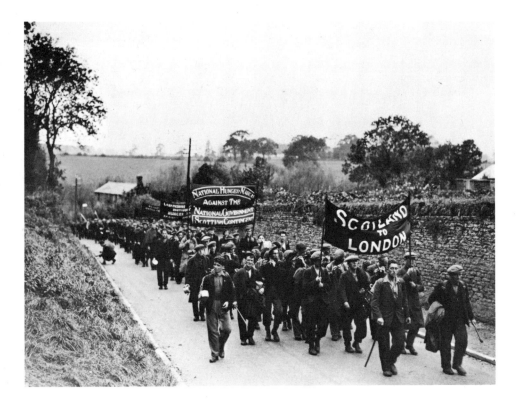

281 (left) THE MEETING OF THE UNIONS ON NEWHALL HILL 1832 by Benjamin Robert Haydon. This painting commemorates a great radical gathering in Birmingham (City Museum and Art Gallery, Birmingham)

282 (bottom left) The unemployed march on London. A photograph taken in 1932 during the depression in Britain (Topical Press/Radio Times, Hulton Picture Library)

283 (opposite) An idealised Russian painting showing Lenin at the Second All-Russian Congress of Soviets of Worker and Soldier Deputies, 1917 (Mansell Collection)

In spite of parody, over-use to the point of banality, and ridicule by those whose situation was less desperate, the exhortation 'Workers of the world, unite and fight. You have nothing to lose but your chains, and a world to win' embodies well the force and extremity of the struggle at the point where it turned into revolution. Rhetoric and gesture characterize the functional art of the moment when class divisions crystallize into violence.

It is easy to be cynical about past revolutions. The twentieth century has too often experienced the pogroms which follow victory and the disillusions which follow reform. We know too much about the pedantry and obscurantism that come when idealism is institutionalized. Only Maoist China appears to be able to continue to arouse primal enthusiasm and devotion long after the original revolutionary days. Although this is a salutary lesson, it is one that can also insult the experience of those who originally took part. The serious intensity of an ordinary soldier in the Bolshevik revolution is not necessarily devalued by the Stalinist terror. There comes a tragic moment when all the oppressed have is their ability to revolt and overthrow their oppressors. In such a moment they take up their cultural resources as a

weapon and, in the events which follow, create a new basis which, for better or worse, has a decisive discontinuity with the culture which existed before.

But there is another use of art, when a revolution has passed, It is to keep the memory of it alive and its meaning vivid. The recent past has produced few religious icons, but it is rich in political devotional pictures, parades, and emblems.

The visual language used is too often dismissed as empty and without interest. Yet, as has already been suggested, these represent the continuation of that age-old function of art discussed in Part Two. They partake, with war memorials, going away presents, souvenirs, and testimonials, in the attempt to weld together the experience of past, present, and future into a tangible physical form.

As work and the struggles and revolutions surrounding it have occupied such a central place in the history of the immediate past, it is not surprising that these events have produced and *needed* such a rich variety of graphic art for their support and for their preservation in the minds of men. What is surprising is the way in which this vast production

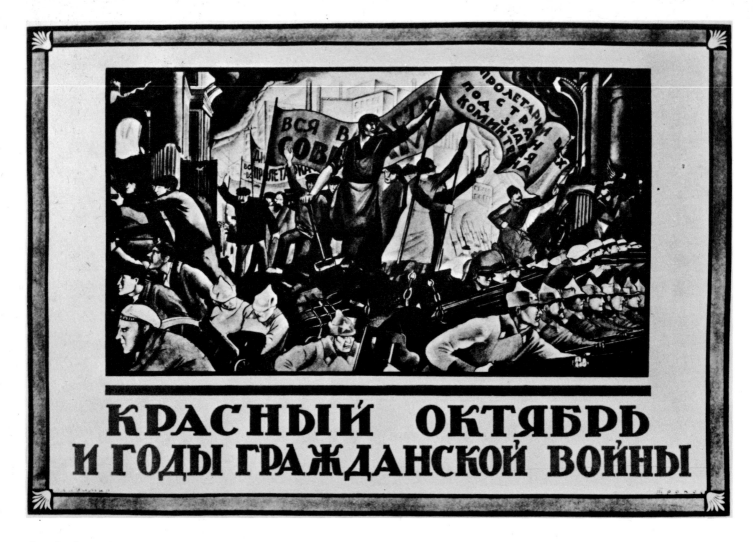

КРАСНЫЙ ОКТЯБРЬ И ГОДЫ ГРАЖДАНСКОЙ ВОЙНЫ

has, in the main, remained outside the domain of conventional criticism. The situation is serious because this body of art connected with the egalitarian ethos of the past two hundred years is one of the key indicators of the spiritual and emotional state of 'industrial' man. It embodies at once his most disastrous mistakes, his most facile optimisms and the most enduring aspect of his great scientific and humanitarian idealism. In a very real sense, it can be said to be the quintessential art of the immediate past.

284 (above) 'Red October and the Years of the Revolution!' A Soviet poster of heroic workers and soldiers (Mansell Collection)

285 (opposite: top) A British poster published by the radical magazine *The Black Dwarf*

286 (opposite: bottom) A photograph by Henri Cartier-Bresson, taken in 1954, and showing a canteen for construction workers in Moscow (The John Hillelson Agency Ltd)

287–292 (overleaf) A series of photographs, now in the possession of the National Union of Mineworkers in Durham, showing events during a strike which is believed to have taken place about 1870. Miners with their families were evicted from their homes which were owned by the colliery companies (National Union of Mineworkers, Durham)

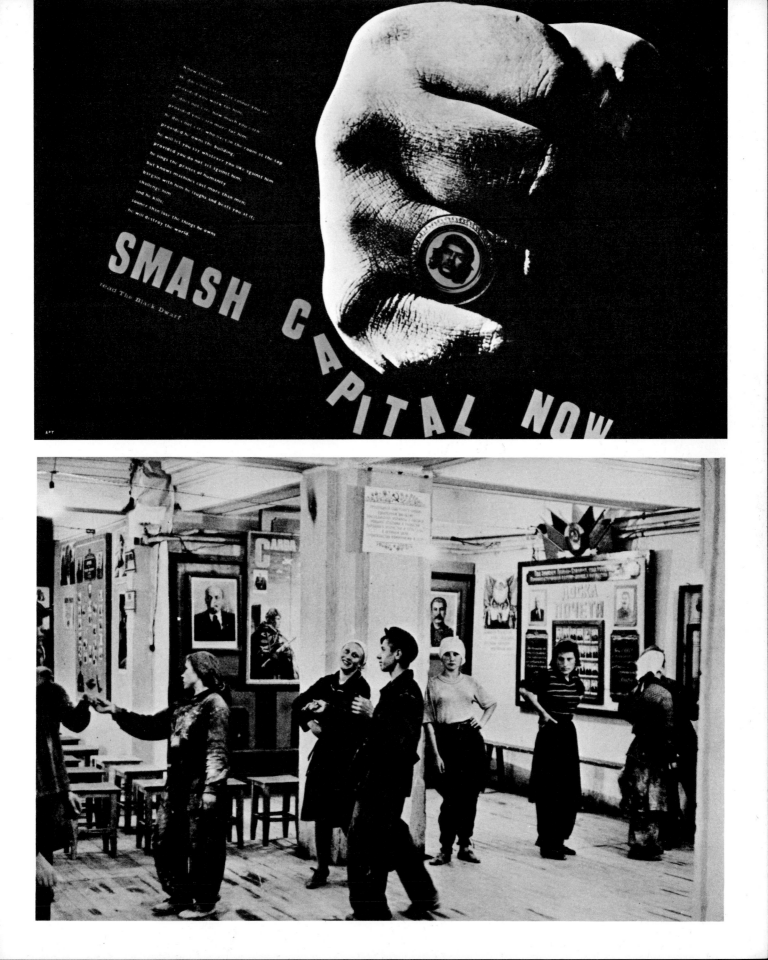

293 (left) An intimidating industrial future is foreseen in the British film *Things to Come*. Based on H G Wells' book, the film appeared in the inter-war years. It is remarkable for its representations of 'modern' architecture (National Film Archive)

294–296 (above) Panels from the British 'funny paper' *Chips*. They depict the work-shy adventures of Weary Willie and Tired Tim, immensely popular tramps who appeared week after week for many years. The comic is now defunct (© Syndication International Ltd, London)

297 (below left) The ludicrous figure of the king from *The Political House That Jack Built*, 1819 (James Klugmann Collection)

298 (below right) Harpo Marx at work in *A Day at the Races* (National Film Archive/Metro-Goldwyn-Mayer Pictures)

Part Five
WAR

In fifty years, when peace outshines
Remembrance of the battle lines,
Adventurous lads will sigh and cast
Proud looks upon the plundered past.
On summer morn or winter's night
Their hearts will kindle for the fight,
Reading a snatch of soldier-song,
Savage and jaunty, fierce and strong.
And through the angry marching rhymes
Of blind regret and haggard mirth,
They'll envy us the dazzling times
When sacrifice absolved our earth.

from a poem by Siegfried Sassoon about the First World War[1]

When the French Revolution set in train the events which led to the creation of a world of large nation states, it also pushed the world decisively into an era of 'total' war. It was ironic that democratic intentions went hand in hand with the development of a modern-style citizen's army which in the future would represent the cutting edge of a struggle in which a whole society would or would not survive The *levée en masse* which the *sans culottes* demanded in the streets of Paris was necessary if revolutionary France was to continue to exist, but it dramatically foreshadowed the gigantic war organizations of the present century. It introduced the huge arena of violence and destruction with which we are now familiar.

Two great wars haunt the imagination of the twentieth century: wars in which the whole of the resources of culture on each side were engaged. The result is a shambles of unresolved dreams and longings: of fears, hopes, and unrequited desires. If we were not so completely involved in the situation, we would surely be struck by the ambiguousness of the fact that, in an era so bloody, so many people should find entertainment in the spectacle of warfare. Yet books, films, and television programmes throughout the industrialized world use conflict as a setting for adventure stories of every kind. At the same time, documentary material has a vast audience. Is this the sublimation of aggression or the continuing resonance of wish-fulfilment? Either way, war plays a disturbingly large role in the spiritual life of contemporary society.

We have already seen how Romanticism came to give sexuality a central place in the dream world of the nineteenth and twentieth centuries. It also promoted and fed upon violence. It made of war a thrilling episode: a context in which the hero and heroine could find and lose one another, where they could face danger, be wounded, wander in strange lands, and finally come home to peace and security. Delacroix's *Massacre at Scio*, painted in 1824, already contains familiar themes which, over a hundred years later, found their appropriate apotheosis in the scale, noise, and movement of the cinema. It is easy to imagine the painting serving as the poster for a film. The characters in the foreground are the protagonists: their roles are played by the stars and it is with them that we, as the audience, identify. The others are extras: we are not concerned with them, they are just a backcloth. In the film, the massacre would be just one episode among many. But it is significant that Delacroix also provided the scenario for these in other paintings – incarceration in a harem, for example, or shipwreck, or a lion hunt. In the Romantic vision of extreme experience, war appears as the biggest thrill of all, the greatest and most dramatic show on earth.

At first sight this aspect of Romanticism may appear superficial and trivial: something that we may take or leave as we wish. On the other hand, it is evidently a phenomenon which has great significance for the interior life of people living in an orderly but highly complex world. It is possible to catch the echoes of it everywhere. In many ways the motive power behind violent student revolt is disgust at the expediency and related rationality that goes with technological bureaucracy. A revolution, like a war, provides a seductive dream medium for romance. At the opposite extreme, monolithic organizations try to preserve links with periods in

300 THE MASSACRE AT SCIO by Eugène Delacroix, 1824 (The Louvre)

301 ACT OF JUSTICE. A French cartoon attacking the terror of the Revolutionary period (Ets J E Bulloz)

their history when they were concerned with adventure and exploration. High technology itself has a strong ability to identify with the romance inherent in its power to battle with nature. Turner's *Rain, Steam and Speed* is a natural ancestor of the US Air Force's superb photograph of an intercontinental ballistic missile rising against the sunset (see page 237).

Because Romanticism today goes so deep it supports a complex layer of comment and involvement. A painting like Lichtenstein's *Whaam!* is romantic, but it is also a revealing statement about contemporary preoccupations. It originates from inside the attitude it is a comment on. James Thurber's short story, *The Secret Life of Walter Mitty*,[2] works in a similar way. The truth and irony of what Thurber has to say about the technological dream world used by Mitty to escape his dull suburban life does not destroy our own involvement in the same dream. Rather we recognize Mitty's problems and attitude as our own:

. . . The pounding of the cylinders increased: ta-pocketa-pocketa-pocketa-POCKETA-POCKETA.

232

The Commander stared at the ice forming on the pilot window. He walked over and twisted a row of complicated dials. 'Switch on No. 8 auxiliary!' he shouted. 'Switch on No. 8 auxiliary!' repeated Lieutenant Berg. 'Full strength in No. 3 Turret!' shouted the Commander. 'Full strength in No. 3 Turret!' The crew, bending to their various tasks in the huge, hurtling eight-engined Navy Hydroplane, looked at each other and grinned. 'The Old Man'll get us through,' they said to one another. 'The Old Man ain't afraid of Hell!'

'Not so fast! You're driving too fast!' said Mrs Mitty. 'What are you driving so fast for?'

Romanticism exists as the tangible expression of men's continuing identification with figures of superhuman ability and violence, sexual prowess and ecstasy.

Beneath the romantic layer it is possible to glimpse another which is even more fundamental and intractable. It is important to recognize that it is no accident that, for many Europeans, two wars seem to represent the most vivid part of their lives. On reflection, it becomes understandable that it is these years which stand out in their precision of purpose and extremity of experience. They inevitably have a sharpness which the generality of confused social existence in a large industrial state cannot have. It was to this fact that the German writer Ernst Bloch was pointing when, in 1930, he wrote in his book, *The Inheritance of our Time*,[3] that 'the vulgar marxists are not keeping sufficient watch on what is happening to primitive and utopian trends. The Nazis are already occupying this territory, and it will be an important one.' It was. The tribal certainties of fascism, supported by the mesmeric rituals of Hitler's Germany, swept aside the liberal doubts and uncertainties of the Weimar Republic.

When the Irish writer, Sean O'Faolain,[4] talked about his life in a recent BBC broadcast for Northern Ireland, he identified the piercing reality of this kind of

302 WHAAM! by Roy Lichtenstein (Tate Gallery, London)

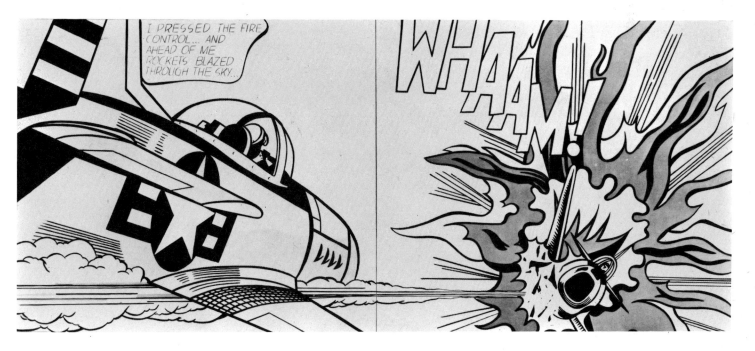

experience. Here is how he described his experience as a private in the IRA in the years immediately before Eire obtained its independence from a reluctant and oppressive Britain:

The French Revolution and the Irish Troubles bear little comparison with one another in point of bloodshed, military glory, foreign conquest, moral disarmament, ecclesiastical reform, the curtailment of the aristocracy, and financial bankruptcy. However, in such matters size is purely a matter of digestion, and I am sure that between 1800 and the fall of Napoleon no dragoon in the *Grande Armée* consumed more emotion than I did as a private in the Irish Republican Army between 1918 and 1924. It was one of the most ecstatic periods of my life, during which all moral problems vanished in the fire of patriotism, and death, destruction, bloodshed and brutality became dear alike to God, Ireland and the British Cabinet.

O'Faolain went on to describe how he became disillusioned with 'those heavenly years', but the nature of his infatuation is clear. He was in love with certainty: with a cause that simplified the complex face of the world into a black and white silhouette and which called for courage and comradeship.

The uncomfortable truth seems to be that the culture of war is like traditional culture in microcosm: that is why it exerts such a powerful fascination. It exemplifies vividly the simplification of possibilities. Its effect upon the individual is imperative. Goals are clearly prescribed, life is purposeful, simplified, and collective. War means rigidly hierarchical structures, strongly symbolic art, and closely confined patterns of behaviour. With it we may contrast the characteristics of a pluralistic society. Here goals are various and confused, life is free to proliferate into exotic and complex paths, and collectivization is confined to small groups who hold specific interests and attitudes in common. The influence of shared cultural forces on the individual is weak and there is not likely to be any clearly agreed programme for society as a whole. Art will not be symbolic: it will be personal and even eccentric.

The issues raised by the culture of war are piercingly topical, and not only in terms of our efforts to attain a peaceful world. The microcosm exhibits such a clear affinity between purposefulness, and order and ritual, that it seems to demonstrate that hierarchy and power are inseparable from social clarity and therefore from human community. In short, that it is traditional 'aristocratic' culture which actually functions best. But this is the opposite of the ideal underlying the great humanitarian impulses which have inspired the most brilliant reforms of the past century and a half. During this period, radicals everywhere have looked to a lessening of man's exercise of power over man and have thought that from this would grow not confusion but a greater wealth of mutual understanding, sympathy, and respect. The enterprise has been for man to recognize man in everyman and to give substance to Donne's superb statement that 'no man is an island'. Is it possible that this aim must founder on the central reality of culture's social function? How can we evaluate the trade-off that seems to occur between intensity of purpose and involvement? The old pattern means the subordination of the individual, but

303 An illustration showing the spirit of Ireland rising from amongst Republican soldiers fighting the British in 1916. It appeared on a poster produced at the time by 'The Art Depot' in Dublin (Imperial War Museum: photograph by Chris Ridley)

234

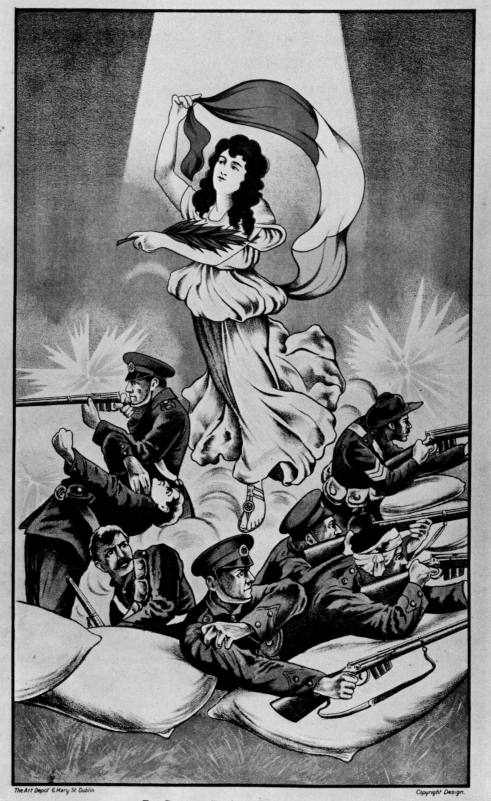

THE BIRTH OF THE IRISH REPUBLIC - 1916.

freedom for the individual seems as though it may mean a weak kind of social involvement, perhaps the trivialization of popular culture and apparently the mild or strong alienation of the majority of people one from another.

It is as though we find ourselves in a 'double-bind' situation. We may have close-knit groups of people strongly involved with one another within the group but who inevitably define their interests by conflicts with other groups. Or we may have a loose and flexible society whose members become so alienated from one another that loneliness and frustration inevitably sinks into anarchy. The dramatic thing is that today all European/American cultures appear to contain both these directions at the same time. On one scale our cultures are loose and uninvolving, but at the level of the nation-state and the street-gang the necessary conditions exist for mobilizing resources for warfare.

Two dialectics are at work. They are concerned with the definition of brotherhood and their resolution remains the single most important cultural question facing mankind. How can men identify strongly with one another on a small enough scale for clarity of purpose and yet avoid the crystallization of enmity that leads inevitably to a vision of others as sub-human? Deeper still: how can collective purposes be defined except in terms of human conflict? Deeper yet: does the structural, simplifying contribution of culture conflict absolutely with the diversity of possibilities for human response and development? Since men have created the totality of their own strivings by means of culture, can the desire to do great things, run risks, and display courage be wrenched free of a context where it inevitably means that lives are destroyed and resources wasted?

These are not questions that are likely to be answered simply. But they do suggest that it would be worth while to look more closely at some of the most frequently neglected cultural aspects of total war. In the context which we have just explored, propaganda, in the most far-reaching sense of the word, becomes less an aesthetic nonentity than a central element in twentieth-century art. So do the signs and symbols of aggressive conformity and violence. So do the realistic images of warfare which, through the mass media, may counter Romanticism and act as reminders of futile waste and suffering. When such things are examined in their historical setting it may become easier to forecast the outcome and, at the same time, to obtain some insight into the possibilities and limitations of contemporary mass culture.

304 (top) An official US Air Force photograph taken as the '200th Minuteman II ICBM Blasts Off'. It is by the 13-2d Photo Group (United States Air Force)

305 (bottom) During the Chouan uprising the new well-trained French army that resulted from the Revolution was used against fanatical but ill-armed peasants. This cut-out gouache is by Le Sueur (George Rainbird Ltd/M. Bidault de L'Isle/Musée Carnavalet, Paris)

WAR: Symbols

Art is no less involved in a Nazi banner than in a pacifist poster. In purely aesthetic terms, a Nazi banner may even be stronger and more dramatic, a visual symbol of great intensity. The emotions that men feel for and against insignia – the cross, the hammer and sickle, the plough and the stars – are specially potent in the link between art and war, but they also characterize in a general sense the functional link between art and social coherence.

Symbolism is intimately involved in the conceptual framework which makes war possible. It provides a visual means of expressing the abstract national and religious ideas which hold together the individual and the group. The basic multiplication table from one soldier to platoon, to company, to regiment, to nation depends on a complex structure which must somehow be made comprehensible if it is to work. At bottom, even the existence of war can be seen to be dependent on the effectiveness of symbolism and its associated rhetoric.

Stephen Crane's story *The Red Badge of Courage*[6] is one of the most vivid representations of large-scale war in literature and one of its fundamental insights is into the identification which martial symbols support:

Once the youth saw a spray of light forms go in houndlike leaps towards the waving blue lines. There was much howling, and presently it went away with a vast mouthful of prisoners. Again, he saw a blue wave dash with such thunderous force against a grey obstruction that it seemed to clear the earth of it and leave nothing but trampled sod. And always in their swift and deadly rushes to and from the men screamed and yelled like maniacs.

This small extract contains much that explains the purpose of military forms of art. Even today blue and grey symbolize for Americans the clash between two decisively opposed traditions of life. The 'Thin Red Line' description of Britain's small army at the height of her imperial power carries the same kind of tense meaning. So did the crosses of the crusaders.

306 (left) A selection of model aircraft transfers for use on miniature war planes made from plastic kits (Airfix Ltd: photograph by Brian Gardiner)

307 (above) Hitler in a still from Leni Riefenstahl's Nazi propaganda film *Triumph of the Will* (National Film Archive)

So did Rome's eagles. Behind the banners and insignia, behind the unique rousing power of national or religious war hymns, behind the martial ballet of the drill square, behind a thousand symbolic devices designed to sink individual identity in that of the religious or national group, lies the central tenacity and meaning of militarism.

Anybody who has ever been to a vast parade of soldiers, or seen a fly-past, or a fleet of warships can feel in touch with the immensity of the emotions that are locked up in these spectacles and reinforced by them. It is indeed at this point, and with a frightening intensity, that the concept of violence between nations and the cultural forms which support that violence, merge with the whole question of national and individual identity:

Once more unto the breach, dear friends, once more;
Or close the wall up with our English dead! . . .
Dishonour not your mothers; now attest
That those whom you call'd fathers did beget you!

Be copy now to men of grosser blood,
And teach them how to war. And you, good yeomen,
Whose limbs were made in England, show us here
The mettle of your pasture; let us swear
That you are worth your breeding; which I doubt not;
For there is none of you so mean and base
That hath not noble lustre in your eyes.
I see you stand like greyhounds in the slips,
Straining upon the start. The game's afoot:
Follow your spirit; and, upon this charge
Cry 'God for Harry, England and Saint George!'

The significant thing about this magnificent speech, which Shakespeare put into the mouth of Henry v,[7] is that not only is it intended to unify and inspire 'good yeomen, whose limbs were made in England' but that it is also directing them against the enemy, in this case the French. This appears to be absolutely fundamental in any such warlike identification. It links Shakespearean heroics with the most sordid expressions of anti-Semitism or racial intolerance. It is literally an effort to de-humanize the enemy and its function

309 (above) A German dinner plate commemorating a tank campaign (Imperial War Museum: photograph by Brian Gardiner)

308 (above) A model soldier made from a kit and painted by an enthusiast (Lynn Sangster/Historex)

310 (right) A 'Shrine' in a British street in the First World War (Beaverbrook Newspapers Ltd)

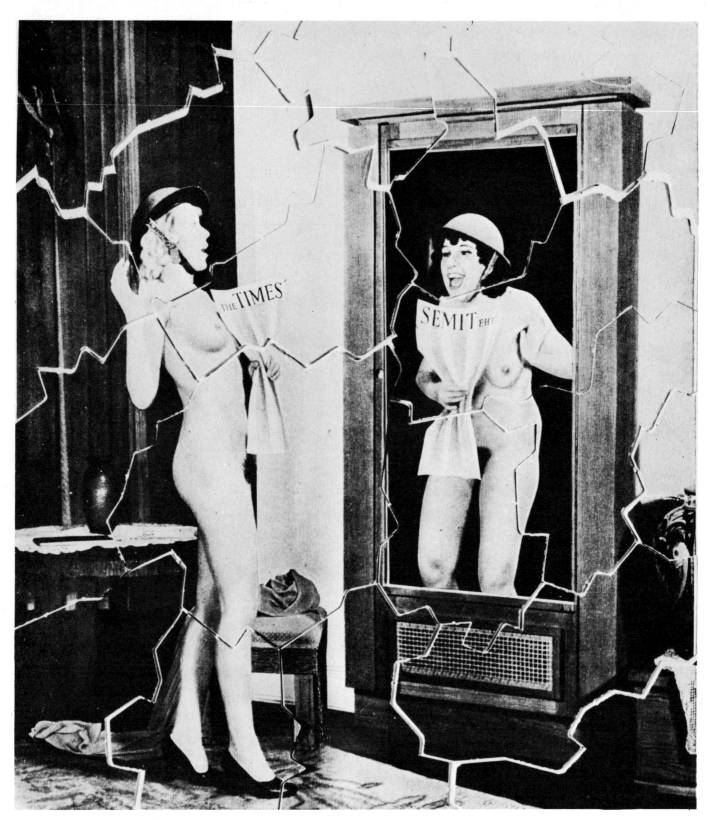

311 A German propaganda jigsaw produced during the Second World War.
It attempts to suggest Jewish influence over the British press (Auckland
Collection/The Psywar Society)

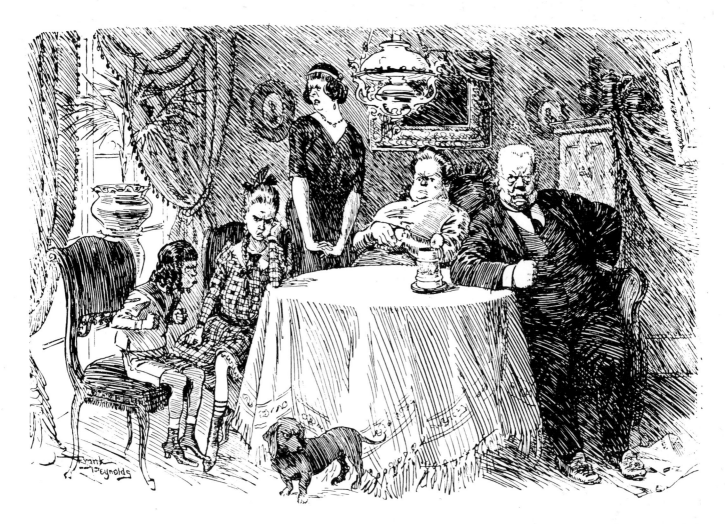

312 STUDY OF A PRUSSIAN HOUSEHOLD HAVING ITS MORNING HATE. An anti-German cartoon by Frank Reynolds, published in *Punch* during the First World War (Reproduced by permission of *Punch*)

is either to diminish the terror of the thought that he may turn out to wield effective power or to excuse our assault on him.

The cartoon above is by Frank Reynolds. It shows *A Prussian Household having its Morning Hate* and dates from the First World War. In its own way it must have had a function complementary to the speech of King Henry. It was a loaded representation of 'the enemy'. It is a little hard now to reconstruct the exact meaning that the drawing would have had when it appeared in *Punch*. Was it to be taken seriously? Did readers really believe that Prussians looked and acted like this? Presumably not, though many straight-faced contemporary representations of Germans as stage villains now seem absurd to us. More likely it was funny. Who could not take on and beat these grotesques?

Grandpa and grandma like balloons waiting to pop, mother a genteel gargoyle, the children, and the sausage dog caught up in it all.

Laughing at the idiocy of foreigners has an ancestry of great length but, in wartime, it has extra significance and seems to well up spontaneously in an outburst of xenophobia. The art of invective drenches a society at war, creating something like a temporary mass myth of the enemy's combined beastliness and incompetence. All this the Reynolds cartoon perfectly exemplifies, making clear a particular aspect of art's involvement in the effort to sustain national morale and self-consciousness at a time of crisis.

Since these processes are frequently caught up in the scintillating rhetoric of mass parades or meetings, emotional

music and sweeping poetry, it is particularly important to look coolly at what is being articulated. Here, dressed in the distancing jargon of professionalism and taken from the *International Encyclopedia of Social Sciences*,[8] is a description of the nature of what is known as 'scapegoating':

Scapegoating is probably the most common form of ideology focused on the causes of the strain. Scapegoating is the displacement of blame for frustration from the true cause into a person or persons, a group or groups, who have little or nothing to do with the frustration. For scapegoating to occur, some, at least, of the scapegoaters must be unaware of the irrationality and injustice of what they are thinking and doing. They, as well as the scapegoats, must be the victims of ideology. These victims – the scapegoaters themselves – may or may not also be the victims of propagandists who are deliberately deceiving them in order to mobilize or divert their energies.

. . . in every case one should also seek to understand both the susceptibility of the audience to the distorted ideas and the

313 (left) A Russian anti-German poster produced during the Second World War (The Lords Gallery, London)

314 (right) A French anti-Semitic poster produced at the time of the elections in 1889 (The Lords Gallery, London)

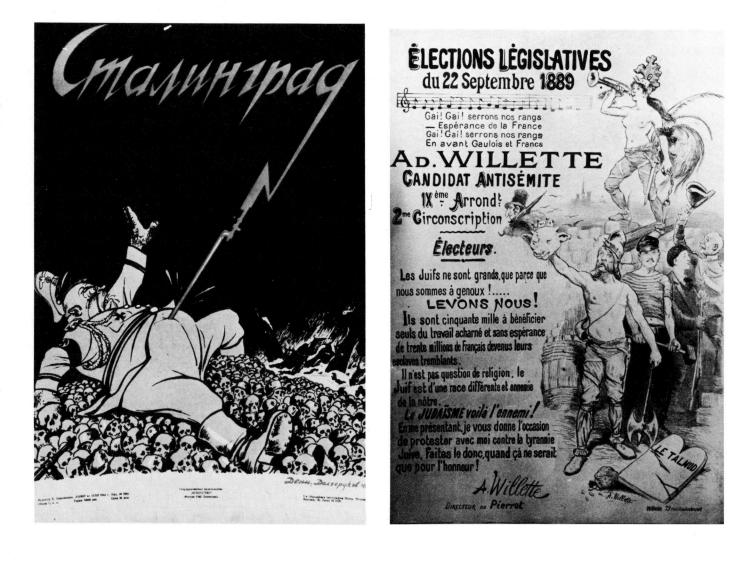

315 THE SCAPEGOAT by Holman Hunt. This splendid but over-dramatic
Victorian painting vividly illustrates the custom which has given its name
to what sociologists recognize as 'scapegoating' in human communities
(City of Manchester Art Galleries)

vulnerability of the scapegoat. These are related. The selection of a scapegoat is not determined by its weakness alone; the scapegoat is always SYMBOLICALLY connected with the frustration of the scapegoaters.

Clearly this is more like what happens today in racial prejudice, or what happened in the European witch frenzy of the Counter-Reformation period, than it is like the cultural glue which binds an army together. But in the wider picture of conflicts between nations the parallel holds good even when, as is often the case, the clash of interests is real and practical. The striking thing is that issues of economics or political power are forgotten when the struggle starts: at once the battle takes on the aspect of an encounter between good and evil. The cultural context is one which lifts warfare to a place in man's most exalted mythology about himself. It is from these heights that it is so extraordinarily difficult to dislodge.

316 (bottom left) An American poster for a book about 'The Ku-Klux-Klan *against* the Carpet Bagger' (The Lords Gallery, London)

317 (bottom right) A Russian propaganda cartoon directed at discouraging cooperation with invading Germans during the First World War (Imperial War Museum)

318 (right) Cornel Wilde shouts rage and defiance at the enemy in the American film *Beach Red* (National Film Archive)

319 (top left) An American poster produced in the First World War (Imperial War Museum)

320 (bottom left) USA – EVERY CRIMINAL LEAVES HIS MARK, a Russian anti-Vietnam poster by E Kaxhdan, 1966 (Welsh Arts Council Collection)

321 (above) An American anti-German recruiting poster designed by James Montgomery Flagg during the First World War (Imperial War Museum)

322 (right) A Chinese Red Guard propaganda poster (Central Press Photos Ltd)

323 (left) An early twentieth-century drum shield used by the Royal Regiment of Wales (The Royal Regiment of Wales: photograph by Brian Gardiner)

324 (below) The German Imperial eagle from a helmet of the First World War period (Imperial War Museum: photograph by Julian Sheppard)

325 (right) An 'idol' erected in a French town during the First World War to encourage saving (Beaverbrook Newspapers Ltd)

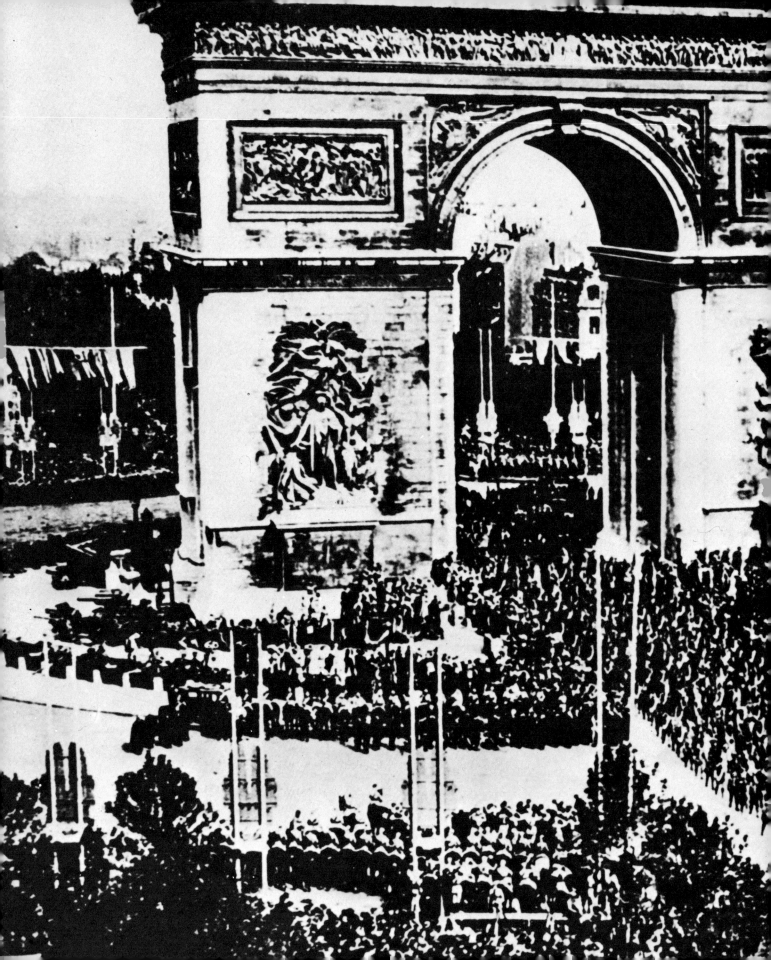

326 PATHS OF GLORY. A photograph of the Armistice celebrations in Paris which followed the end of the First World War (Beaverbrook Newspapers Ltd)

327 The badge of *HMS Bellona*
(Imperial War Museum:
photograph by Brian Gardiner)

328 (right) Lapel badges, postcards
and charity ribbons produced by
the various countries involved in
the First World War (Imperial War
Museum: photograph by Chris
Ridley)

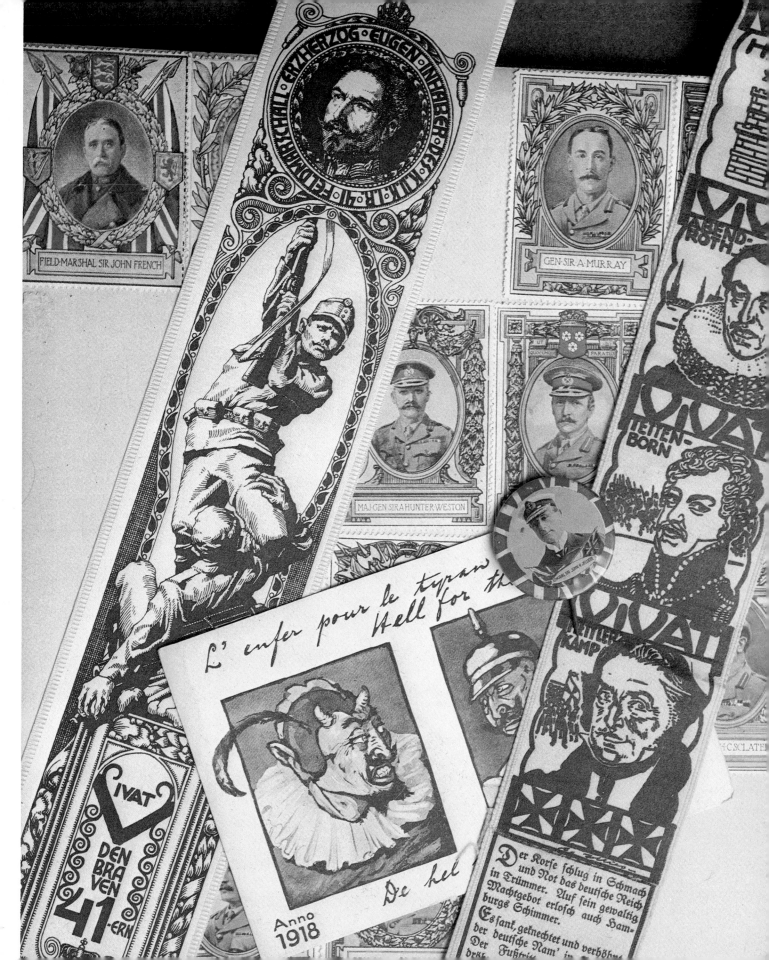

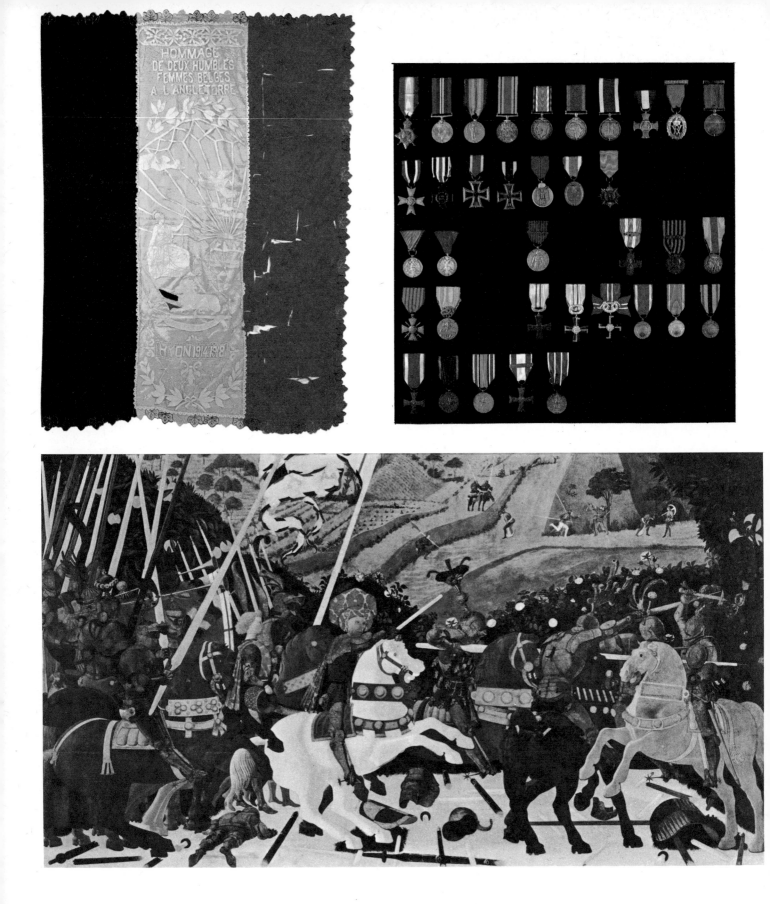

WAR : Images

329 (opposite: top left) A hand-worked flag produced during the First World War and inscribed 'Hommage de deux humbles femmes Belges à l'Angleterre' (Imperial War Museum: photograph by Brian Gardiner)

330 (opposite: top right) A selection of European medals and ribbons (Imperial War Museum: photograph by Brian Gardiner)

331 (left) THE ROUT OF SAN ROMANO by Paolo Uccello. This early Renaissance painting was an experiment in perspective as well as the picture of a battle (The National Gallery, London)

332 (above) VERY MUCH UP, a First World War *Punch* cartoon by Bernard Partridge (Reproduced by permission of *Punch*)

Art is not detached from life. Yet it maintains its own identity. It works – can only work – through the ingredients of its own visual language and the historical precedents that it has set and that have become accepted. This operates at a number of levels. In patriotic posters there is one kind of gesture; in pin-ups another. Innovation crystallizes and becomes a genre. Popular imagery is made up of thousands of these limited areas where communication is carried on through the stereotypes of a particular form. Thus the visual language of the regimental badge is totally different from the visual language of the political cartoon, and this difference is an essential part of the possibility of communication. The distinctiveness of each form gives the viewer a frame of reference, a visual clue about how the message is to be read.

The link between stereotypes and communication brings us face to face with the contradictory nature of all art and design, whether it is Uccello's *Rout of San Romano* or a *Punch* cartoon. A *Punch* cartoon is a *Punch* cartoon before it is anything else. We can propose it as a rule that a painter wants to paint because he is obsessed by art, not only because he is inspired by events in life. That a film maker is obsessed by films, not only by social purpose or the simple desire to communicate. Similarly with a writer – it is other writing which is normally the starting point for his work. The role of art in the life of an artist must be different from the role of art in the life of society. It is important to understand this at the moment when we are considering art's role in interpreting war because it affects what art can say and how it says it.

For example, the work of Paul Nash, who painted pictures in both world wars, demonstrates the way in which an artist will search out images to fit his own vision. As Nash's work was normally lyrical, built on a pantheistic feeling for the movement of the seasons in the English countryside, his war paintings are often quite peaceful. It is interesting to compare his famous picture of First World War desolation,

257

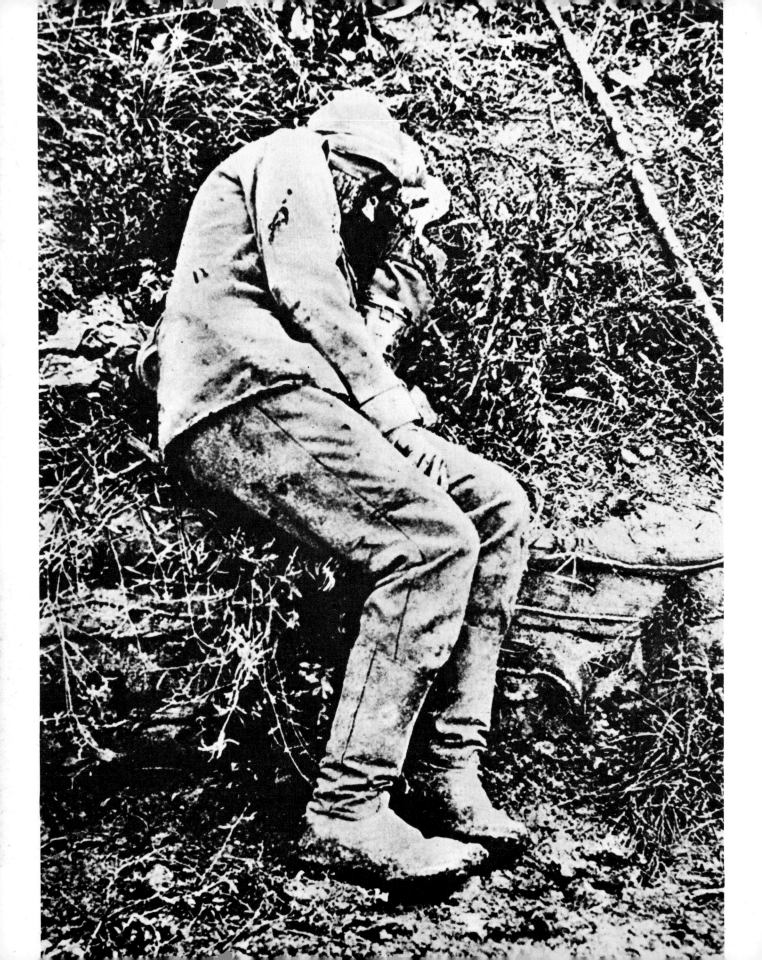

333 (left) ICH HATTE EINST EIN SCHÖNES VATERLAND; ES WAR EIN TRAUM. A First World War photograph of a German corpse in the trenches (Beaverbrook Newspapers Ltd).

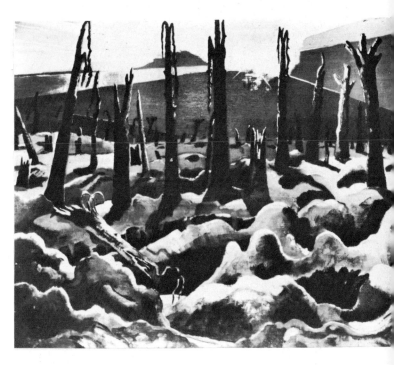

We are making a New World, with photographs of actual conditions at the front. In spite of the unearthly red cloud and the fungus-like mounds in the foreground, there is a feeling of order which depends on the painting's composition and structure. This orderliness is completely missing from the mindless chaos depicted in the photographs, and seems to come from Nash's own sensibility. It is probably the only way in which he could come to terms with the subject as an artist. In the Second World War he painted the beautiful aircraft trails in the sky over south-east England and – an extremely effective picture – the hulks of destroyed German aircraft dumped in a pattern recalling the waves rolling onto a deserted beach.

But it is Goya who shows, most dramatically, the tremendous complexity of the interaction between art, everyday life, and the world of the imagination. Perhaps no other artist has interpreted so compellingly, the enormity of the heroic illusion about war or showed so decisively its foundation in mindless terror and negation. Significantly, the events which provided the basic material for his work were directly connected with the upheavals caused by the French Revolution and its aftermath. However, it does not make sense to suppose that Goya's great etchings on *The Disasters of War* originated solely, or even mainly, from his experiences. There is in them a complicated tension between antecedents in art, the techniques of etching, actual events, Goya's own horror of war, and the phantasmagoria of his imagination. If the depths had not already been there inside Goya, it is unlikely that he could have interpreted them in the way he did. André Malraux makes this clear in his book *Saturn, an Essay on Goya*:[10]

Again, there is here no more a reporting of war than before there had been a reporting of sorcery. The element 'from life', in the *Disasters*, as in the *Caprichos*, is indeed slight . . . Like all artists Goya eagerly probed reality for what he needed; a gesture, a kind of lighting, very often an expression, by isolating them from their surroundings and by introducing them into his dream, the dream to which they had given shape.

334 (above) WE ARE MAKING A NEW WORLD, a painting of First World War desolation by Paul Nash (Imperial War Museum)

335 (below) A still from Lewis Milestone's anti-war film *All Quiet on The Western Front*. It was made after the First World War (National Film Archive)

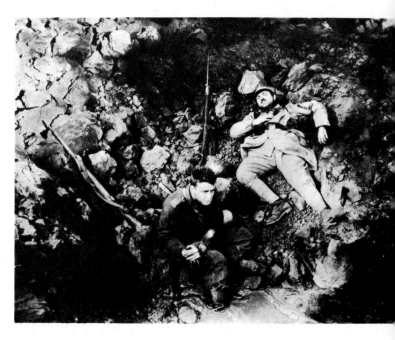

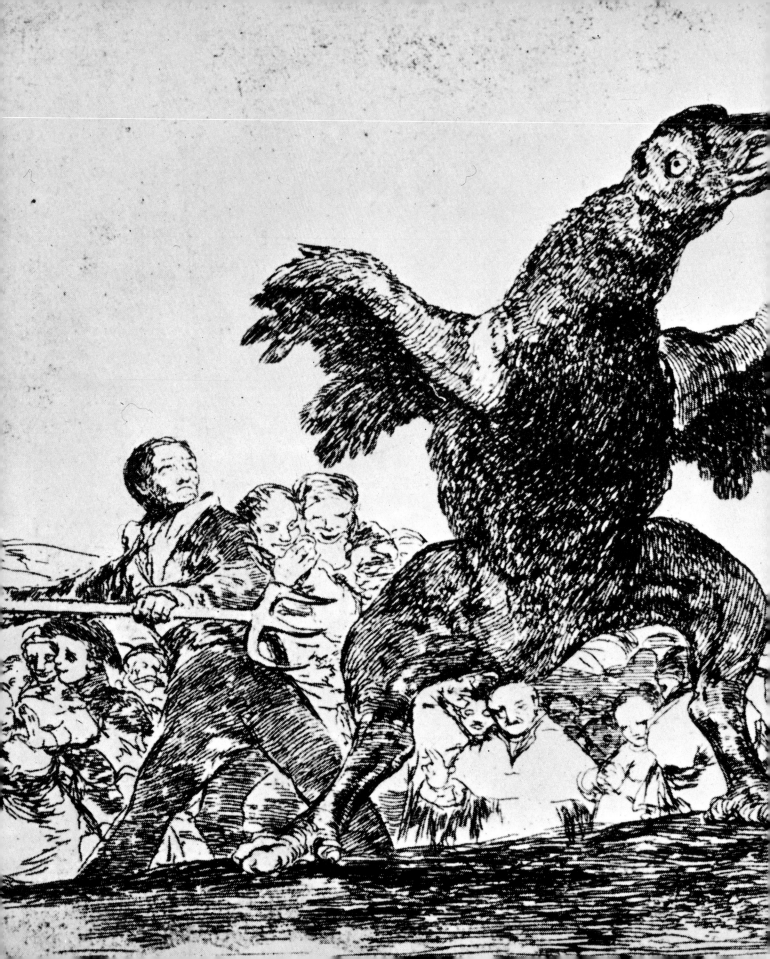

336 One of the DISASTERS OF WAR series of etchings made by Goya during the Napoleonic invasion of Spain (British Museum)

At the same time, his work did come from the upheavals of his day, and had bitter relevance for them. Malraux also writes:

Is it often given to an artist to embody his age-long obsessions in the suffering of a people? His art, till then incurably solitary, suddenly embodied the brotherhood of Spain . . . The *Disasters* take on their full meaning when we realize that they are not only the work of a bitter patriot but also of a deceived friend, [they are like] the sketchbook of a communist after the occupation of his country by Russian troops.

So we too, living one hundred and sixty years later, recognize the meaning of Goya, and see that his work illuminates our own crisis, our own black night:

His genius sprang from other sources; from the dialogue that has gone on, ever since the songs of Sumeria, between the closed lips of a tortured child and the face, for ages past invisible – and perhaps inexorable – of God. He [Goya] also bears witness, on the other side. An endless procession of misery moves forward from the depth of ages towards these figures of horror and accompanies their torments with its subterranean chorus.

With rage Goya asks 'Why?' It is a question at once metaphysical and psychological, reaching beyond the fact of war into the meaning of suffering and the meaning of life. The question, and the visual form which Goya found for it, are as vivid now as they ever were. But, because Goya was an artist, it is impossible to wrench his work completely free from the context of art and history. Malraux ends his book with these words: 'And now modern painting begins'.

Goya's astonishing achievement was to develop a form which exposed plainly the futility of violence. His language of images is powerful enough to stand against the romantic frisson of tales of adventure while its tattered soldiers are an effective reproach to the shining symbols of uniforms and flags. There are no victors in Goya's world: only victims. Murderers and murdered alike are sunk into a limited and inhuman world of violence: it is black and claustrophobic, savage and atmospheric.

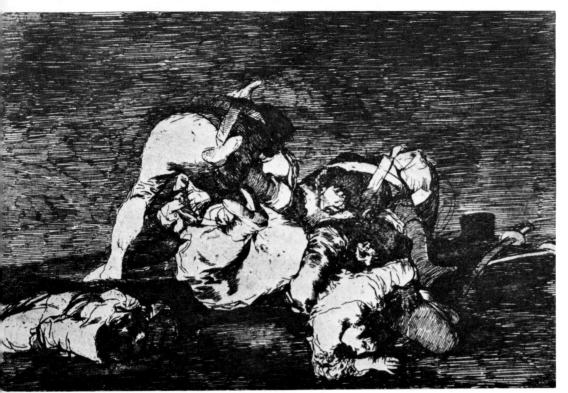

Goya produced a brilliant tool which others have taken up. His 'expressionism' has proved to be a widely appreciated and used method of asserting the absurdity of violence. It has not only been an attitude for great artists who, in their different ways, assaulted the conditions of their time by means of the spectres that stalked their imaginations. It has also been at the basis of that kind of black comedy which is mordantly applicable to hollow patriotism and jingoistic profiteering, and which the twentieth century has made peculiarly its own. After the cataclysm of the First World War, disillusion was cauterized by some of the bitterest humour ever produced. Today such comedy burgeons and continues to berate and attack the age-old weaknesses of the human race. A slap-stick version of the Ten Commandments, it has the terrible sharpness of true despair.

As an assault on the power and unreason of institutions and on those who serve them mindlessly by placing duty above conscience and profit above humanity, it is a tremendously healthy and invigorating element in society.

The faces of the people in Goya's world have the look of survivors: they appear to have suffered some terrible accident. Their eyes are round with shock. They stoop close to the earth. They are dirty and they do not laugh. It is an aspect of man with which we are most familiar through the medium of photography. Those same exhausted eyes which

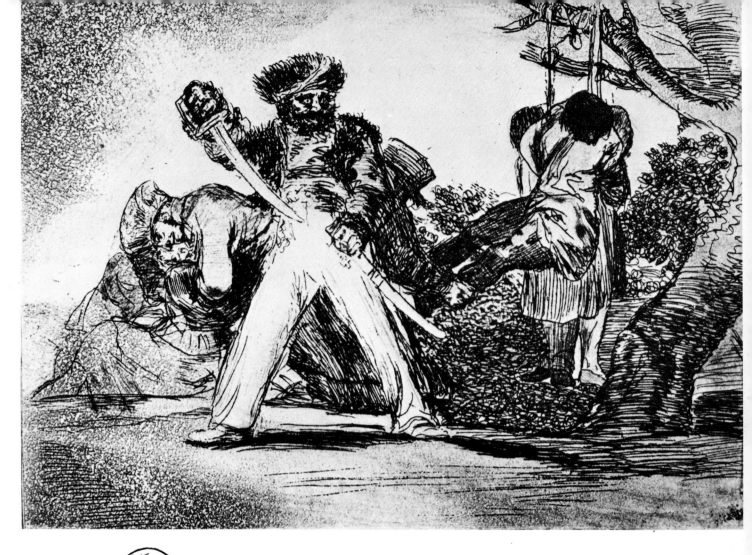

340 A British First World War cartoon by Fougasse. The caption reads as follows: *First Contemptible*. 'D'you remember halting here on the retreat, George?'/*Second ditto*. 'Can't call it to mind, somehow. Was it that little village in the wood there down by the river, or was it that place with the cathedral and all them factories?' (Reproduced by permission of *Punch*)

Goya etched during the Franco–Spanish war also stare out of numerous First World War photographs. Goya predated photography, but this aspect of realism about the true image and meaning of war is one which the mass media have carried alongside Romanticism. It must be one of their greatest contributions to man's efforts to attain a more peaceful world for it, above all, gives the lie to Sassoon's soldier-song 'savage and jaunty, fierce and strong', showing instead the grim truth about the 'plundered past'.

Before the invention of the camera, every representation of a battle, or a soldier in a battle, required the recreation – the reconstruction – of the scene in the form of a painting or sculpture. For centuries, the work of artists was integrated in the mechanism of state and church power and the language of their art rarely permitted the idea of questioning that power. The invention of printing was a decisive moment, but it was photography that finally made the suffering of the common soldier as widely accessible as the portrait of the brave and wise general or the aesthetic grandeur of the set-piece battle picture.

Mangled remains, photographed lying in a pool of drying blood, show just death alone. The round shocked eyes staring from below the bandages show just individual weariness and loss. The symbolic myth of war and glory is not necessarily destroyed, but the human aftermath is nakedly exposed. Tim O'Sullivan's well-known photograph of a dead Confederate soldier taken in the American Civil War says the same as Robert Capa's *The Last Man to Die* taken eighty years later.

However, it is important to realize that the camera is not in any sense an automatic producer of this kind of realism and that such realism is not automatically interchangeable with anti-war propaganda. Although the camera is uniquely important in the development of twentieth-century imagery, photography and cinema are capable of an immense range of imagery and to that extent their contribution is ambiguous. They present a continuum from the most humane to the most exploitative. The cinema, in practice, is far more romantic than realistic. What is true, is that the combination of the camera with the mass media gives an enormous potential for communicating vividly the fact that war is messy and brutal. When there is added the possibility of reporting through newspapers and other media that are to some degree independent of the state, something exists which is quite new in the history of ideas.

At this point, however, the wheel comes full circle and realistic clarity in reporting is clouded by the technological inventions that have made possible its fuller development.

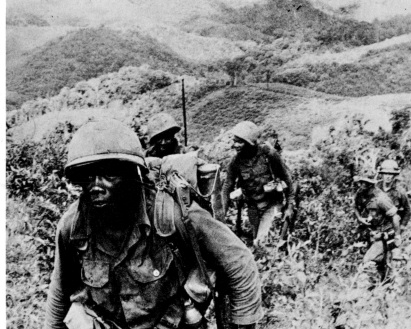

341 (left) American troopers in Vietnam photographed by Sgt Sam Wallace (MACOI)

342 (right) THE LAST MAN TO DIE, a photograph taken by Robert Capa at the end of the Second World War (Magnum)

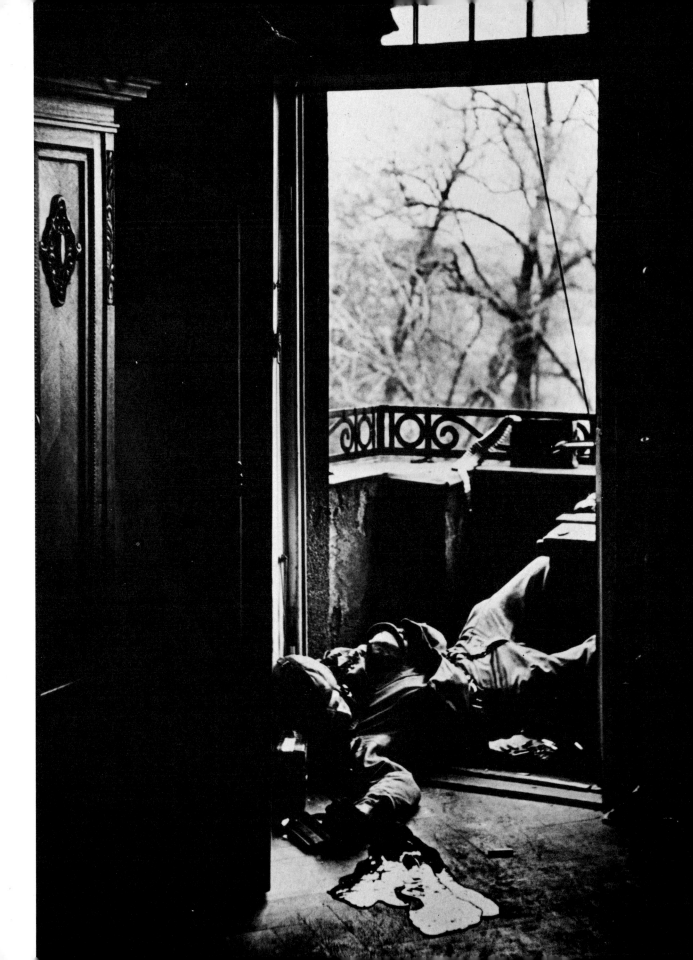

The situation is particularly acute in television where the mixture of entertainment with news and documentary is ubiquitous. It is not so much that an individual presentation may be distorted by the necessities of the medium, but that the sequence of programmes can destroy objectivity and distort the significance of events.

Writing in *The Listener*,[11] Krishan Kumar gave a good example of what can happen:

. . . A National Commission on Violence heard that the average American between the ages of two and 65 spends nearly nine years of his life simply sitting watching television. He sees, on average, an incident of violence every 14 minutes and a killing every three-quarters of an hour.

Much of this violence is political. In a current British study children were asked what programmes they associated most with killings. Many replied: 'The News'.

Here what seems to be the characteristic pessimism of realistic reporting is being multiplied on an enormous scale and communicated by a powerful medium that provokes involvement over the tea-table and the coffee-cups. Nobody can yet say if this blunts or sharpens its impact: what is certain is that its effect on people cannot be judged by a discussion of individual programmes in isolation. On television, realism and Romanticism, true statement and vicarious experience, are locked together to provide what an American professor of sociology calls (next to the H-bomb) 'the most dangerous thing in the world today'.

The equation we are looking at is complex. There was, and is, immense hope in the breakdown of old myths about war and power, and in art's new ability to stand aside from the hierarchic machinery of social repression. In the context of war we have traced out two cultural developments, both of which can be set against the reinforcing cultures of romance and military and nationalistic symbolism. But these developments, insofar as they are able to reach a wide audience, depend on technological means which can themselves only be provided by hierarchical institutions wielding great social power and influence.

What we can say is that there are now alive in the world ideals and aspirations that could not have existed in traditional cultural structures. If they had, they would have been available to a very small and economically privileged minority. And, in any case, they are ideals of equality which it would be a solecism for an elite to foster with any seriousness. It is clear that no mass industrial culture, either capitalist or communist, has yet evolved an effective 'semantic whole' for articulating in any realistic way the brotherhood of man. On the other hand, the developments discussed in this chapter have drastically changed the image of man in war. They have pushed the ordinary soldier to the forefront to make of him a kind of anti-hero. Suffering and surviving, the conceptualization of the reality of his misery has also been a part of the conceptualization of his humanity.

It has been a tremendous achievement and one that has taken place against all the odds. It is amazing that this, and not the triumph of state-supported propaganda, remains as a memorable and effective cultural outcome of nineteenth- and twentieth-century turmoil. The result is a tribute to the great liberal ideals of freedom of thought and education, to the intelligence and compassion that can be elicited from men, and to the humanizing potential of the technological media which the industrial revolution produced.

343 FIT FOR ACTIVE SERVICE, a drawing by George Grosz, 1916–17 (Museum of Modern Art, New York, from the A Conger Goodyear Fund)

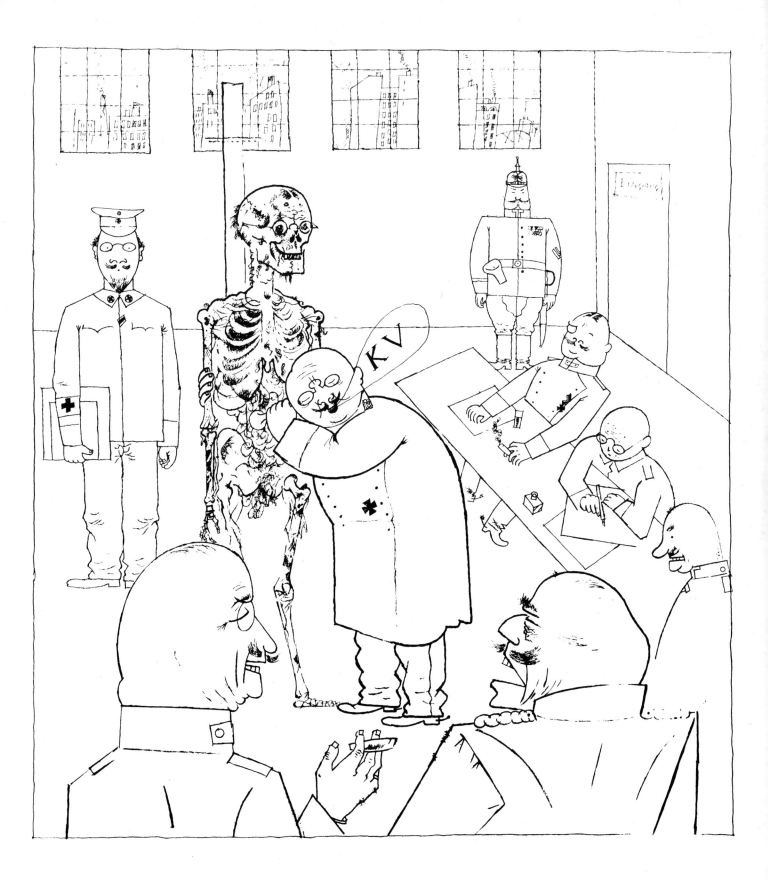

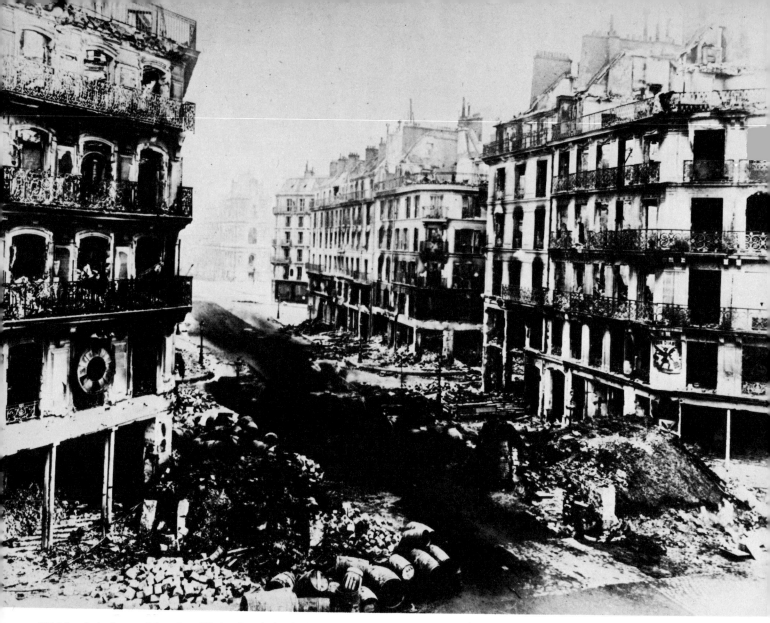

344 (above) A picture of the ruins of Paris taken during the Commune in 1871. This was one of the first European battles to be fully covered by photography. At this stage it was impossible to photograph fighting as it happened, but its aftermath in terms of death and destruction could already be vividly portrayed (Mansell Collection)

345 (right) A French illustration showing an early photographer at work amongst ruins (Mansell Collection)

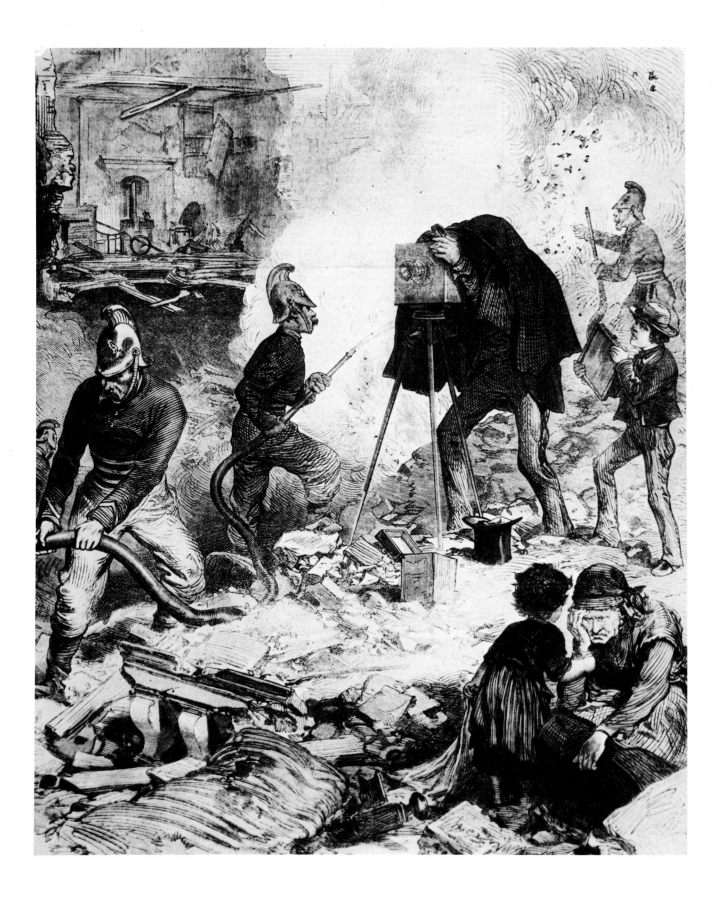

269

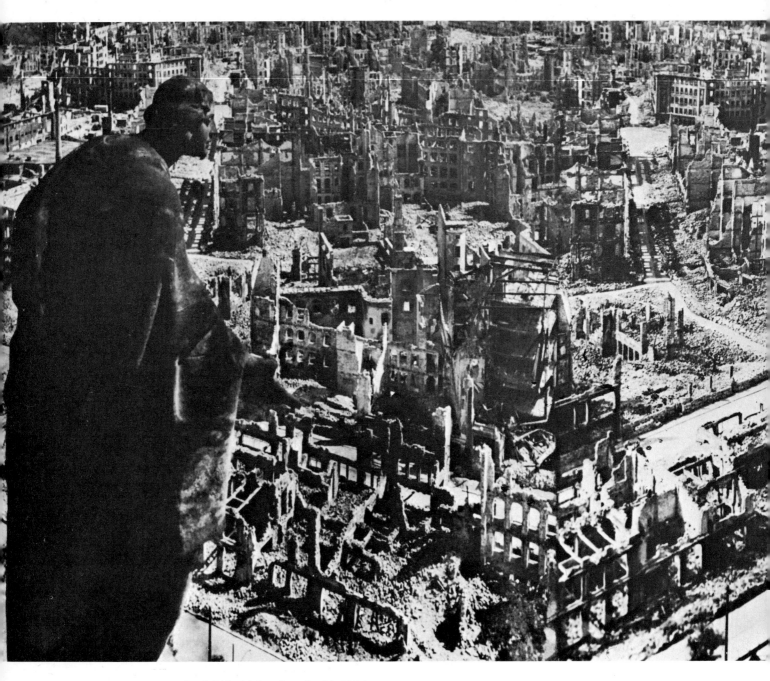

346 A photograph of Dresden after British and American air raids. This is one of a moving series taken by the German photographer Richard Peter (Richard Peter)

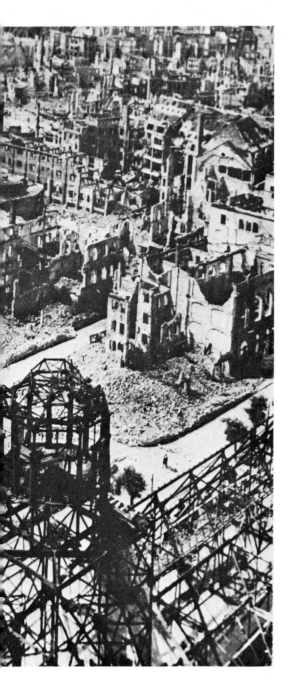

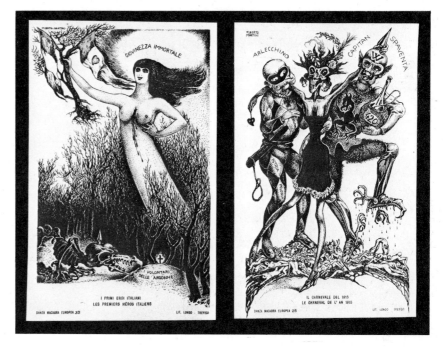

347 Two postcards from a series by the Italian artist Alberto Martini. Produced in 1914, they attack Germany and Austria and appeal to Italian patriotism. The series is called *Danza Macabra Europea* and is notable for its use of mordant surrealistic images (Imperial War Museum)

348 ANY ORDERS TODAY SIRE? A British anti-German cartoon showing death and the Kaiser. It is by Will Dyson (Imperial War Museum/Hodder and Stoughton)

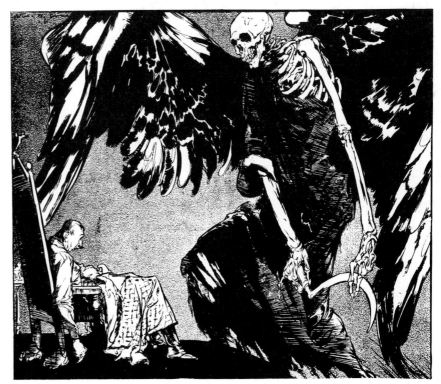

Norddeutsche Ausgabe / Ausgabe A · Ausgabe A / Norddeutsche Ausgabe

31. Ausg. ★ 46. Jahrg. ★ Einzelpreis 20 Pf. · Berlin, Dienstag, 31. Januar 1933

Freiheit und Brot

VÖLKISCHER BEOBACHTER

Herausgeber Adolf Hitler

Kampfblatt der national-sozialistischen Bewegung Großdeutschlands

Ein historischer Tag:

Erste Maßnahmen der Reichsregierung Hitler

Interview des „Völkischen Beobachters" mit dem Reichsinnenminister Frick — Tagung des neuen Kabinetts

Der Reichspräsident von Hindenburg hat Adolf Hitler zum Reichskanzler ernannt. Der neuen Regierung werden neben Adolf Hitler als Reichskanzler der frühere Minister Pg. Frick als Reichsinnenminister und der Reichstagspräsident Pg. Goering als Reichsminister ohne Geschäftsbereich und Reichskommissar für den Luftverkehr angehören. Pg. Goering wird gleichzeitig mit der Wahrnehmung der Geschäfte des Preußischen Innenministeriums betraut.

ADOLF HITLER

Reichsinnenminister Dr. Frick *Reichsminister Goering*

Das Ziel der neuen Regierung:

Die geistige und willensmäßige Erneuerung des deutschen Volkes

Erklärt Reichsinnenminister Dr. Frick in einer Unterredung mit dem „Völkischen Beobachter"

Während der Platz vor dem „Kaiserhof" sich immer mehr mit Menschen füllt, die in freudiger Erregung auf den Augenblick warten, wo der neuernannte Reichskanzler Adolf Hitler mit seinen nächsten Vertrauten das Hotel verläßt, während Zeitungsreporter die Photoapparate aufbauen, Schupopolizei die Regelung des notwendigen Verkehrs übernimmt, in den Räumen des Führers im geschäftigen Kommen und Gehen.

Hier befinde ich mich im eifrigen Gespräch mit dem neuen Reichsinnenminister, Pg. Dr. Frick, um die geistigen und willensmäßigen Maßnahmen zu besprechen.

Berlin, 30. Januar.

Die im Anschluß an die Ernennung Adolf Hitlers herausgegebene amtliche Mitteilung hat folgenden Wortlaut:

„Der Reichspräsident hat Herrn Adolf Hitler zum Reichskanzler ernannt und auf dessen Vorschlag die Reichsregierung wie folgt neu gebildet:

Reichskanzler a. D. von Papen zum Stellvertreter des Kanzlers und Reichskommissar für das Land Preußen;

Freiherrn von Neurath zum Reichsminister des Auswärtigen;

Staatsminister a. D. M. d. R. Dr. Frick zum Reichsminister des Innern;

Generalleutnant Freiherrn von Blomberg zum Reichswehrminister;

Graf von Schwerin-Krosigk zum Reichsminister der Finanzen;

Geheimen Finanzrat M. d. R. Hugenberg zum Reichsminister der Wirtschaft und zum Reichsminister für Ernährung und Landwirtschaft;

Franz Seldte zum Reichsarbeitsminister;

Freiherrn von Eltz-Rübenach zum Reichspostminister und zum Reichsverkehrsminister;

Reichstagspräsidenten Goering zum Reichsminister ohne Geschäftsbereich und gleichzeitig zum Reichskommissar für den Luftverkehr.

Reichsminister Goering wurde mit der Wahrnehmung der Geschäfte des Preußischen Innenministeriums betraut.

Reichskommissar für Arbeitsbeschaffung Gereke wird in seinem Amt bestätigt.

Die Besetzung des Reichsjustizministeriums bleibt vorbehalten. Der Reichskanzler wird noch heute Verhandlungen mit dem Zentrum und der Bayerischen Volkspartei aufnehmen. Heute nachmittag 17 Uhr findet die erste Kabinettsitzung statt.

Der Grundstein zum Dritten Reich

Der 30. Januar 1933 wird einmal eingehen in die Geschichtsschreibung als ein Tag, der einen historischen Umschwung der deutschen Entwicklung darstellt.

Stürmische Huldigungen

Berlin, 30. Januar.

Der Ernennung Adolf Hitlers zum Reichskanzler ging ein kurzer Besuch beim Reichspräsidenten voraus.

Nationalsozialistische Staatssekretäre in Preußen

Berlin, 30. Januar.

Flaggen heraus!

HOW LONG CAN PEOPLE LIVE LIKE THIS?

The Outside of the Miner's Home in the Picture on the Right
Houses and more food are the Germans' most urgent needs. They got through last winter on
their last reserves of food and strength. This coming winter, there will be no reserves.

work harder on less food, sees little benefit coming to him from the coal he hews. He knows that coal barges are leaving the great inland port of Duisburg for a dozen European countries, and he knows Allied messes and billets were warm last winter and will be warm again this. He knows, too, that he is best off of all Germans, and that things are worse for steel-workers, labourers, housewives. He is not satisfied that the Occupation authorities are working with the right people in the technical and managerial grades, and he is suspicious of their politics and plans for the future. He hears a lot about democracy, freedom and unity, but he is hungry and tired. By working four or five days a week and then going off to look for black market food, he can live and feed his family better than by putting in a full week's work.

Absenteeism has therefore become a major problem. Total absenteeism in July this year was 19½ per cent., of which just under 11 per cent. was for sickness and injuries. Desertion among 'green labour'—young workers from other parts of Ger-

many compulsorily drafted into the mines—is very high. Of 3,000 green workers sent to one group of mines, only 170 remained after three months. When you can get as much money for one black market cigarette as for a full shift on the coal face, this is not surprising.

Output has naturally suffered, too. Pre-war over-all man per shift output in the Ruhr was 1.6, compared to .86 in July, 1946. When rations were cut last winter, output fell in one month from .85 to .79, but it has since recovered—a tribute to the miner and the Coal Commission officials. The labour force has shrunk in the Ruhr from 313,300 in 1938 to 270,200 now.

The Ruhr lives by coal and steel, and the coal position, bad as it is, is better than in the case of steel. Steel production depends on iron ore, coal, power and labour. The iron ore supplies from Sweden and Lorraine are now lost to the Ruhr, and the great steel industry depends on existing stocks and supplies from the Hartz. Coal is short, which
Continued overleaf

The Women Without Homes
Frau Portugal is 73 years old. With her husband of 72, she lives in an air-raid shelter in Düsseldorf.

She Is 24 Years Old
Frau Achten also lives in a shelter. She has a boy of 3½ years. Her husband is a prisoner of war in Russia

The Family With a Home: A Miner and His Wife and Six Children Live in This One Room in Their Bombed House in Essen
The miner is Heinrich Wenning. His eldest son is a prisoner in England. His is one of a million houses in the Ruhr destroyed by bombing. There is no material for rebuilding. He made this room habitable by using bits and pieces from the rest of the house. In this room, eight people sleep, cook, eat, wash and dry their home-grown tobacco. You can see the outside of their house in the picture at the top of the page.

16

17

349 (left) The front page of the *Völkischer Beobachter* for 31 January 1933. This was the Nazi party's paper: it played a leading role in attacking Jews and Communists while presenting Hitler and the party as national saviours (John Frost Collection: photograph by Chris Ridley)

350 (above) A spread from the famous British magazine *Picture Post*. It is from an article attempting to arouse sympathy for the plight of the German people after the Second World War. It calls for an end to retribution (John Frost Collection: photograph by Chris Ridley)

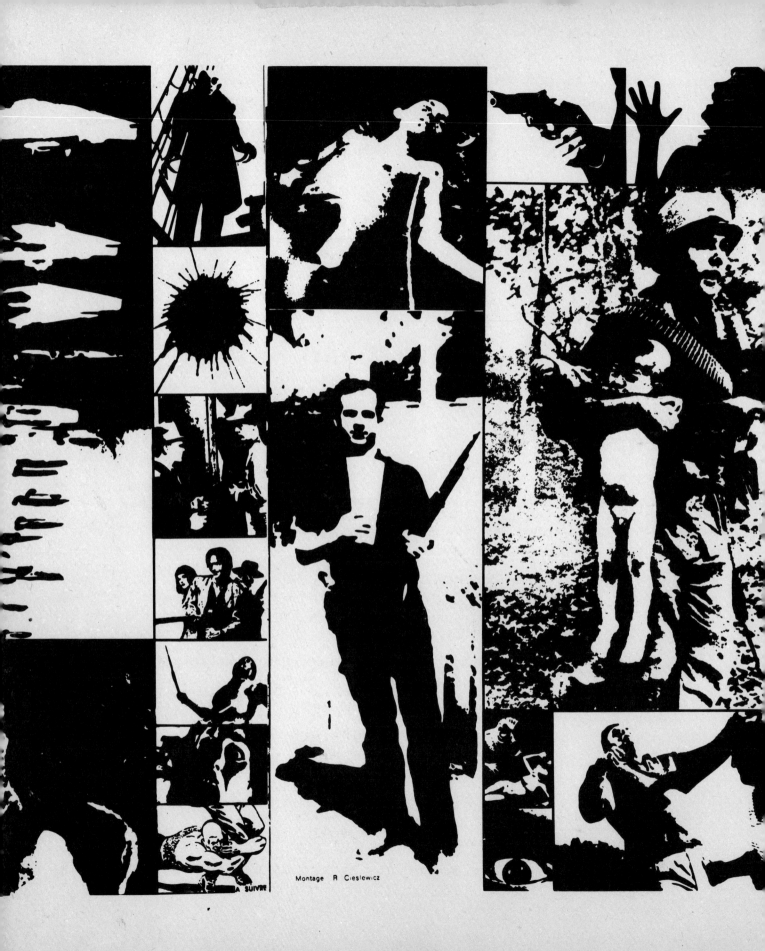

Montage R Cieslewicz

WAR: The Struggle for Peace

Orr was crazy and could be grounded. All he had to do was ask; and as soon as he did, he would no longer be crazy and would have to fly more missions. Orr would be crazy to fly more missions and sane if he didn't, but if he was sane he had to fly them. If he flew them he was crazy and didn't have to; but if he didn't want to he was sane and had to. Yossarian was moved very deeply by the absolute simplicity of this clause of Catch-22 and let out a respectful whistle.

from CATCH 22 by Joseph Heller[12]

351 (left) Detail of a montage used in a recent issue of the French magazine *Opus International* devoted to the problem of violence in contemporary society. It is by the Polish artist R Cieslewicz (*Opus International*)

352 (above) WOMAN IN TEARS by Pablo Picasso. This was painted at about the time when Picasso was working on *Guernica*, the large mural which commemorates those killed in an air raid on a Spanish village during the civil war (Pallas Gallery Reproduction/© S.P.A.D.E.M. Paris, 1974)

The past two hundred years have been Utopian in their idealism but starkly practical in their achievement. The result of this combination has been not only to promote disillusion and cynicism but also to challenge the ability of culture to contain and interpret the strains put upon it. The effect of evolving a culture related to change instead of stability has created a situation where we no longer know how to say what culture is or how it functions.

We have already seen that egalitarian ideals were first given coherent revolutionary expression at a time when technology was about to produce plenty but was also demanding hierarchical organization in order to promote 'efficiency'. It is a conjunction that still lies at the heart of the contemporary paradox and which places us decisively in the continuum of nineteenth-century developments. The tremendous achievements of radicalism in voicing the brotherhood and equality of men were set, and are set, in a highly successful economic world demanding large-scale organization and violent competition for scarce resources. The liberating discoveries of psychoanalysis are housed in a physical world that demands more, not less, rigidly organized styles of life. The rapid expansion of the mass media has taken place at a moment in history when one of their primary functions is to provide an escape from an intolerably tense or boring economic existence. The extension of general education has not been matched by changes in adult institutions to support the ideas and capacities so released.

If we look back to the work of the Scottish economist Adam Smith, who died in 1790, we find that these themes were already then beginning to develop as the reality of industrial life. Smith produced one of the first codifications of the effect of economics on the basic nature of modern society. He summed up the significance of the economic and technological forces which had been gathering strength since medieval times. In his treatment of the production technique known as the 'division of labour', he foreshadowed with

complete accuracy the emergence of the modern world of highly educated specialists. Here in a single quote from a draft of his famous book, *The Wealth of Nations*,[13] is the key:

In opulent and commercial societies, . . . to think or to reason comes to be, like every other employment, a particular business, which is carried on by a very few people, who furnish the public with all the thought and reason possessed by the vast multitudes that labour.

Such a high level of generalization was founded on accurate knowledge of efficient industrial practice. The tendency to specialize which he identified was dramatically effective and destroyed once and for all the old work and craft relations in society. It is unnecessary to be a Marxist to recognize the immense change of human meaning that is involved. In any case, Communist states display exactly the same kind of bureaucratic and alienating structure in their own most 'efficient' enterprises. For us, the salient point is to recognize how rigid and impervious to equality and liberalism is any such vertically organized specialization. The division of labour does not imply the division of responsibility and power: quite the reverse.

There is, however, the other, triumphant side to the division of labour. *The Wealth of Nations* emphasized what it meant to have hopes of a growth in human prosperity, of a spreading of the enlightenment and a consequent extension of civilization. Smith predicted with satisfaction that the division of labour was a radical element in society. He saw that a vast increase in productivity, based on technology and modern methods of production, must inevitably change the power relations in society. What he actually predicted was the end of the feudal aristocracy and the rise of the middle classes, not the extension of democracy, but it was, all the same, clearly meant to be the start of an economy of plenty. Smith looked to a time when even the labourer in a civilized community would be better accommodated than 'many an African king, the absolute master of the lives and liberties of ten thousand naked savages'! Smith argued that when shortage disappeared it would be open to men to extend their other capacities in exactly the same way as the division of labour was already extending their productive capacity.

Any hungry man would agree with Smith about the deforming and destructive aspects of shortage. What is less easy to evaluate is how far the structural inflexibility of industrialization has been such as to negate the advances that might otherwise be expected from the spread of wealth.

In *News from Nowhere*,[14] written for his magazine *The Commonwealth* in 1890, William Morris presented an ideal Socialist world of the future. Politics as we know them had disappeared. He pictured the workings of a community without money, property, competition, ugliness, or heavy industry. Men and women worked because they did not wish to be idle: because the work they did ennobled and developed them. The style of life in this *Nowhere* was gentle and pretty: England had become a peasant democracy in which everybody had more than enough leisure and resources to interest himself in previously aristocratic tastes and pursuits.

It is instructive to see how the inhabitants of Morris's world handled problems that might involve social conflicts. In the following extract Morris, the time traveller, is sitting in a house in the village which has grown up round the British Museum, talking to Old Hammond, one of the few inhabitants of the new rural London still interested in what was by then thought to be the hideous history of the nineteenth century. They talk about law and government – about 'how things are managed' in Utopia:

'How is that managed?' said I.

'Well,' said he, 'let us take one of our units of management, a commune, or a ward, or a parish (for we have all three names, indicating little real distinction between them now, though time was there was a good deal). In such a district as you would call it, some neighbours think that something ought to be done or undone: a new town-hall built; a clearance of inconvenient houses; or say a stone bridge substituted for some ugly old iron one, – there you have undoing and doing in one. Well, at the next ordinary meeting of the neighbours, or Mote, as we call it, according to the ancient tongue of the times before bureaucracy, a neighbour proposes the change, and of course, if everybody agrees, there is an end of discussion, except about details. Equally, if no one backs the proposer – "seconds him", it used to be called – the matter drops for the time being; a thing not likely to happen amongst reasonable men, however, as the proposer is sure to have talked it over with others before the Mote. But supposing the affair proposed and seconded, if a few of the neighbours disagree to it, if they think that the beastly iron bridge will serve a little longer and they don't want to be bothered with building a new one just then, they don't count heads that time, but put off the formal discussion to the next Mote; and meantime arguments *pro* and *con* are flying about, and some get printed, so that everybody knows what is going on; and when the Mote comes together again there is a regular discussion and at last a vote by show of hands. If the division is a closed one, the question is again put off for further discussion; if the division is a wide one, the minority are asked if they will yield to the more general opinion, which they often, nay, most commonly do. If they refuse, the question is debated a third time, when, if the minority has not perceptibly grown, they always give way; though I believe there is some half-forgotten rule by which they might still carry it on further; but I say, what always happens is that they are convinced, not perhaps that their view is the wrong one, but they cannot persuade or force the community to adopt it.'

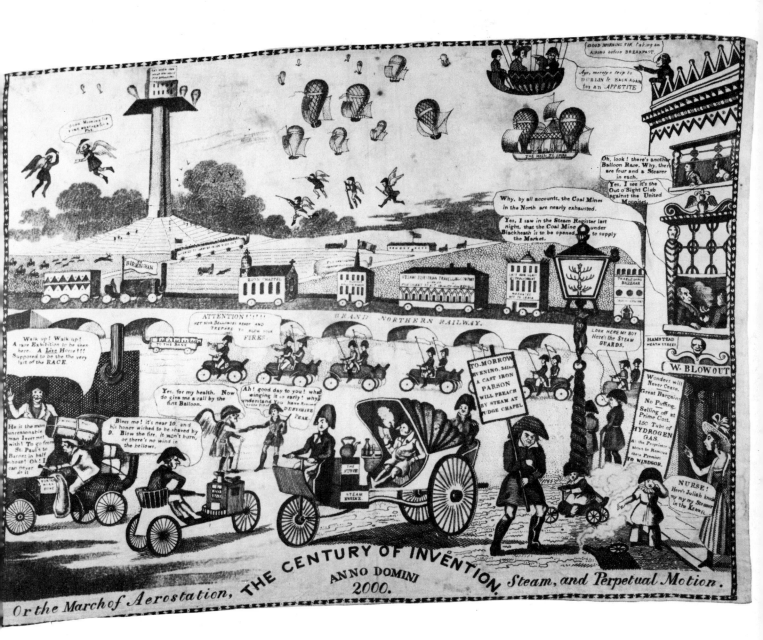

353 THE CENTURY OF INVENTION. A printed textile produced at the time of the Great Exhibition in 1851. The exhibition was a vast three-dimensional hymn of praise to progress, industry and technology: many satirists looked doubtfully at the future (John Johnson Collection, Bodleian Library, Oxford)

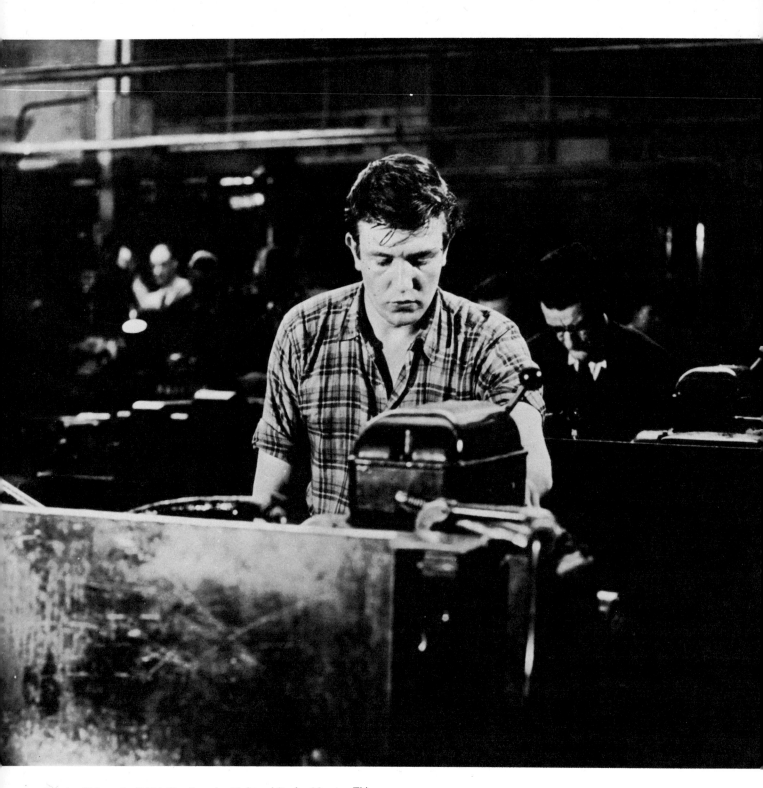

354 A still from the British film *Saturday Night and Sunday Morning*. This was one of a number of films which tried to show the reality of industrialisation. Boring work and squalid environments were depicted as dominating the attempts of ordinary people to lead better, more stimulating lives (National Film Archive/Woodfall Film Productions Ltd)

'Very good,' said I, 'but what happens if the divisions are still narrow?'

Said he: 'As a matter of principle and according to the rule of such cases, the question must then lapse, and the majority, if so narrow, has to submit to sitting down under the *status quo*. But I must tell you that in point of fact the minority very seldom enforces this rule, but generally yields in a friendly manner.'

'But do you know,' said I, 'that there is something in all this very like democracy; and I thought that democracy was considered to be in a moribund condition many, many years ago.'

The real purpose of *Nowhere*, like that of every Utopian book, was less to map out a precisely attainable programme for a future world, than to draw attention to the shortcomings of the present. The carefully drawn picture of community procedure depended for its validity on whether or not Morris's contemporaries could accept his equally carefully drawn denunciation of the evils of his own time, those alienating evils which sprang directly from the impact of ruthless capitalism on the ordinary people of England. It was the substitution of money and property values for the true sensuous values of life and art which according to him caused misery and inequality and which resulted in slavery for the majority and greedy decadence for the minority.

Morris is particularly interesting for us because, in outlining his participatory democracy, he made an implicit identification of three of the principal variables involved. He dealt with work and scale, but only after he had devised a social structure in which each man had an equal share of the available 'political' power and gross national product. He saw the relationship between this trio, and seems to have been clear about their effect on one another. Unlike most other nineteenth-century socialist Utopians he saw the crux of the problem in the nature of technology and the development of a world dependent on technological means of production. It is clear that Morris saw no hope in this way of working.

Aspects of the present book suggest that, although Adam Smith's hopes of an enlightenment have not been fulfilled, we should be cautious about accepting Morris's condemnation. We have seen how technology aided the rejection of the heroic image of war and affirmed instead the reality of its ability to inflict suffering on ordinary people. The years of industrialization have seen the mass of people emerge from the anonymity of the past. They have witnessed dramatic changes, mostly for the good, in the commonly held assumptions about the content and meaning of the

355 BEFORE THE WAR AND SINCE THE WAR. An American print contrasting the lives of negroes before and after the war between the Northern and Southern states (The Bettmann Archive Inc, New York)

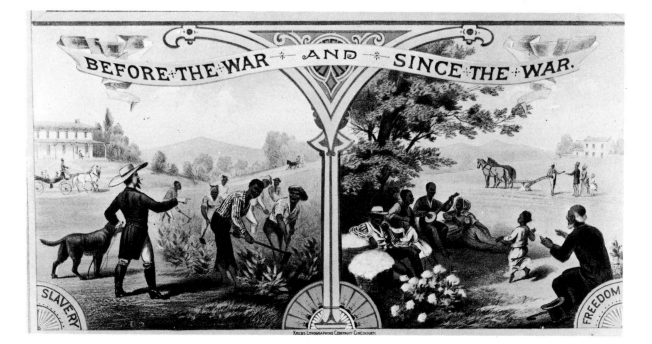

356 (above) MY SWEET HOMELAND, WHAT HAS BECOME OF YOU. an etching by Georges Roualt from his suite *Miserère* (City Museum and Art Gallery, Birmingham)

357 (right) END BAD BREATH, an anti-war poster by the American graphic designer Seymour Chwast (Push Pin Studios Inc)

relationship between the individual and such cultural resources as education, government, and welfare. On the other hand, plenty has fostered greed to an unmanageable degree and has enshrined competition as the key structural element in economic progress. The rich third of the world has found itself impotent to help adequately the poorer part or to recognize their inter-relationship. Men have lost their grip on concepts such as democracy, liberalism, and equality in a maelstrom of consumption.

It is when we turn to more structural issues that the most hopeful signs appear. The degree of transformation which culture has proved able to accommodate already is quite remarkable. It suggests a great degree of flexibility. The possibility seems to exist for more far-reaching adaptations in the future. Even when we recognize the powerful simplicity of hierarchical models, the past two centuries also demonstrate the viability of broader subtleties and a wider inclusiveness. The concepts, though not the practical applications, already exist by which we could extend the probability of a mutually dependent, fraternal world.

It looks as though, almost by accident, the industrial revolution has created the ecological-cum-cultural conditions which might also bring about the next stage in the social revolution. The dialectic appears to be a possible one. The awareness of injustice and danger exists. Technology has created a communications network of unique power and completeness. The media already contain appropriate historical precedents and contemporary talents for the development of new visual realities. The transformation would be no more remarkable than that which we have already documented in Part Four.

Recently, Herbert Marcuse wrote, in *Das Ende der Utopie*,[15] of the likelihood of a really decisive change of attitude in

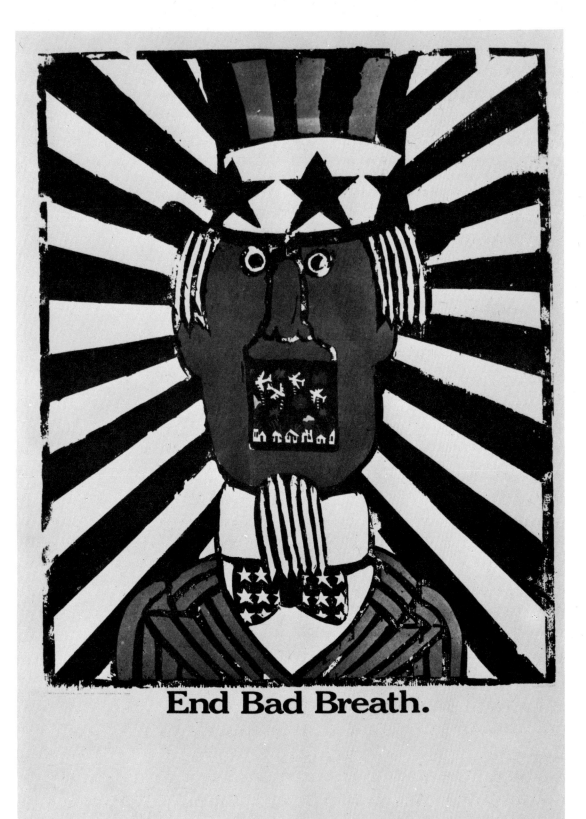

End Bad Breath.

culture and society. He made the statement that 'all the material and intellectual forces needed for the realization of a free society are there'. This appears to be true. We *are* now at the end of an era. The first phase of industrialization has run its course and it is up to the present to find ways to use the practical and intellectual resources released in the industrial revolution so as to create a more responsive form of society. Marcuse sees the present as a decisive moment: 'the new possibilities for a humane society and its environment cannot be conceived as a continuation of the old, cannot even be set in the same continuum as the old'. He wants 'a break in the historical continuum'. If, by this, he means a conceptual rupture similar in scope to that brought about by the French and industrial revolutions, it is easy to agree. The popular imagination has not yet fully absorbed the new biological and sociological theories, nor has the world of culture yet come to terms with the impact of education or the change of polarization in the sources of culture and power which are implied by genuine democratization. When these come together, and are fostered by the technology of mass communications, the result may be very dramatic indeed.

The hope must be that mass communications are a system big enough, free enough, and accessible enough to respond to man's profound longings for justice as well as they have responded to his longings for satisfaction and wealth. Success would bring peace. Failure, the destruction of the

carefully built but fragile structure of the human worlds of art and society. There really is no reason why such an adaptable creature as man should fail to produce the imaginative leap which would make possible the creation of the necessary cultural basis for such a transformation. After all, and as we have seen, he has made similar leaps before.

358 (below) British clandestine medals produced at the time of the French Revolution (James Klugmann Collection: photograph by Chris Ridley)

359 (right) A detail from THE TRIUMPH OF DEATH by Pieter Bruegel (Prado, Madrid)

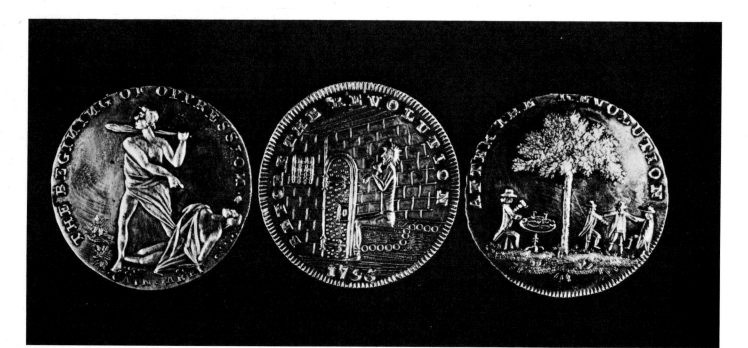

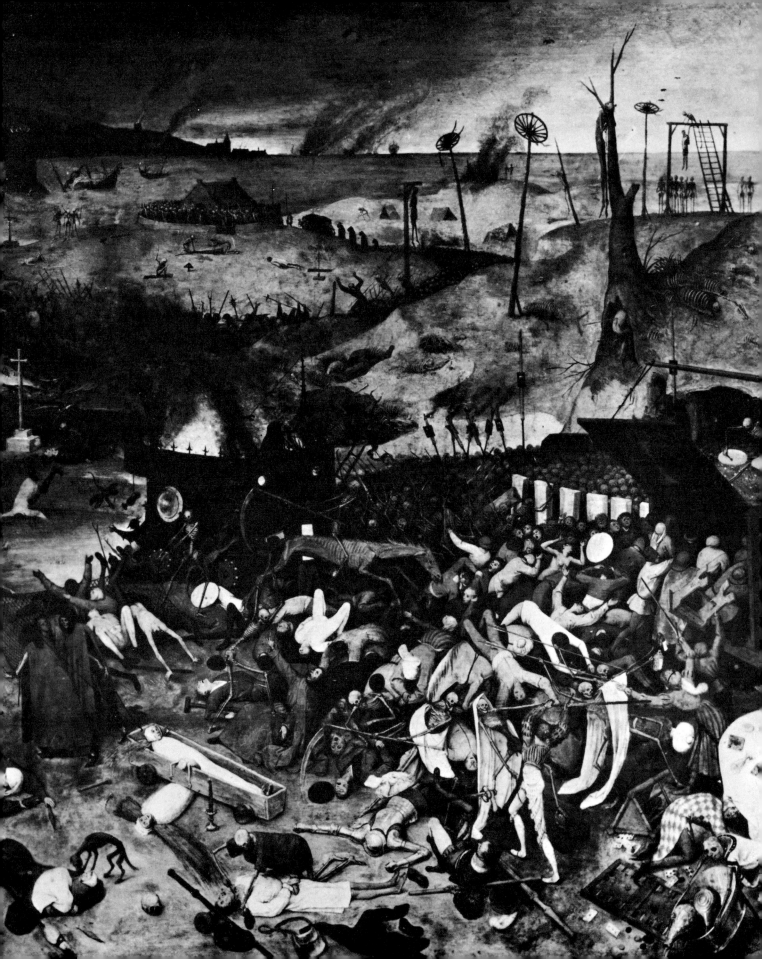

References

Part One

1 THERE IS NO NATURAL RELIGION by William Blake (1757–1827).

2 PATTERNS OF CULTURE by Ruth Benedict. London, Routledge and Kegan Paul, 1935. Boston, Houghton Mifflin Company, 1959.

3 SEXUALITY AND CLASS STRUGGLE by Reimut Reiche. London, New Left Books, 1970. Originally published in German: SEXUALITÄT UND KLASSENKAMPF, Verlag Neue Kritik, 1968.

4 THE WHEELWRIGHTS SHOP by George Sturt. Cambridge, Cambridge University Press, 1963. Originally published: 1923.

5 BEFORE PHILOSOPHY by Henri and H A Frankfort, John A Wilson and Thorkild Jacobsen. Harmondsworth, Penguin Books, 1949. Originally published: The University of Chicago Press, 1946.

6 THE CITY IN HISTORY by Lewis Mumford. Harmondsworth, Penguin Books, 1966. Originally published: Secker and Warburg, 1961. New York, Harcourt, Brace and World, 1961.

7 POETRY IN THE MAKING: AN ANTHOLOGY OF POEMS AND PROGRAMMES FROM 'LISTENING AND WRITING' by Ted Hughes. London, Faber and Faber, 1967.

8 ART AND SOCIETY by Herbert Read. London, Faber and Faber, 1945 (revised edition).

9 STEPS TO AN ECOLOGY OF MIND by Gregory Bateson. London, Paladin, 1973. Originally published by Chandler Publishing Company, 1972. The essay quoted was originally a paper for the Wenner-Gren Conference on Primitive Art, 1967.

10 SELF AND OTHERS by R D Laing. Harmondsworth, Penguin Books, 1971. Originally published: Tavistock Publications, 1961.

11 THE MAKING OF THE ENGLISH WORKING CLASS by E P Thompson. Harmondsworth, Penguin Books, 1968. Originally published: Victor Gollancz, 1963.

12 *Classic Culture and Post-Culture* by George Steiner. *The Times Literary Supplement*, October, 1971.

13 PIT TALK IN COUNTY DURHAM by Dave Douglass. History Workshop Pamphlet no 10, Ruskin College, Oxford, 1973.

14 THE OTHER VICTORIANS by Steven Marcus. London, Weidenfeld and Nicolson, 1966. New York, Basic Books, 1966. Originally published: Institute for Sex Research, Indiana University, 1964–66.

15 THE POLITICS OF EXPERIENCE AND THE BIRD OF PARADISE by R D Laing. Harmondsworth, Penguin Books, 1967. New York, Pantheon Books, 1967.

16 THE LONG REVOLUTION by Raymond Williams. Harmondsworth, Penguin Books, 1965. Originally published: Chatto and Windus, 1961.

Part Two

1 Quoted from BEFORE PHILOSOPHY. See ref 5 in Part One above.

2 See ref 2 in Part One above.

3 THE NECESSITY OF ART by Ernst Fischer. Harmondsworth, Penguin Books, 1963. Baltimore, Penguin Books, 1963. Originally published: Verlag der Kunst, 1959.

4 See ref 8 in Part One above.

5 GENESIS, Chapter 1, verses 26 and 27.

6 MY PEOPLE by Credo Mutwa. Harmondsworth, Penguin Books, 1971.

7 MUNTU by Janheinz Jahn. London, Faber and Faber, 1961. New York, Grove Press, 1961.

8 PASSION AND SOCIETY by Denis de Rougemont. London, Faber and Faber, 1956 (revised edition).

9 THE NARROW ROAD TO THE DEEP NORTH, translated by Nobuyuki Yuasa. Harmondsworth, Penguin Books, 1966.

10 THE AGE OF REVOLUTION by E J Hobsbawm. London, Cardinal, 1973. Cleveland, World Publishing Company, 1962. Originally published: Weidenfeld and Nicolson, 1962.

11 ILLUSTRATED ENGLISH SOCIAL HISTORY by G M Trevelyan. Harmondsworth, Penguin Books, 1944. New York, Longmans, Green, 1953–57.

12 Quoted from THE AGE OF REVOLUTION. See ref 10 above.

13 OEDIPUS AT COLONUS translated by E F Watling. Harmondsworth, Penguin Books, 1947.

14 Quoted from BEFORE PHILOSOPHY. See ref 5 in Part One above.

15 Unpublished paper by B de L Carey. American Museum in Britain, Bath.

16 THE SERMONS AND DEVOTIONAL WRITINGS OF G M H, edited by Christopher Devlin, S J. Oxford, Oxford University Press. New York, Oxford University Press, 1959.

Part Three

1 BALLAD OF LADIES LOVE, NUMBER TWO, translated by John Payne. Quoted from: EROTIC POETRY, edited by William Cole. London, Weidenfeld and Nicolson, 1964. New York, Random House, 1963.

2 TANTRA (exhibition catalogue) by Philip Rawson. London, Arts Council of Great Britain, 1971.

3 See ref 14 in Part One above.

4 COLLECTED POEMS 1934–52 by Dylan Thomas. London, J M Dent, 1952.

5 DAILY LIFE IN ANCIENT INDIA FROM 200 BC TO AD 700. London, Weidenfeld and Nicolson, 1965. Originally published: Librarie Hachette, 1961.

6 THE BACCHAE, translated by Philip Vellacott. Harmondsworth, Penguin Books, 1954. Baltimore, Penguin Books, 1954.

7 THE USES OF LITERACY by Richard Hoggart. Harmondsworth, Penguin Books, 1958. Originally published: Chatto and Windus, 1957.

8 Quoted from DAILY LIFE IN ANCIENT INDIA FROM 200 BC TO AD 700. See ref 5 above.

9 See ref 2 in Part One above.

10 SUICIDE WEAPON by A J Barker. London, Pan/Ballantine, 1972. Originally published in the USA, 1971.

11 THE ENGLISH HOUSEWIFE IN THE SEVENTEENTH CENTURY by Christina Hole. London, Chatto and Windus, 1953.

12 *Work and Consumption* by André Gorz. Published in: TOWARDS SOCIALISM, London, Fontana/New Left Review, 1965.

13 See ref 3 in Part One above.

14 See ref 10 in Part Two above.

Part Four

1 Quoted from THE NECESSITY OF ART. See ref 3 in Part Two above.

2 VAGRANCY by Philip O'Connor. Harmondsworth, Penguin Books, 1963.

3 See ref 10 in Part Two above.

4 See ref 11 in Part One above.

5 SWEET SATURDAY NIGHT by Colin McInnes. London, Panther, 1969. Originally published: MacGibbon and Kee, 1967.

6 THE LORE AND LANGUAGE OF SCHOOLCHILDREN by Iona and Peter Opie. Oxford, Clarendon Press, 1959.

7 THE BOOK OF BEASTS by T H White. London, Jonathan Cape, 1954. New York, GP Putnam's Sons, 1954. This is the translation into English, with commentary, of a twelfth-century Latin Bestiary.

8 See ref 11 in Part Three above.

9 GENESIS, Chapter 3, verse 23.

10 THE OLDEST SCOTTISH POEM: THE GODODDIN by Kenneth Hurlstone Jackson. Edinburgh, Edinburgh University Press, 1969.

11 and 12 Quoted from ART AND THE INDUSTRIAL REVOLUTION by Francis Klingender. Revised edition by Sir Arthur Elton. London, Evelyn Adams and Mackay Ltd, 1968. Originally published, 1947.

13 LONDON LABOUR AND LONDON POOR by Henry Mayhew. London, Griffin, Bohn and Company, 1961–62. Originally published in a number of volumes, 1851–61.

14 LET US NOW PRAISE FAMOUS MEN by James Agee and Walker Evans. London, Peter Owen Ltd, 1965. Boston, Houghton Mifflin Company, 1960. Originally published in the USA, 1939/1940/1941.

15 Quoted from THE MAKING OF THE ENGLISH WORKING CLASS. See ref 11 in Part One above.

16 BABAR THE KING by Jean de Brunhoff. English edition: London, Methuen, 1936. New York, H Smith and R Haas, 1935.

17 Quoted from THE MAKING OF THE ENGLISH WORKING CLASS. See ref 11 in Part One above.

18 SELECTED ESSAYS by Karl Marx. Translated by H J Stennings and Leonard Parsons.

Part Five

1 Quoted by kind permission of Mr G T Sassoon.

2 *The Secret Life of Walter Mitty* from MY WORLD AND WELCOME TO IT by James Thurber. Quoted from THE THURBER CARNIVAL. Harmondsworth, Penguin Books, 1945. New York, Modern Library, 1957.

3 Quoted from SEXUALITY AND CLASS STRUGGLE. See ref 3 in Part One above.

4 *Portrait of the Artist as an Old Man* by Sean O'Faolain. *The Listener*, vol 87, no 2250, May 1972.

5 THE PAINT HOUSE. Harmondsworth, Penguin Books, 1972.

6 THE RED BADGE OF COURAGE AND OTHER STORIES by Stephen Crane. London, Oxford University Press, 1960. New York, Macmillan Publishing Co, Inc, 1966. The title story was first published in the USA in 1895.

7 KING HENRY V (c. 1598–99) by William Shakespeare. Act III, Scene One.

8 INTERNATIONAL ENCYCLOPEDIA OF SOCIAL SCIENCES, edited by D Sills. Macmillan and Free Press, 1968.

9 THE PENGUIN DICTIONARY compiled by G N Garmonsway. Harmondsworth, Penguin Books, 1965.

10 SATURN, AN ESSAY ON GOYA by André Malraux. Translation by C W Chilton, published: London, Phaidon Press, 1957. Distributed by Garden City Books, New York, 1957.

11 *The Political Consequences of Television* by Krishan Kumar. *The Listener*, vol 82, no 2101, July 1969.

12 CATCH 22 by Joseph Heller. London, Jonathan Cape, 1962. New York, Simon and Schuster, 1961. Originally published in the USA, 1955/1961.

13 Quoted from ART AND THE INDUSTRIAL REVOLUTION. See ref 11 and 12 in Part Four above.

14 NEWS FROM NOWHERE by William Morris, edited by James Redmond. London and Boston, Routledge and Kegan Paul, 1970. Originally published: *The Commonwealth*, 1890.

15 Quoted from SEXUALITY AND CLASS STRUGGLE. See ref 3 in Part One above.

Acknowledgements

This book owes its existence to the Welsh Arts Council. It is based on the research for a series of four exhibitions on the general theme of art and society which they commissioned from me in 1968. The members of the Council have generously continued their support right up to the present. They have provided the widest possible range of inspiration and practical assistance. I am most grateful to the Council as a whole, to the Art Committee, and to all the members of the executive staff who have born the brunt of the resulting administrative and physical work. A happy result of organizing the series is that I have many new friends in Wales: this is something which gives me the greatest pleasure.

Peter Jones, assistant director of the Council, deserves my special thanks. He should, in justice, be credited as co-author. The ideas and approaches presented here have all been developed jointly with him. They spring from six years of the most fruitful discussion and debate that I have ever experienced. I have developed the greatest respect for his wisdom and for his subtle appreciation of the positive role which art can play in the development of human societies. Without his contribution, it simply would not have been possible to organize the exhibitions and write the book. Thank you.

My wife, Kate, who is co-author of Part Two, has worked with me throughout and has, herself, conducted a considerable amount of the research. She has also been very patient with me when things went wrong and has given most generously of her moral and practical support. She has made it possible for me to write with such affection about the institution of marriage! Alan Robinson contributed particularly to Parts Three and Four, but also helped generally with his sociological expertise and his wide-ranging knowledge of the popular cinema.

In London, at Lund Humphries, my publisher John Taylor and my editor, Charlotte Burri, have, like Peter Jones, been very closely involved. The contribution they have made to the intellectual and visual development of the book is incalculable. I have greatly enjoyed their professionalism and their good humour. Once again, working with them has led to friendship. In the United States, I have to thank Peter Mayer of Overlook Press for the inspiration which led directly to the creation of this international volume.

Chris Ridley has taken a large number of photographs specially for the book. They have a distinctive character and excellence which does much to give these pages whatever quality they may have. Over the past five years his work has consistently pleased me: his photographs have frequently added to my appreciation of the objects they depict.

Many people in the Welsh Arts Council office in Cardiff and in my own in London have done a tremendous amount of hard and frequently mundane work. It is not possible to mention them all, but in Cardiff I am grateful to: Francine Allen; Peter Bugler; Hugh Chilcott; Joy Goodfellow; and Valmai Ward. In my own office to: L A Baynes; Annie Finlayson; Anne Porter; Steve Storr; and Margaret Tully.

Apart from all these personal helpers a book like this depends, above all, on the generosity of individuals, companies and institutions who own rare and important material. All of us involved are grateful to those who have contributed by allowing us to reproduce items from their collections. Each lender is credited at the end of the appropriate caption. We are similarly grateful to publishers for permission to quote from literary sources: these credits are given in detail in the references.

Some lenders have done even more than allow me access to their collections. They have actively helped with advice and suggestions of various kinds. Among these are: Dr Noble Frankland and his staff at the Imperial War Museum; the

late Sir Arthur Elton; James Klugmann; the staff of the
Pitt Rivers Museum in Oxford; the staff of the Mansell
Collection in London; Patrick Murray, lately Director of
the Museum of Childhood in Edinburgh; Victor Arwas;
and Eduardo Paolozzi.

I hope these acknowledgements make clear the extent to
which the original 'art and society' series and now this book
are the result of cooperative effort. In a very real sense, an
author who has no team to work with him is in a lonely and
weak position. I have been quite outstandingly fortunate.

Ken Baynes
Battersea, August 1974

360 An ancient Greek bronze
sculpture known as *The Charioteer
of Delphi*. The photograph by
Martin Hürlimann is from his book
Eternal Greece, published in Britain
by Thames & Hudson, 1953

361 (next page) RIQUEVAL BRIDGE,
1918 (Imperial War Museum)

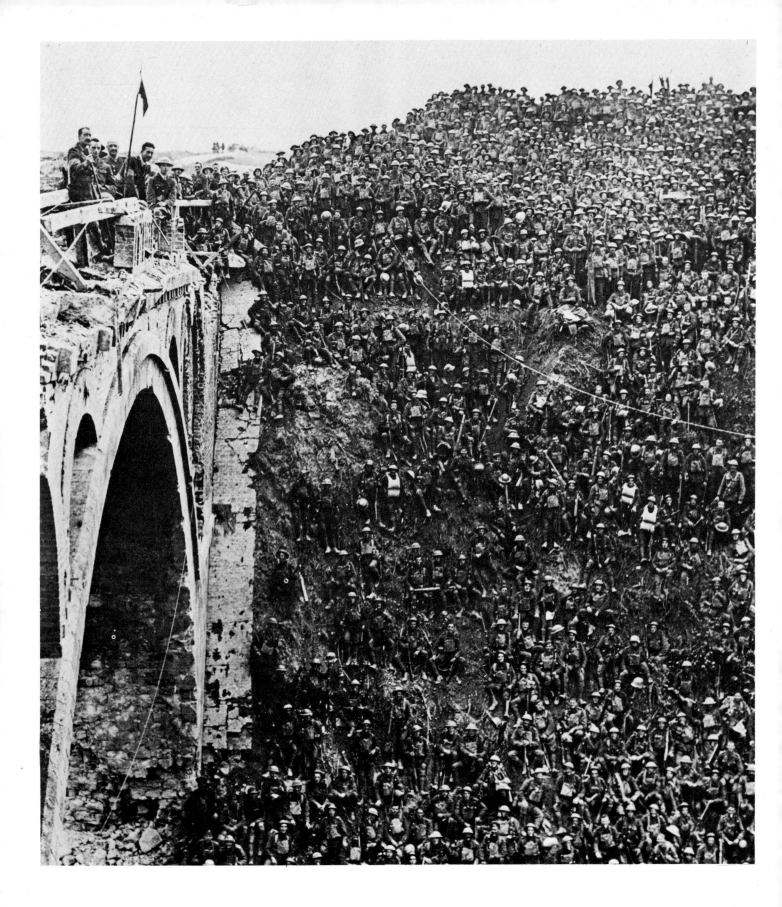